THE YOUNG MICHELANGELO

 In association with Esso UK plc

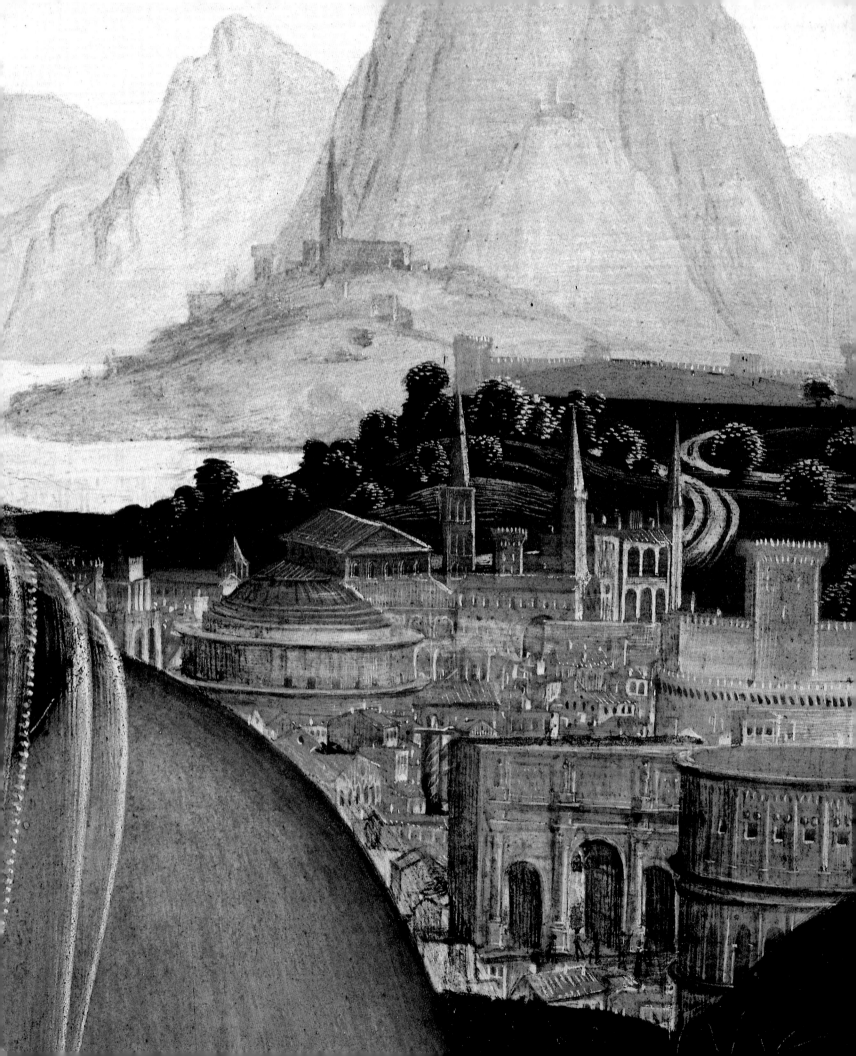

THE YOUNG MICHELANGELO

THE ARTIST IN ROME 1496-1501

MICHAEL HIRST

MICHELANGELO AS A PAINTER ON PANEL

JILL DUNKERTON

NATIONAL GALLERY PUBLICATIONS, LONDON DISTRIBUTED BY YALE UNIVERSITY PRESS

In memory of Fabrizio Mancinelli (1940–1994)

This book was published to accompany an exhibition at
The National Gallery, London
19 October 1994 – 15 January 1995

First published in Great Britain in 1994 by
National Gallery Publications Limited
5/6 Pall Mall East, London SW1Y 5BA

NGPL ISBN 1 85709 066 7 hardback
525184
NGPL ISBN 1 85709 065 9 paperback
525185

British Library Cataloguing-in-Publication Data.
A catalogue record is available from the British Library.

Library of Congress Catalog Card Number: 94–67667

Editor: Felicity Luard
Designed by Tim Harvey

Printed and bound in Italy by Grafiche Milani

Front cover: Michelangelo, detail of Saint John the Evangelist from the
Entombment (Pl. 42).

Frontispiece: Pl. 1 David Ghirlandaio, detail of Pl. 62. The view of
Rome (probably assembled from drawings) includes representations of
the Colosseum (front right), the Arch of Constantine, Castel
Sant'Angelo (behind the Colosseum on the right), Trajan's Column
(behind the Arch of Constantine), the dome of the Pantheon (to the
left), the Basilica of St Peter's with the Vatican and Sistine Chapel.

Page 6: Pl. 2 Michelangelo, detail of Angels from the *Manchester
Madonna* (Pl. 23).

Acknowledgements

For help in the preparation of this book and of the exhibition which it accompanies we are indebted to many friends and colleagues – among them Padre D'Amato OP and Marzia Faietti in Bologna; Sergio Benedetti, Raymond Keaveney and Andrew O'Connor in Dublin; Giovanni Agosti, Ezio Buzzegoli, Alessandro Cecchi, Margaret Daly Davies, Diane Kunzelman, Antonio Natale, Antonio Paolucci, Alessandro Parronchi, Agnese Parronchi, Pina Ragionieri, Magnolia Scudieri, Anna Maria Petrioli Tofani and Renzo Ristori in Florence; Veronika Poll-Frommel and Cornelia Syre in Munich; Everett Fahy and Kathleen Weil-Garris Brandt in New York; Dominique Cordellier and Françoise Viatte in Paris; Andrea Carignani, Arnold Nesselrath, Carlo Pietrangeli, Pier Luigi Silvan and Alessandra Uncini in Rome; Laurie Fusco in Santa Monica; Veronika Birke, Sylvia Ferino, Martina Fleischer, Marina Galvani, Franz Mairinger, Konrad Oberhuber and Renate Trnek in Vienna. In this country we are grateful for the help given by Martin Bailey, Lorne Campbell, Martin Clayton, Caroline Elam, Peta Evelyn, David Franklin, Antony Griffiths, Charles Hope, Lord Methuen, James Methuen-Campbell, Theresa-Mary Morton, Ruth Rubinstein, Marjorie Trusted, Susan Walker, Philip Ward-Jackson, Catherine Whistler, Christopher White, Paul Williamson, Tim Wilson and Diane Zervas. The Staff of the Bibliotheca Hertziana in Rome, the Kunsthistorisches Institut in Florence, the Warburg Institute and the Conway Library in London supplied essential help. The last two chapters owe much to the expertise of the National Gallery's Scientific Department and we would like to thank Joyce Plesters (now retired), Ashok Roy and Jilleen Nadolny for their work on the pigments, and Raymond White, Jennie Pilc and Jo Kirby for the analysis of the paint media and dyestuffs. We are also grateful to Astrid Athen, Rachel Billinge, David Bomford and Colin Harvey for responding so magnificently to the challenge of matching the quality of the technical photographs of the *Doni Tondo* generously supplied by the Ufficio Restauri of the Soprintendenza per i Beni Artistici e Storici of Florence. Felicity Luard of National Gallery Publications has been patient and punctilious in preparing the book for publication. Tom Henry very kindly compiled the index.

Finally, the debt which students – and lovers – of Michelangelo owe to Fabrizio Mancinelli who died when we were completing work on this book is incalculable. What we owe to his generosity as a scholar and hospitality as an administrator is inadequately acknowledged in the dedication of this book.

JD, MH, NP

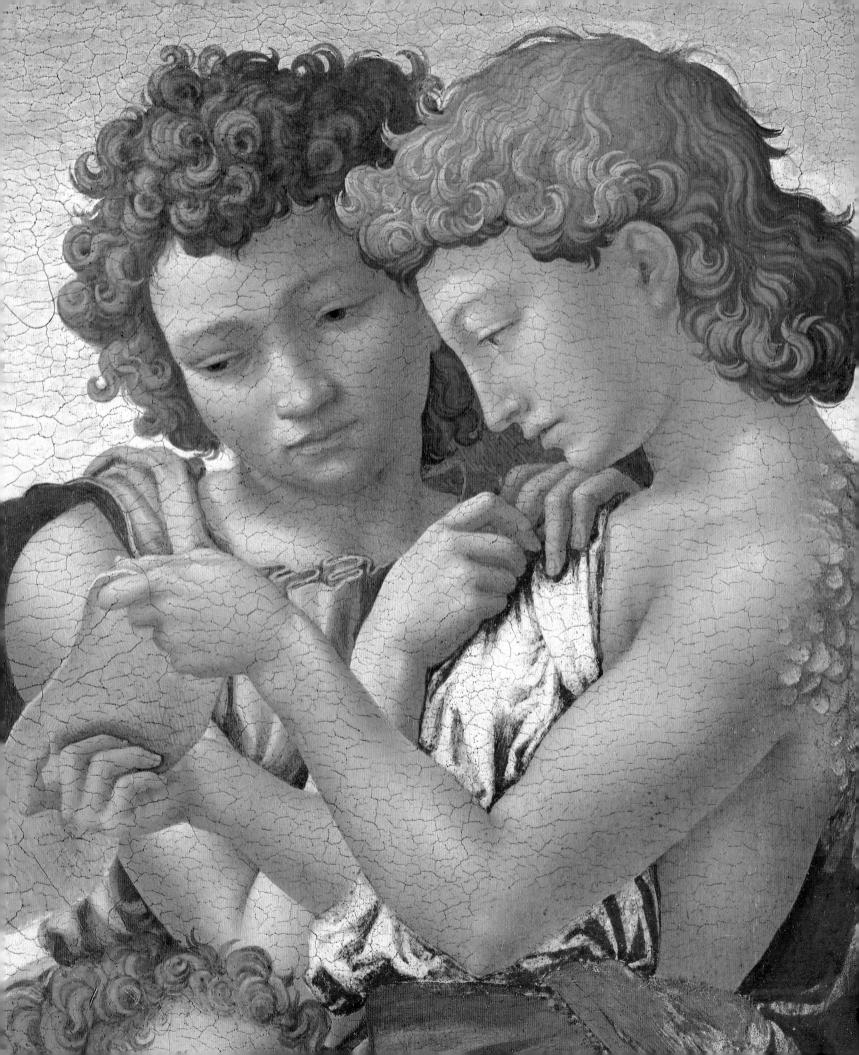

Contents

Sponsor's Preface

It is a pleasure to be associated once again with the National Gallery in the second in the 'Making and Meaning' series of exhibitions.

This is now the fifth exhibition we at Esso have sponsored with the Gallery, and 'The Young Michelangelo' exemplifies the excellent research and scholarship that are the Gallery's hallmarks. It also shows flair and innovation in opening up well-known subjects to new treatment. The genius of the young Michelangelo is convincingly shown by the juxtaposition of sculpture and painting.

This sponsorship is important for the opportunity it gives the Gallery to make more of its vast array of treasures while providing the general public free access to an enthralling and educational experience. Behind this exhibition lies analysis based on sound science as well as deep understanding of the artist's skills and objectives.

We are delighted to continue this cooperation with the National Gallery.

K.H. Taylor
Chairman and Chief Executive, Esso UK plc

Foreword

Of the three panel paintings which may be attributed to Michelangelo, two are in the National Gallery in London. Both unfinished, they arrest the viewer and challenge the scholar. Each presents for our meditation the suffering and death of Christ, foretold on the scroll read by the angels in the *Manchester Madonna*, eternally fulfilled in the heroic figure of the dead Saviour in the *Entombment*.

The contemplative, elegiac power of these two pictures is beyond question, but it is almost the only thing about them that is. By a close comparison of the paintings with Michelangelo's early sculpture, Michael Hirst convincingly argues that both the National Gallery panels are indeed by the master. Teasing inferences out of letters and bank accounts, he places both works in the years of Michelangelo's first Roman visit, a period of which we know tantalisingly little, but which produced the supreme masterpiece of the Vatican *Pietà*. There is always a fascination in fixing the portrait of the artist as a young man, and the view of the twenty-one-year-old Michelangelo that emerges here is fuller than ever before, and entirely compelling.

This is also due to the work of Jill Dunkerton of the Gallery's Conservation Department. Interpreting the complex results of recent examinations, she is able to tie both panels more closely than before to the techniques of the Ghirlandaio workshop in Florence, where Michelangelo had trained. We also discover how far we are from seeing the pictures as Michelangelo made them, for the muted hues of the *Entombment* today are the result not of the artist's intention, but of dirt, mould and the alteration of pigments.

The result of these combined researches is a fuller understanding than ever before of the early years of perhaps the supreme genius of Italian art, whose skill in sculpture can here be seen to go hand in hand with a growing prowess in painting.

The exhibition which this book accompanies is the second in the series 'Making and Meaning', which aims to present to the public great pictures in the National Gallery, and to investigate how and why they were made. These exhibitions could not take place without the support of Esso UK plc, patrons as generous and enlightened as any you will find mentioned in this book – and a good deal more patient. To them the National Gallery and its visitors owe a deep debt of thanks.

Neil MacGregor
Director of the National Gallery, London

Introduction

By the time Michelangelo began work on the frescoes of the vault of the Sistine Chapel in 1508 at the age of thirty-two, he had had a rich and varied experience as a sculptor. But the artist's first biographers, Giorgio Vasari and Ascanio Condivi, record only two paintings from this early period: a juvenile work based on Schongauer's celebrated engraving of the *Temptation of Saint Anthony* and the *Doni Tondo*, the round painting of the Holy Family made for Agnolo Doni in Florence, of 1504 or 1506, which is now one of the greatest treasures of the Uffizi galleries in Florence. That Michelangelo made other paintings between his apprenticeship in the workshop of the Ghirlandaio brothers and his creation of the *Doni Tondo* can hardly be doubted. The perfection of the *Doni Tondo* suggests that it cannot have been his first exercise in painting since his early youth. But that has not always made it easy for scholars to accept the only two panels which have a serious claim to have been painted by him in his early years – the two unfinished panels in the National Gallery, the *Manchester Madonna* and the *Entombment*.

The silence of Michelangelo's biographers is not difficult to explain, for the artist was reluctant to have uncompleted works recorded, and Vasari and Condivi were much too young to have intimate knowledge of his early activities. As a consequence, the authorship of both paintings has been controversial, but that of the *Manchester Madonna* is perhaps especially so.

The painting takes its name from the Manchester Art Treasures exhibition of 1857, where it was displayed as by Michelangelo and as a discovery made by one of the organisers, the great German scholar Gustav Waagen. The painting had, in fact, been offered twice to the National Gallery in the 1840s when the Keeper, Charles Eastlake (later the Gallery's first Director), was desperately keen to acquire it but failed to persuade the Trustees to agree. Eastlake believed it to be by Domenico Ghirlandaio – and as Jill Dunkerton demonstrates in the second part of this book it is very close to Ghirlandaio in technique. But he was aware that experts in Rome had declared it to be by Michelangelo. When the painting was finally acquired for the Gallery in 1870 it was widely – but not universally – accepted as such.

However, in this century the hypothesis that the *Manchester Madonna* belongs to a group of works by an associate of Michelangelo, the so-called 'Master of the Manchester Madonna', has proved highly seductive. But the weak link in the chain is that which connects the *Manchester Madonna* itself to the other paintings in the group. In style and in details of technique, the *Manchester Madonna* is not acceptable

as a work by the 'Master of the Manchester Madonna', as is strongly argued here by both authors and as is demonstrated in the exhibition which this book accompanies. There is also a difference in quality – it was justly described by the late Alessandro Conti as 'una delle più belle tempere che mai siano state dipinte' (one of the most beautiful tempera pictures that has ever been painted). The name of the master responsible for the other works in the group will surely have to be changed.

In the most recent catalogues of sixteenth-century Italian paintings in the National Gallery (of 1962 and 1975) the compiler hesitated to accept the *Manchester Madonna* as by Michelangelo and preferred the formula 'ascribed to', observing that 'if it were autograph it would have to be very early, and since there is no means of judging Michelangelo's handling of paint in a panel picture at this stage of his career the question cannot be settled.' But comparisons can be made with paintings by Michelangelo's teachers, friends and associates – also, of course, with the *Doni Tondo*. As Jill Dunkerton explains, this exercise reveals the technical similarities with paintings by the Ghirlandaio brothers and by Michelangelo's friend and fellow student Francesco Granacci which we would expect. But the differences remain. The sculptural compactness of the forms in the *Manchester Madonna*, the gravity of the expressions, the austere reduction of setting and accessories, the novelty of the angelic youths – more youths than angels – not merely witnessing but participating in the solemn narrative of the child Baptist's prophecy to his infant cousin – such features distinguish the painting from others of the late fifteenth century. And if there are no other paintings by Michelangelo with which it may appropriately be compared then there are his sculptures – the *Madonna of the Stairs*, the angel on the Arca of Saint Dominic in Bologna, the *Bacchus*, the *Bruges Madonna*, the *Pitti Tondo* – and with these, as Michael Hirst demonstrates, the affinities are profound.

The *Entombment,* which came to the Gallery in 1868, was a more controversial acquisition than the *Manchester Madonna*. Its provenance was somewhat murky – it had been spotted by a Scottish photographer among some dirty scraps from the collection of Cardinal Fesch, purchased in the shop of a Roman dealer and furtively exported from Italy. It is also a damaged painting as well as an unfinished one. The Gallery's Director at the time of its purchase, Sir William Boxall, believed it to be by Michelangelo, so did Giovanni Morelli, the father of modern connoisseurship. But the greatest of British connoisseurs, Sir John Charles Robinson, would not accept it. No one wrote more eloquently in its defence than the young Bernard Berenson: 'It fills me with no little amazement that this masterpiece, this quintessence of Michelangelo's art, should encounter so little acceptance...this Pietà is essentially Michelangelo's. No other artist was capable of putting together a design of such gigantic forms and powerful action as we have in the four principal figures of this composition.' In recent years the painting has found more advocates in favour of it being by Michelangelo than has the *Manchester Madonna*. Two preliminary drawings by Michelangelo – included in the exhibition and discussed here – can be related to the *Entombment*. Moreover, in 1981 Michael Hirst published evidence, re-examined

in this book, that Michelangelo was contracted to paint an altarpiece for a church in Rome in 1500 which he abandoned unfinished in the following year. It can be shown that the subject and scale of the *Entombment* would have been appropriate for the chapel in question.

Hirst demonstrates that the curious treatment of the *Entombment* has its source in a Florentine tradition which can be traced back to Fra Angelico, and also that the subject, which Michelangelo left unfinished in this painting, continued to haunt his imagination to the end of his life. But the focus in this book is on a period of five years of Michelangelo's activity. Hirst provides the fullest account ever attempted of Michelangelo's first stay in Rome between 1496 and 1501. This is the period in which the *Entombment* must have been painted if it is the altarpiece mentioned in the documents, and it is the period to which the *Manchester Madonna* is most plausibly assigned. Michelangelo came to Rome to regain one sculpture (the *Sleeping Cupid*) and left it to undertake another (the colossal *David*). It was in Rome that he created the most daring and original of his early sculptures (the *Bacchus*) and the most perfect and widely admired (the *Pietà*). To recall this is perhaps to understand why he was dissatisfied with his early unfinished paintings. If we accept these paintings as by Michelangelo we can only understand them in relation to his early sculpture. Even when painting the Sistine Chapel ceiling the artist signed himself 'Michel Agnolo Scultore'.

Nicholas Penny
Clore Curator of Renaissance Painting

I

The Sculptor of the *Sleeping Cupid*

ICHELANGELO arrived in Rome for the first time on Saturday, 25 June 1496. He was twenty-one years old. On the following Saturday he wrote a letter which describes his first days in the city and recounts – all too sparingly – some of the events of his first week. Michelangelo was addressing his most recent Florentine patron, who had been a party to his decision to leave Florence and had given him letters of introduction to help him achieve some of his aims on his arrival in the city of Pope Alexander VI.[1]

Michelangelo stayed in Rome until March 1501; his return to Florence would be repeatedly postponed. Towards the end of his stay, he carved the marble *Pietà*, the work which effectively established his fame as an artist. It is the first period of his life in which biographical facts become fairly plentiful. We owe this not to an abundance of letters, very few of which remain from this time, but to the fortunate survival of the account books of the bankers, Baldassare and Giovanni Balducci, with whom the young artist had his account in these five years of his Roman residence. These books contain information still not fully exploited for an examination of Michelangelo's activity in this formative period and they will be referred to repeatedly in the following pages.

In part, the information confirms and amplifies the detailed story given to us by Michelangelo's chosen biographer, Ascanio Condivi, whose life of the artist appeared in 1553. Condivi had no personal knowledge of these early years and his account therefore depends almost exclusively on what Michelangelo chose to tell him: 'dal vivo oraculo suo'.[2] However, the information in the Balducci bank-books can, on occasion, present discrepancies with what we are told in Condivi's Life and these are not always flattering with regard to Michelangelo's veracity in old age. We shall see that, when we turn to the marble *Bacchus*, his first major undertaking on his arrival in the papal city, the old artist subsequently attempted, with remarkable success, to change the historical record.

Condivi's account of Michelangelo's youth has an abundance of detail nowhere equalled in Vasari's Life of 1550, for when he wrote Michelangelo's biography in his first edition, Vasari was poorly informed about the early years. Nevertheless, when we read Condivi, we must reckon with the artist's wish to present himself as an autodidact, the pupil of nobody. And on the one occasion when Condivi sought to refute what Vasari had written about Michelangelo's training, the ground was ill-chosen. The case is a celebrated one. In his 1550 account, Vasari had referred to the young man's apprenticeship with the Ghirlandaio brothers, Domenico and David; he

had even referred to a document known to him. Condivi, undoubtedly at Michelangelo's insistence, had poured scorn on the contribution that Domenico Ghirlandaio had made to his upbringing. In his massively revised Life of 1568, Vasari went to the length of quoting the text of the agreement between the Ghirlandaio brothers and Michelangelo's father, Lodovico Buonarroti, drawn up on 1 April 1488, whereby Michelangelo was apprenticed to them for the following three years.3

Recently, further confirmation of Michelangelo's presence in the Ghirlandaio workshop has been discovered. It shows that he was there, acting as a collector of credit for the master (then working on the altarpiece for the Ospedale degli Innocenti; Pl. 3), a traditional task for a young workshop assistant, earlier than the date of April 1488 supplied by Vasari; the reference to the youthful Michelangelo is dated 28 June 1487, nine months before.4

Some of Michelangelo's early works are striking evidence of the connection established by the documents. Michelangelo's earliest surviving panel painting, the so-called *Manchester Madonna* in the National Gallery, which we shall turn to in a later chapter, was already recognised as a work deeply Ghirlandesque in some of its features in the nineteenth century; for a time it even bore the name of Domenico Ghirlandaio.5 And that Michelangelo's early drawing style in pen and ink was closely modelled on that of Ghirlandaio has been a commonplace for many decades (Pls 4, 5, 6 and 52); in fact, the influence can be detected in drawings of Michelangelo's as late as the 1520s.6

The two early biographies, that of Vasari of 1550 and of Condivi of 1553, are less sharply at odds over the subsequent stage in Michelangelo's upbringing, his frequenting of the Medici sculpture garden on the piazza of San Marco. It has been later art historians who have come to cast doubt on the garden's real existence or importance in late fifteenth-century Florentine culture or in Michelangelo's own development as a sculptor. Recently, however, its location and its history have been reconstructed in unprecedented detail.7 Both Vasari and Condivi refer to the role of Francesco Granacci in their accounts of Michelangelo's link with the garden under Lorenzo the Magnificent. Vasari alludes to him as Michelangelo's colleague there, while Condivi identifies him as the friend who introduced him to it, one among many kindnesses that Granacci is credited with by the latter. Granacci, born in late 1469 or early 1470, was Michelangelo's senior by about five years. Nevertheless, there are significant differences of emphasis in the two accounts. For Condivi the sculpture garden is a place of informal study, for Vasari a much more organised centre of artistic training. It is telling that it is Vasari who, in 1550, writes of the didactic role at the garden of Bertoldo, a sculptor who had been a pupil of Donatello and one conceded particular favour by Lorenzo de' Medici. Of Bertoldo, Condivi makes no mention of any kind, a silence that has even been adduced as evidence that he can never have had anything to do with the young Michelangelo. But to argue for such a conclusion from Condivi's silence is to fall victim to the myth of the auto-didact cultivated in his deceptively simple text. Michelangelo's earliest sculptures,

OPPOSITE Pl. 3 Domenico Ghirlandaio, *Adoration of the Magi*, 1486–8. Panel, 285 × 240 cm. Florence, Ospedale degli Innocenti. The painting was nearing completion in the Ghirlandaio workshop when Michelangelo was a young apprentice there.

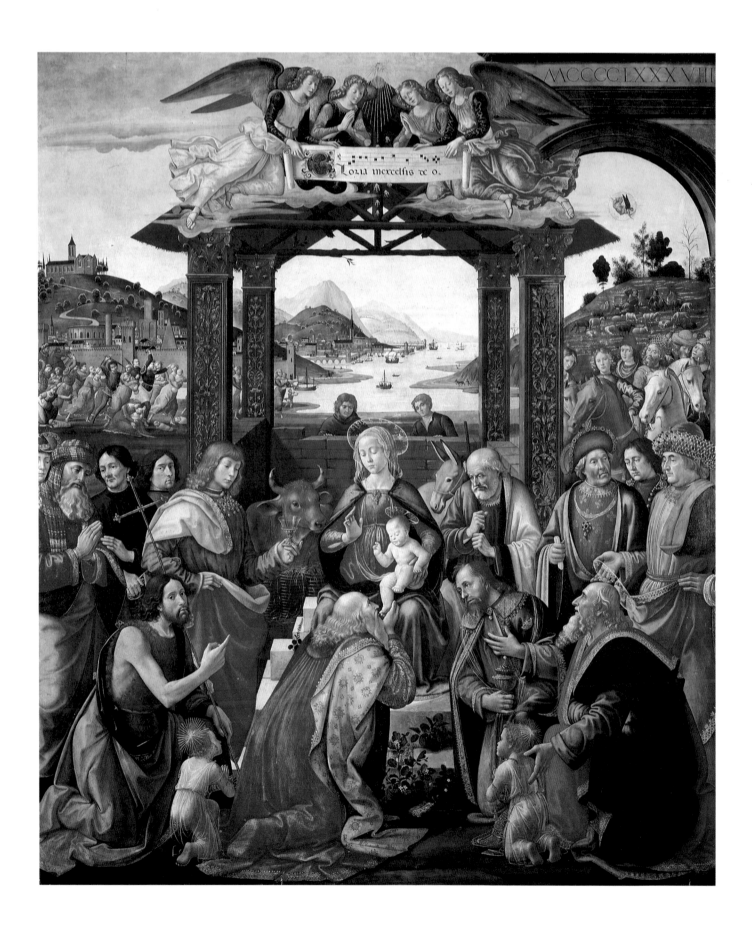

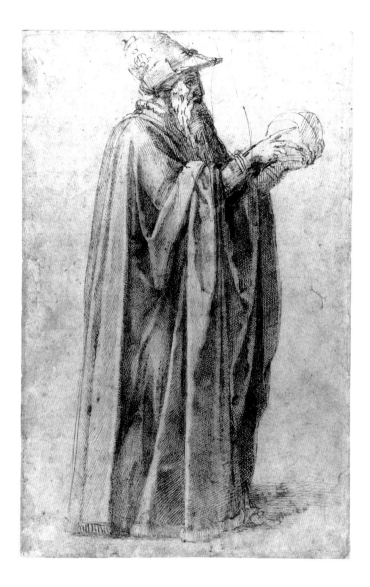

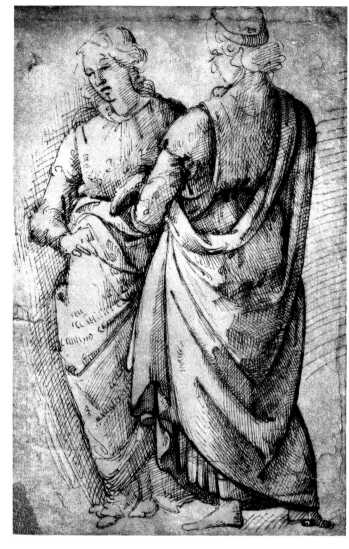

especially the relief of the *Madonna of the Stairs* (Pl. 7), tell a different story. Had Michelangelo died after he had carved this relief, we should still be seeking the identity of its author among the later followers of Donatello.[8] The slightly later relief of the *Battle of the Centaurs* (Pl. 8) was, Condivi explicitly states, based on Angelo Poliziano's explanation of the legend to the young artist. The information is entirely credible, for Poliziano, philologist and poet, nearly twenty years Michelangelo's senior, had been entrusted by Lorenzo de' Medici with the education of his sons, Piero and Giovanni (the latter the future Pope Leo X). Michelangelo's relief, where every figure is naked and the majority are engaged in a conflict which pervades the whole, is a sculpture of unique character in Florentine art of the last years of the fifteenth century. While we may speak of an inspiration from antique reliefs and detect a few details still indicating traces of Bertoldo's influence, the work's deeply personal character obscures all signs of where Michelangelo learned his skills as a marble carver.[9]

Pl. 4 Michelangelo, *Philosopher*, *c*.1495–1500. Pen and brown and grey ink, 31.1 × 21.5 cm. London, British Museum. The pen and ink technique with its use of parallel hatching and cross-hatching is very close to that of Ghirlandaio.

Pl. 5 Domenico Ghirlandaio, *Two standing women*, study for the fresco of the *Naming of the Baptist* in S. Maria Novella, Florence, 1486–90. Pen and ink, 26 × 16.9 cm. Florence, Uffizi.

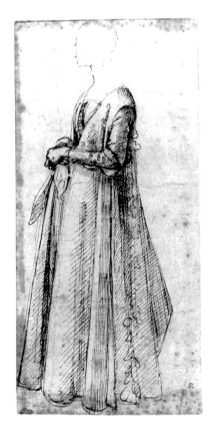

Pl. 6 Domenico Ghirlandaio, *Standing woman*, study for the fresco of the *Birth of the Baptist* in S. Maria Novella, Florence, 1486–90. Pen and ink, 24.1 × 11.5 cm. London, British Museum. For the figure in the fresco see Pl. 58.

Although, as we can see, Condivi's Life of Michelangelo is one with many traps for the unwary, it is, none the less, an astonishingly rich account of Michelangelo's early years in the 1490s. He states that, at some point following Lorenzo the Magnificent's death in the spring of 1492, his eldest son, Piero, reintroduced Michelangelo into the Medici palace household. Some of Condivi's anecdotes may seem suspect. It is, for example, tempting to dismiss his story about Michelangelo's snowman made at Piero's request as no more than an indication of the latter's frivolity, inspired by Michelangelo's later contempt for Lorenzo's son. Yet, before we do so, we should note the exceptionally heavy snowfall in Florence recorded by a diarist on 20 January 1494 (1493 Florentine style).[10] There can be little doubt that Michelangelo did enjoy Piero's patronage up to the moment of his abrupt abandonment of his patron in circumstances alluded to below. It is probable that Michelangelo's earliest large marble statue, a Hercules over two metres high, was commissioned by Piero and, after his fall from power in 1494, remained in the artist's possession, only later passing to members of the Strozzi family.[11]

Many of Condivi's details are exceptionally striking and cannot have been based simply on written records, Michelangelo's *ricordi*, which the aged master handed over to his chosen biographer to stitch together into a narrative. It is doubtful, indeed, whether such records of these early years would have been available in Rome in the early 1550s. The astonishing apparition which a fellow member of Piero de' Medici's household recounted to Michelangelo is given to us in vivid detail by Condivi: the dead Lorenzo de' Medici had appeared twice in dreams, warning him of imminent disaster to the family house. The young artist's decision to flee Florence shortly before the collapse of the Medicean regime was, we are told, precipitated by this remarkable episode. This is not the kind of material that Michelangelo confided to his *ricordi*.[12]

Michelangelo's flight in 1494 is described at some length by Condivi, and his subsequent stay in Bologna in still more detail. Remarkably, Vasari makes no reference to it at all in his Life of 1550 and was evidently totally unaware of it. The Bolognese episode exhibits many of the features of these early years of Michelangelo's life; and his highly dramatic – and self-dramatising – involvement in the political vicissitudes of his age would become a recurrent one in the artist's biography. It exemplifies the pattern of the breakdown of patronage, followed by a providential recovery, which marks the first half of the 1490s prior to his move to Rome. *Fortuna* appears at moments of seemingly irreversible adversity. Michelangelo arrived in Bologna (after a brief sortie as far as Venice) at the moment when the master sculptor of the Arca of Saint Dominic in San Domenico had died, and Michelangelo's newly acquired Bolognese protector, Gian Francesco Aldovrandi, arranged for the nineteen-year-old artist to succeed him; Michelangelo would execute three of the four statues still required. We are told by Condivi that in the evenings, patron and young artist studied Dante, Petrarch and Boccaccio together.[13]

Each of the three statues that Michelangelo carved for the Arca of Saint

Pl. 7 Michelangelo, *Madonna of the Stairs*, *c.*1490. Marble, 56.7 × 40.1 cm. Florence, Casa Buonarroti. This unfinished relief is Michelangelo's earliest surviving sculpture and remained in Florence, quite unknown, in the artist's possession until his death.

Dominic has a different character (Pls 9, 10 and 12). They are not our concern here, but a few comments can be made about the one which might have seemed to offer him the least scope for autonomy, his candle-holding, kneeling angel (Pl. 12). The figure was required to balance the angel already completed by Niccolò dell'Arca on the left side of the altar (Pl. 11). Yet conformity is avoided. Michelangelo's work is both a companion and a critique of the older sculptor's statue, a critique inspired by

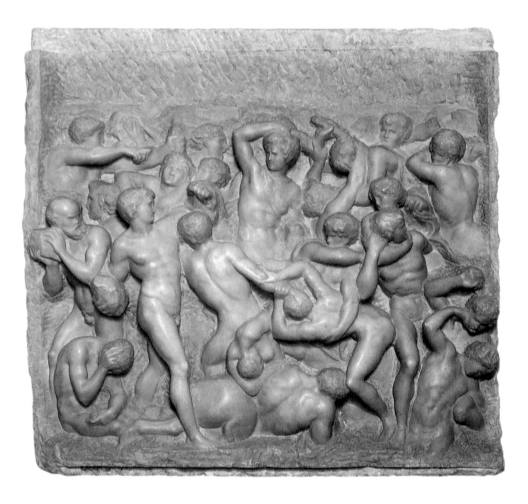

Pl. 8 Michelangelo, *Battle of the Centaurs*, 1491–2. Marble, 80.5 × 88 cm. Florence, Casa Buonarroti. The relief, probably undertaken a little later than the *Madonna of the Stairs*, may have remained unfinished because of the death of the artist's patron, Lorenzo il Magnifico, in 1492.

some of the ideals that had been expressed in the unfinished *Madonna of the Stairs*. There can be little doubt that, for his angel, Michelangelo was given a block already prepared for his predecessor. But it is striking to what extent he succeeded in imparting movement to a figure cut from a shallow block; he avoided carving it in the plane. Michelangelo chose to do away with the voluminous Gothic robe of Niccolò dell'Arca's figure and clothed his own angel in a much more classically inspired belted dress. Even the detail of the neckline strikes a different note. The elaboration of Niccolò's candle-holder was replaced by one both more monumental and simpler. For Niccolò's long falling locks of hair the young artist substituted a more closely modelled, more *all'antica*, haircut. Michelangelo's drapery is less deeply cut than Niccolò's, but its forms are more active. They are carved, like the features of the head, with very great refinement, a response to the proximity of the viewer. There is little visible evidence of the use of a drill. In this, the angel contrasts with the two standing saints on the much higher level of the monument, whose treatment is broader and less delicate (Pls 9 and 10). Such differences will distinguish the two surviving carvings of the Roman stay, the *Bacchus* and the *Pietà*.[14]

Condivi states that Michelangelo remained in Bologna for just over a year and returned to Florence only when he felt it safe to do so. In fact, an amnesty for many

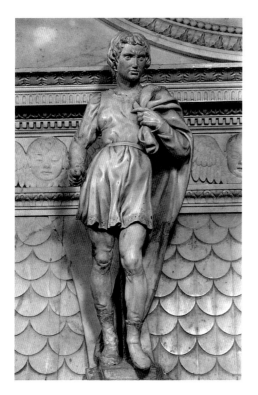
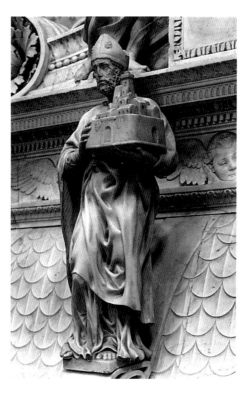

adherents of the old regime had been passed in the spring of 1495. Michelangelo may have been kept in Bologna by his work on the sculpture for the Arca; he may also, as an ex-Medicean dependant, have been maintaining that self-protective caution which will mark so many of his acts in the future.[15] The outlawed Piero de' Medici, whose service Michelangelo had so summarily abandoned, made an abortive attempt to regain the city in the autumn of 1495; perhaps it was following this failed coup that Michelangelo decided to return. Back in Florence, he found, in circumstances we cannot reconstruct, a new patron in Lorenzo di Pierfrancesco de' Medici, who, with his brother Giovanni, had gone over to the new republican regime following the expulsion of their Medici cousins. Lorenzo di Pierfrancesco de' Medici was a significant patron in his own right; Michelangelo's association with him is, however, a warning not to expect political loyalties from the artist in his affiliations with his patrons.[16]

For Lorenzo di Pierfrancesco Michelangelo made a marble statue of a youthful Saint John, called by Condivi a 'San Giovannino'. No trace of it is known but its existence is firmly attested.[17] More significantly for our concern here, it was Michelangelo's association with this new patron which led him to dispose of the marble *Sleeping Cupid* as a simulated antique, the fate of which would lead him to Rome in the mid-summer of 1496.

Vasari had briefly alluded to the affair of the *Cupid* in his first edition of his Life in 1550, but he gives no indication of its appearance or even of its whereabouts.[18] In 1553, Condivi tells the story in circumstantial detail. The carving is described as a god of love, aged six or seven years old and asleep ('un Dio d'Amore, d'eta di sei anni in sette, a giacere in guisa d'uom che dorma').[19] Considered, on completion, to

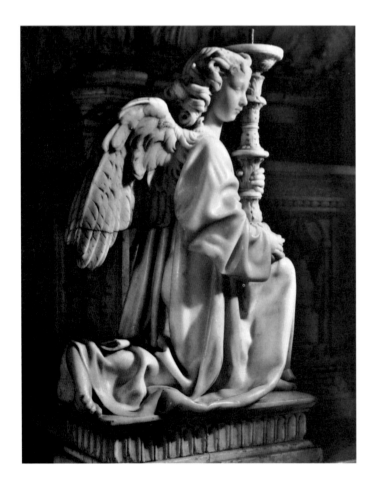 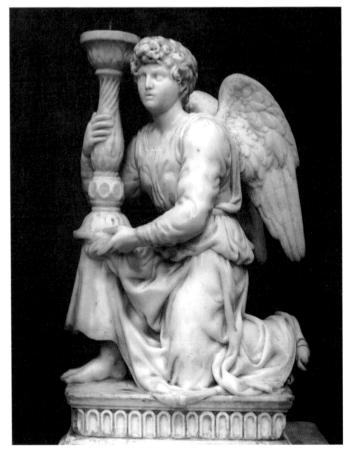

Pls 11 and 12 *Angels holding Candlesticks* from the Arca of Saint Dominic by Niccolò dell'Arca (left), between 1469 and 1494, and Michelangelo (right), 1494–5. Marble, 51.5 cm high (Michelangelo's figure). Bologna, S. Domenico.

be a work of great beauty by Lorenzo di Pierfrancesco de' Medici, he advised Michelangelo to age the work, send it to Rome and thereby achieve a better price by selling it as an antique. The dealer entrusted with the piece outwitted both the sculptor and his patron, selling the work to Cardinal Raffaele Riario for two hundred ducats while reporting back to Florence that he had disposed of it for thirty. We are told that word reached Riario that the work was modern and Florentine in origin. He sent an associate to Florence who met Michelangelo, confirmed the modernity of the *Cupid* and prevailed on him to accompany him back to Rome. Condivi adds that, on arrival in Rome, Michelangelo stayed in the house of this emissary of Riario's, and, as the Balducci bank-books show, Michelangelo lodged with Jacopo Gallo in his first year in the city. (The document is one to which we shall return in the following chapter).[20] Thus, as long ago suspected, Riario's agent was none other than the man who, more than any other, extended repeated help and lengthy hospitality to the young artist in these years, and for whom he would, at some point in his Roman stay, carve a standing Cupid, now lost.[21]

Vasari in his 1550 account gives us the name of the dealer, Baldassare del Milanese, whom Condivi does not name. In his 1568 edition, he offers three different accounts of how the idea of deception originated, but adds nothing fundamental to Condivi's report.[22]

This remarkable episode, strange among so many exceptional episodes in Michelangelo's career, should not be dismissed as an art historical fable. Michelangelo's memory failed him over certain details, but that Riario had bought the *Cupid* as an antique for a correspondingly high price had been known in Rome long before Vasari and Condivi put pen to paper. The episode is recounted in a brief biography of Michelangelo written by Paolo Giovio in the 1520s but which remained unpublished until the eighteenth century.[23] In the light of Renaissance attitudes, the fact that Riario subsequently took an interest in the young sculptor is not incompatible with his returning the *Cupid* to the man who had misled him; he declined it because it proved to be a modern sculpture sold to him at a price commanded by an antique. Cardinal Riario used the Balducci bank (with which Gallo was affiliated), the bank that Michelangelo chose for his own account after his arrival in Rome. And we find that Riario actually paid out to Michelangelo money for the expenses of the journey he had made from Florence.[24] An earlier credit paid into the cardinal's account should also not escape our notice. He was credited with two hundred ducats, the exact sum he stood to regain on handing back the *Cupid*, on 5 May 1496, just over three weeks before Michelangelo arrived in the city. Unfortunately, the name of the payer is omitted in the entry.[25]

By the time that Michelangelo arrived in Rome, the *Cupid* had been returned to the dealer and was back on the market. Evidence of the interest that it had aroused in the city can be found in two remarkable letters written to Isabella d'Este, Marchesa of Mantua. Mindful of the Marchesa's avid pursuit of antiquities for her celebrated collection, her correspondent reported to her, in a letter of 27 June, that he had just seen a carving offered for sale to Cardinal Ascanio Sforza, the Vice-Chancellor of the Church.

Sforza has declined to buy it. Isabella's correspondent describes the piece: 'a Cupid recumbent and asleep, resting on one hand. The work is intact, measures about four *spanne* [about 80 cm] and is very beautiful. It is held by some to be antique and by others to be modern. Whichever is the case, it is absolutely perfect.' He would not part with it for four hundred ducats; the owner is asking two hundred.[26]

Another letter followed, nearly a month later, on 23 July. Isabella is informed that the *Cupid* is modern and that the master who made it has arrived in Rome. It is so perfect that everyone had believed it to be antique. Now that it has been established as modern, he believes it will be offered for a low price. However, if the Marchesa does not want it because it is not antique, he will say no more.[27]

Michelangelo, therefore, arrived to find his *Cupid* on sale. In his letter of 2 July to Lorenzo di Pierfrancesco de' Medici, he first describes his meeting with Cardinal Riario and then turns to discuss the *Cupid*. He has given the dealer his Florentine patron's letter and has asked for the sculpture back, offering to return the money he himself has had from him. But his approach has met with a violent rebuff, for the dealer has reaffirmed his ownership of the piece and threatened to cut it into a

hundred pieces rather than surrender it. Michelangelo writes that he will try other means to secure it. Hence, the young man's letter is at odds with the old artist's recollection reported to Condivi over fifty years later. In Condivi's text, we are told that Michelangelo wanted reimbursement; in fact, he had wanted the carving back.[28] In this he failed.

Isabella d'Este, single-minded in her search for ancient art, did not pursue the *Cupid* further in 1496. She may never have learnt the name of the sculptor. But even if she had, it would probably have meant little to her at this early date. By a number of extraordinary vicissitudes, she would acquire it from Cesare Borgia, Pope Alexander's son, in 1502, a present after Cesare had sacked Urbino. (Exactly how and when it had been taken to Urbino is unknown.) It arrived in Mantua on mule back, together with an antique Venus, by 21 July 1502. Writing to her absent husband a day later, Isabella comments that she will not dwell on the beauty of the Venus as she thinks that the Marquis Francesco has already seen it. The *Cupid*, for a modern work, has no equal ('el Cupido per cosa moderna non ha paro').[29]

Cesare Borgia had acquired the *Cupid* after sacking Urbino, the duchy of Isabella's own brother-in-law, but, after the duchy had been restored to him, Isabella, behaving at her worst, refused to give up Michelangelo's sculpture.[30] The *Cupid* remained at Mantua, to be joined by a truly antique *Cupid*, which the Marchesa had secured, after arduous negotiations, in 1505. The two pieces were shown in close vicinity in the same room; Isabella had achieved a didactic confrontation of ancient and modern, one open to the admiration of discriminating visitors. The two works are listed in a much published inventory of Isabella's collection drawn up not long after her death.[31] Yet, in a comparison with the old, the new was bound to lose. Even when she expresses her admiration of Michelangelo's carving on its arrival in 1502, Isabella's commendation is still qualified; it has no equal among modern works. Visitors who subsequently had the opportunity to compare the two *Cupids* for themselves continued to award the prize to the antique piece.[32]

The episode of the *Cupid* has assumed a particular prominence in the history of imitation and forgery. But its notoriety owes much to the identities of those who had been involved. The faking of modern sculptures to be sold as antiques was, as the fifteenth century approached its end, a response to a demand which threatened to outstrip supply. The practice extended throughout the Italian states and was especially common in North Italy. And we owe to a Venetian an account of an episode involving the burial of a porphyry vase in Rome in 1495 – just one year before the *Cupid* deception – which would subsequently change hands at a very high price as an antique.[33] However, it is important to note that forging the antique had been sanctioned by literary practice long before. No less than Leon Battista Alberti, when only about twenty, had written a light comedy which he himself had successfully passed off as the work of a fictional classical playwright.[34]

Michelangelo's *Cupid*, the work that led him to Rome and the scene of his future public success, must be deemed lost, despite repeated attempts to identify it

with existing carvings. It is one of that list of important lost works carved in the 1490s which includes the *Hercules*, the youthful *Saint John* and the *Standing Cupid* made for Jacopo Gallo, already referred to. These losses seriously hinder our attempts to follow his progress as a sculptor in this critical decade. We are, of necessity, compelled to assess his marble *Bacchus*, his first Roman assignment, without secure knowledge of how he had designed and carved his *Hercules*, a statue of much the same scale as the Louvre *Rebellious Slave*.[35] Nor do we possess sure evidence of the appearance of the *Sleeping Cupid*. One of the famed masterpieces of the Mantuan ducal collection, which began to be broken up on a serious scale in the later 1620s, it was sold relatively late in the disposal of the Gonzaga treasures. What is seemingly the last certain reference to it can be found in the correspondence of one of the agents in Italy most active in the service of Charles I. In a letter that he wrote from Venice in June 1631, Daniel Nys reports that he will shortly dispatch to England a number of exceptional pieces of sculpture, among them '"children" by Michelangelo, Sansovino and Praxiteles'. Circumstantial evidence suggests that they did arrive in England. That Michelangelo's *Cupid*, which had been subjected to so many turns of fate, perished in a great fire in Whitehall Palace in 1698 is a sad presumption, but one likely to be true.[36]

Excursus: The *Sleeping Cupid*

This excursus does not set out to present solutions to the problems raised by Michelangelo's *Sleeping Cupid*. Its purpose is a brief review of the nature of some of the issues: it does not provide a historiographical survey.

Acquired from Cesare Borgia in 1502, Michelangelo's *Cupid* was initially housed in Isabella d'Este's *grotta* in the Castello di San Giorgio in Mantua, to be joined there by the antique piece, ascribed to Praxiteles, purchased for her in Rome in 1505. Both *Cupids* moved, with her other treasures, to her new quarters in the Corte Vecchia after her husband's death in 1519. Isabella's two *Cupids* are listed in an inventory of her collection compiled at some date after her own death in 1539. In it the two are described as follows:

> E più, un Cuppido che dorme sopra una pelle di leone fatto da Prassitele, posto in un armario da un de' lati della finestra all sinistra. (And in addition, a Cupid sleeping on a lion skin, made by Praxiteles, placed in a cupboard on one side of the window on the left.)
> E più, un altro Cuppido che dorme, di marmo da Carara, fatto de mano de Michel'Agnol fiorentino, posto dall'altra banda della finestra in un armario.
> (And in addition, another sleeping Cupid, of Carrara marble, made by the hand of Michelangelo of Florence, placed on the other window-ledge in a cupboard).[37]

The *Cupids* remained together and later visitors to Mantua who enjoyed access could compare the two works.

An inventory drawn up in 1627, on the eve of the dispersal of the Gonzaga sculpture collection, lists four Cupids. Unfortunately, the names of the artists are not given. The descriptions do, however, contain valuations and read as follows:

Un amorin che dorme sopra una pelle di Leone extimatto scudi otto (An *amorino* sleeping on a lion skin valued at eight scudi)

Un amorin picolino che dorme sopra un sasso, ha due papaveri in mano e stimatto scudi cinque (A little *amorino* sleeping on a stone, two poppies in his hand and valued at five scudi)

Un amorin che dorme sopra un sasso e stimato scudi venti (An *amorino* sleeping on a stone and valued at twenty scudi)

Un altro amorin che dorme sopra una pelle di Leone con un funerale in mano e stimato scudi venticinque (Another *amorino* sleeping on a lion skin with a funerary torch in his hand and valued at twenty-five scudi).[38]

It has been suggested that the latter two of these four, with the higher valuations of twenty and twenty-five scudi, were the *Cupids* of Michelangelo and Praxiteles.[39]

As we have seen, the next secure reference to the fate of Michelangelo's *Cupid* is in the letter written in French by Daniel Nys to Thomas Cary, dispatched from Venice in June 1631. He reports that some of the finest pieces of the Gonzaga sculpture collection are still in his hands and states that they will be shipped to England in the near future. The group includes a crouching Venus ('une figure de femme acroupie de marbre') and three Cupids: 'un enfant, Michiel Angelo Bonarota; un enfant, Sansovino; un enfant de Prasitelle. Ces trois enfants n'ont pris et sont les plus rares choses qu'avoit le ducq.'[40] It is now generally (although not universally) accepted that the three Cupids which Nys lists in this letter are three Cupids drawn on a sheet in an album in the Royal Library at Windsor (Pl. 13).[41] The presumption that this is correct seems corroborated by an earlier letter of Nys, dated February 1629, in which he had promised to send drawings of the Gonzaga sculpture that was still available for purchase to England.[42] It is commonly accepted that the Cupid numbered 28 on the Windsor sheet records the appearance of Michelangelo's *Cupid* and it has also been proposed that the Hercules-type Cupid, with a club, numbered 29 on the same sheet, is Isabella's Praxitelean *Cupid*.[43]

If this identification of Michelangelo's *Cupid*, carefully argued for in an article that appeared in 1957, is, indeed, correct, we have to conclude that Michelangelo followed, with remarkable fidelity, a common classical type, of which one Roman example is today in the Uffizi collection (Pl. 14).[44] In this classical statue, as in the figure in question on the Windsor sheet, Cupid lies on his left side. His head rests on his forearm – a minor discrepancy with the description in the letter of 1496 where he is said to rest his head on his hand. In his left hand, in both Uffizi marble and Windsor drawing, he holds two poppies, symbols of sleep or death.

An objection to the identification of the Cupid numbered 28 on the Windsor sheet with Michelangelo's figure has not been adequately acknowledged. In the Mantuan inventory of 1627 already quoted, there are four Cupids listed, and we

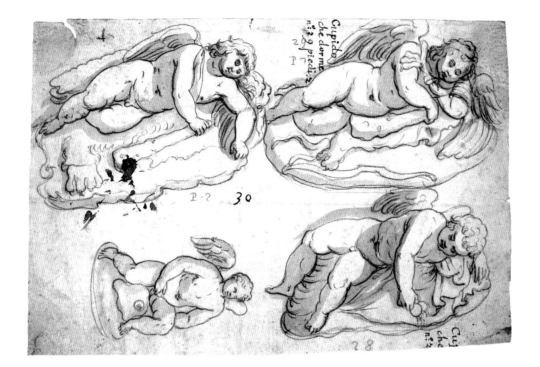

should note that in one of his letters Daniel Nys actually refers to four Cupids.[45] Only one of the four is described as holding poppies ('papaveri'), a feature of the Cupid in the drawing identified as Michelangelo's. Yet the inventory describes this particular Cupid as 'picolino', while we know that Michelangelo's *Cupid* was almost life-size.[46] Furthermore, the very low valuation – the lowest of the four – given to this Cupid in the inventory, of five scudi, seems impossible to reconcile with the prestige of Michelangelo's piece and Nys's own estimate of its priceless quality.[47] An explanation seems required.

Recently, an attempt to establish the appearance of Michelangelo's *Cupid* has been made on very different lines. It is based on a lengthy study of a 'black' sleeping Cupid, carved in 'bigio morato', once a celebrated piece in the Medici collection, which was subsequently lost sight of and was recovered, in effect rediscovered, in a storeroom of the Uffizi following the flood of 1966 (Pl. 15).[48] It has been argued that it was this 'Cupido nero' which was the Cupid presented by the King of Naples to Lorenzo the Magnificent in 1488.[49] This Cupid is of a type quite different from those considered above but is, nevertheless, of a kind frequently encountered in antique art. It does not feature in the Windsor drawing. Its claim to be Michelangelo's prototype rests on the argument that it is the piece owned by Lorenzo and also that it closely resembles a figure in a painting by an assistant of Giulio Romano actually made in Mantua. In fact, the infant Jupiter in this Giulio school piece (now in the National Gallery, NG 624) had been proposed as a record of Michelangelo's *Cupid* over sixty years ago.[50] Many examples of this type of sleeping Cupid survive, including one now in the Methuen collection at Corsham Court which has been unpersuasively identified as Michelangelo's original (Pl. 16).[51]

Pl. 14 *Sleeping Cupid*, Roman, 2nd century AD. Marble, 69 cm long. Florence, Uffizi.

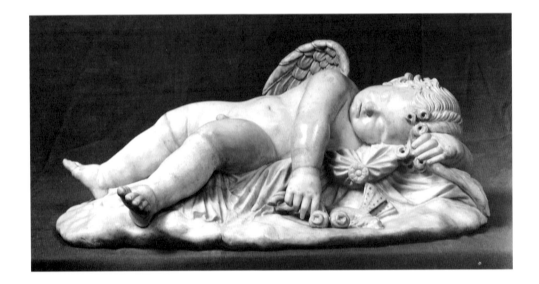

Pl. 15 *Sleeping Cupid*, Roman, 2nd century AD. Black marble ('bigio morato'), 135 cm long. Florence, Uffizi.

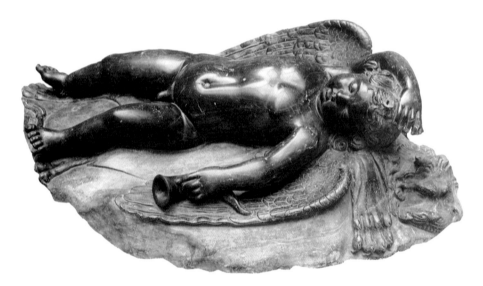

Pl. 16 *Sleeping Cupid*, probably 16th century. Marble, 90 cm long. Wiltshire, The Corsham Court Collection.

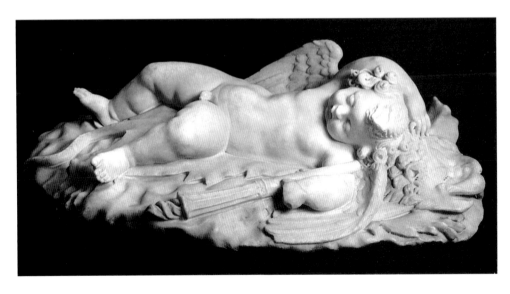

This brief resumé of some of the problems that surround our reconstructing the appearance of Michelangelo's *Cupid* may here be closed, although it has not considered all the proposals (some very recent) which have been advanced. The presumption that the piece, described in Nys's letter, did reach England is very strong, for the 'femme acroupie', the Venus mentioned alongside the three Cupids, still forms part of the Royal Collection. The Venus probably escaped destruction in the Whitehall Palace fire of 1698 because it was placed out of doors. Documentation that Charles I owned Michelangelo's *Cupid* is, however, not conclusive. In the well-known Commonwealth Sale lists drawn up after the King's death we find no less than seven recumbent Cupids listed. None is attributed to an artist. One, described as 'a sleeping Cupid leaning his head on his hand', could have been Michelangelo's for the description agrees with that of the letter of 1496 sent to Isabella d'Este; however, its valuation is strangely low.[52] In a later list of sculpture at Whitehall drawn up in the reign of James II, after many pieces had been recovered for the Crown, three sleeping Cupids are listed, without attribution or valuation. It is in this same list that we encounter Bernini's bust of Charles I, which the fire of 1698 claimed as a victim.[53]

II

The *Bacchus*

MICHELANGELO'S early biographers present us with a seemingly unproblematic account of the origins of his *Bacchus* (Pl. 17). In his 1550 Life, Vasari writes that he carved it in the Roman house of the Gallo family, situated close to Cardinal Riario's palace. Condivi endorsed this information, stating that the work was made for Jacopo Gallo in his house. He added that although Michelangelo stayed with Cardinal Riario for about a year, he was never asked to make anything for him ('in tutto il tempo che seco stette, che fu intorno a un anno, a requisizion di lui non fece mai cosa alcuna'), information in turn repeated by Vasari in his amplified passage of 1568.[1] Condivi compares the fine intelligence of Gallo with Riario's lack of discernment, who, he tells us, understood very little about sculpture ('poco s'intendesse o dilettase di statue').[2]

The early provenance of the statue appears to confirm what the biographers would write, for in a book published in Rome as early as 1506 the *Bacchus* is cited in Jacopo Gallo's courtyard.[3] Nevertheless, as was suspected over fifty years ago, it was not Gallo but Riario who had commissioned it.[4]

Condivi's statement that Michelangelo received no work from the cardinal is a piece of misinformation which we must ascribe to the old artist himself. It is contradicted by what he himself had written in the letter sent to Florence from Rome on 2 July 1496, quoted at the opening of the previous chapter. We have considered the letter for the light it sheds on the failed restitution of the *Cupid*. But in an earlier passage Michelangelo describes his introduction to Riario, armed with Lorenzo di Pierfrancesco de' Medici's letter. The cardinal immediately asked the young artist to go off to inspect some sculpture ('a vedere certe figure'). On the following day, at the patron's new house ('chasa nuova'), he was questioned about what he had seen and after expressing his appreciation was asked if he was prepared to carry out something fine. On his affirmative reply, a block of marble of a scale to accommodate a life-size figure was acquired. Michelangelo, writing on Saturday, the day the post left Rome for Florence, declares that he will begin work on Monday.[5]

It is an all too laconic account of Michelangelo's first encounter with a world far removed from that of his Florentine background. Raffaele Riario, great-nephew of the della Rovere Pope Sixtus IV, had been made a cardinal when only seventeen and, at the time that concerns us, had become a very powerful figure in the Curia. The holder of many benefices, his wealth was regarded as prodigious and his lifestyle extraordinary; one commentator describes his going about Rome accompanied by

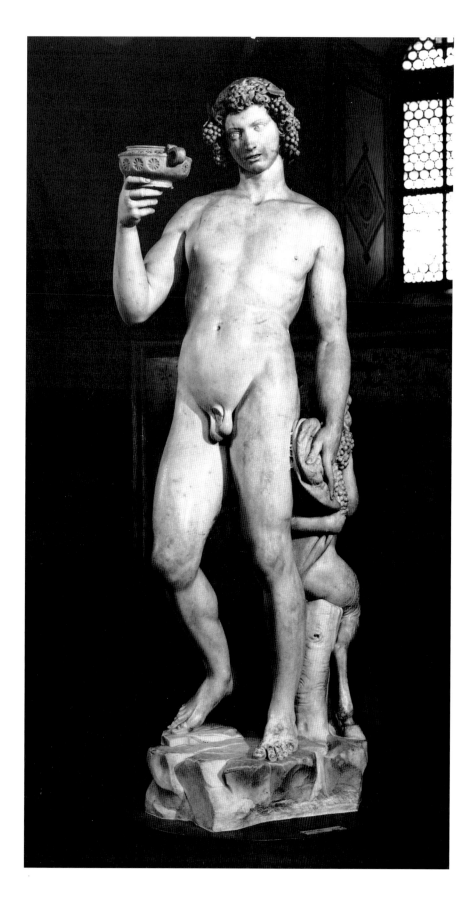

Pl. 17 Michelangelo, *Bacchus*, 1496–7. Marble, 203 cm high. Florence, Museo Nazionale del Bargello.

four hundred horsemen. His greatest monument, his huge palace built near the Campo de' Fiori, which would later come to be called the Cancelleria, was begun in the late 1480s. Still under construction in 1496, it is, of course, the 'chasa nuova' of Michelangelo's letter. Riario's passion for the antique took numerous forms, from the resumption of performances of Greek and Roman plays to the revival of a Roman form for the articulation of the travertine façades of his palace.[6] The 'certe figure' which he wasted no time in sending Michelangelo to see were, we may reasonably assume, part of his collection, among which there may have already featured two colossal Roman statues, a Melpomene, now in the Louvre, and a Juno, now in the Vatican. A later drawing depicts the former, a dominating presence, in the courtyard of the new palace.[7]

Such was the Maecenas who, instead of neglecting the new arrival, set him to work with remarkable promptitude. Proof that it was indeed the *Bacchus* on which Michelangelo began to work in early July 1496 exists in the form of a number of disbursements which survive in an account book of the Rome-based bankers referred to in the first chapter, the Balducci, who served both Cardinal Riario and the artist after his arrival. A payment on 18 July from Riario's account of ten ducats is for the marble block for the work on which Michelangelo is engaged.[8] On 23 August of the same year, there is a payment of fifty ducats to the artist on account for his work.[9] This is followed by a further payment of fifty ducats on 8 April 1497.[10] And, finally, we find that on 3 July 1497 there is a concluding payment of fifty ducats to 'Michelagnolo schultore per resto di pagamento del bacho'.[11] The date has a particular relevance for, two days earlier, on 1 July, Michelangelo had written to his father, Lodovico, explaining that he could not leave Rome until he had straightened out his affairs with the cardinal and had been paid for his work.[12]

The conclusion seems inescapable that Jacopo Gallo, a close associate of Riario as we have seen, took the *Bacchus* after the cardinal had declined to accept it. Such a sequence of events would explain a silence about the true identity of the patron which endured for centuries and Michelangelo's own later disparaging comments about the cardinal. It is a striking case of a Renaissance work of art being rejected by the patron; such episodes are relatively rare in the period.[13] But it must also have constituted something of a crisis for the young artist, who, as we shall see, seems to have immediately turned to painting. In effect, and for very different reasons, Riario had declined two works of Michelangelo's in little more than a year.

We have no information about Michelangelo's life in Rome in the twelve-month period during which he carved the *Bacchus*; there is a gap in the correspondence between his first letter of July 1496 and that to his father of July 1497 just referred to. Condivi states that Michelangelo stayed with Riario for about a year, but the word he uses need not necessarily imply that he actually lived in the cardinal's household, only that he was in his service.[14] On the contrary, it appears that Michelangelo lived in Gallo's house, as Condivi implicitly states, for a documented payment exists which records Riario, a few months after the *Bacchus* was under way, paying for two barrels

of local wine to be taken to Gallo's house for Michelangelo.[15] Perhaps, therefore, the statue was carved on Gallo's premises, and, after Riario's rejection, never left his house. Nor do we know such details as where and from whom the marble block was procured. Ten ducats for a block of the dimensions required is an exceptionally low price, so low that one is led to speculate as to whether the piece was an antique one, lying about and ready to hand.[16]

The block from which Michelangelo carved his two-figure group was a rectangular one; some confusion over this has arisen because the sculptor used it in a highly innovative way. The artist carved the main figure diagonally, from front left to back right, an approach of great boldness – sanctioned by very few antique precedents – which had been just hinted at in one or two of the earlier surviving works (Pl. 12). In fact, the front face of the block was approximately 68 cm across, and it is this view of the block's front face that is reproduced in Pl. 17, one close to that in a much reproduced drawing by Martin van Heemskerck of the group in the Gallo family garden, made on site in the 1530s.[17] The approach is one which differs completely from that of working in parallel planes backwards from the front face, which Benvenuto Cellini, in an often cited passage, would ascribe to Michelangelo *tout court*.[18] Michelangelo's solution was one adopted to answer the group's purpose, to stand free, visible from every side (Pls 18 and 19); as frequently pointed out, the little satyr companion is invisible from a strictly frontal view. That the cardinal had an open space in mind cannot be doubted; perhaps, as has been suggested, the courtyard of his great new palace, or, more plausibly, the garden that lies behind the palace; Bacchus was a garden god.

The decision to make a two-figure group, one which would represent a drunken Bacchus with a satyr, must have been agreed between patron and artist. In terms of antique precedent, the inclusion of the young companion was by no means mandatory. Representations of a drunken Bacchus existed in late antique sculpture, although more common in reliefs than in figure sculpture. But there was little in classical sculpture, or in Michelangelo's own approach adopted for his *Sleeping Cupid*, that could have prepared Riario for the radical interpretation of the youthful god (Condivi writes that Bacchus is here represented as eighteen years old). Michelangelo would later depict drunkenness again, that of Noah, derided by his sons, on the Sistine ceiling. In the mural, Noah falls effortlessly into the pose of an *all'antica* recumbent river god, an image of inebriation which Riario could surely have accepted without problems. The graphic portrayal of drunkenness in the marble group is one which, it has been suggested, is closer to that adopted for the portrayal of Silenus by antique sculptors.[19] Condivi, who must be repeating remarks of the old artist, writes that the appearance and characterisation of the Bacchus follow the prescription of classical authors ('la cui forma ed aspetto corrisponde in ogni parte all'intenzione delli scrittori antiche').[20] It would be an error to dismiss this as, say, a hint of Michelangelo's recurrent self-protectiveness about a work that failed to please the patron; Riario's own circle was a truly learned one. But the sophistication that

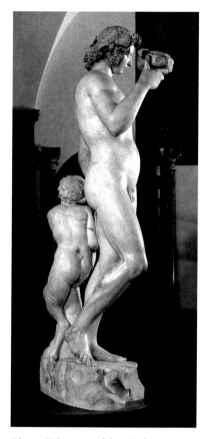

Pl. 18 Side view of the *Bacchus*.

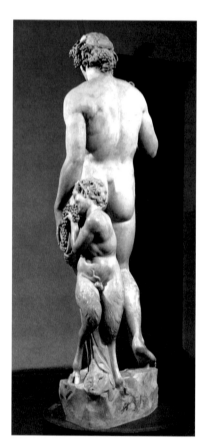

Pl. 19 Back view of the *Bacchus*.

lies behind a number of aspects of the group was, without doubt, indebted to what the sculptor had absorbed in the Florentine Humanist circle around Lorenzo the Magnificent several years earlier.[21]

The description of the god's state is almost brutal. The gait is deliberately uncertain and flagrantly defies the canon of classical *contrapposto* in its precariousness of pose. The obtrusively distended belly is pushed forward and the chest retracted, while above, the head is thrust forward, inclined downwards and tilted to one side. The gaze (Condivi describes the eyes as sidelong-looking and lascivious) is focused on the cup (Pl. 20). The features are unidealised, almost coarse.[22] The characterisation of Bacchus' face is one of the most striking aspects of the work. The lips are slightly parted; by deep undercutting, Michelangelo made visible the teeth within; by such means, expression is given a transient aspect which has no true analogies in fifteenth-century Florentine sculpture. The closest parallels lie in the future, in the art of Bernini.

By contrast, the little satyr appears svelte. He is seated on the tree stump and this provides physical support for the standing figure. He turns with a movement of complex torsion, creating a spiral which can be compared with that in one or two drawings of this same period by Leonardo. He smiles and, a motif antique in origin, covertly nibbles the grapes he holds in both hands like a swag (Pl. 21).

Michelangelo never surpassed the virtuosity in the carving of marble displayed in the figure of Bacchus. His body possesses a fleshiness and a softness in the treatment of the surfaces which can still be appreciated after the vicissitudes the sculpture has undergone. Seen from several viewpoints, the body takes on an unmistakably female appearance as Vasari, in his wonderful passage about the work, already noted in his first edition: 'e particolarmente avergli dato la sveltezza della gioventù del maschio e la carnosità e tondezza della femina' ('and in particular he gave him the youthful slenderness of the male and the fleshiness and roundness of the female').[23] This epicene characterisation, best appreciated when we see the statue in the original (from one viewpoint the pose recalls that of an antique Venus), can be found in late Hellenistic representations of the god, although rarely in so pronounced a form as in Michelangelo's statue. The effeminacy of Dionysus/Bacchus is a persistent theme in literary tradition; a certain girlishness is already hinted at in the Bacchae of Euripides. In antique representations of the god, the archaic bearded figure gave way to an ephebe whose following was, notoriously, chiefly female.[24] Where Michelangelo departed from the common Hellenistic type was in transforming an interpretation of languor into one of latent violence.[25]

For Condivi, Michelangelo's work pointed a moral; it represented the effects of drink and, in the detail of the animal skin, signified that the 'amor del vino' could lead to death. It is a relatively ambitious attempt at interpretation that runs into many difficulties of detail. Some of these must have been based on a misunderstanding of Michelangelo's cryptic utterances; the artist cannot have believed that tigers fed on grapes. And Michelangelo's statue is more than a plea for temperance. For both

Pl. 20 Detail of Bacchus' head.

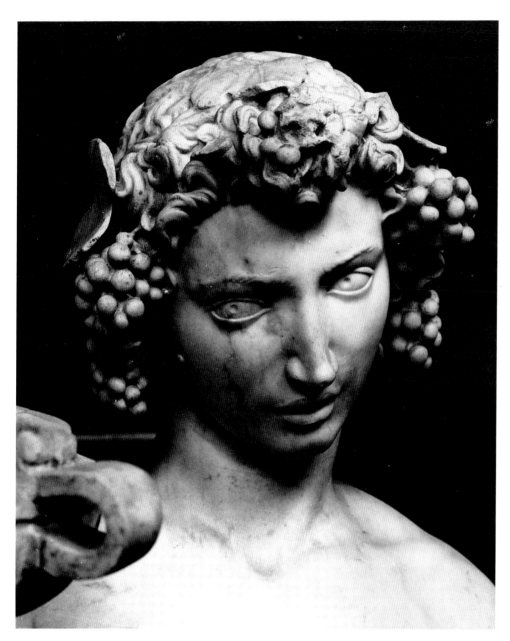

classical and late fifteenth-century commentators, the drunkenness of the god had a much more positive significance. Addressing a friend in a letter of 1481, Marsilio Ficino, *par excellence* the leading Neo-Platonist in Lorenzo de' Medici's circle, correctly invoked antique literary sanction when he wrote that the drunkenness of Dionysus led to the elucidation of divine mysteries. His interpretation is based on a celebrated passage in the *Phaedrus* of Plato, where four kinds of divine madness are characterised.[26]

Two final observations about the making of the *Bacchus* are worth recording. Throughout the group, there is a marked inequality in the degree of finish given to different parts; hair has, for example, been left at a perceptibly rougher stage than skin; Bacchus' hair, in particular, contrasts with the head adornment of grapes and

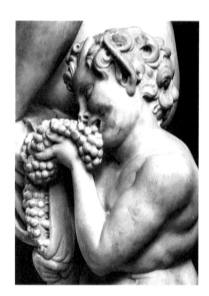

Pl. 21 Detail of the satyr's head.

Pl. 22 Detail of the animal pelt.

ivy wreath, the leaves of the latter cut with exceptional virtuosity.[27] This variety of finish is, once more, at odds with much later fifteenth-century Florentine practice; Michelangelo's satyr does not look like a polished putto of Desiderio da Settignano. Another, more remarkable feature, is the widespread use of a drill and the artist's evident unconcern about its obtrusiveness. Lines of drill holes can be seen in many areas of the group, sometimes, as in those that form the eye sockets of the animal's skin (Pl. 22), creating an almost violent staccato.

Michelangelo's material, bought, as we have seen, with little delay and at low cost, let him down. There are disturbing blackish flaws on both sides of the main figure's face. Across the back of the satyr and the inner thigh of the god there runs an obtrusive rusty-brown flaw. Further discolorations can be seen under Bacchus' left shoulder and around the base. Such faults in the marble cannot be attributed to the statue's outdoor exposure in the Gallo family garden (which, in any event, lasted less than a hundred years). Michelangelo's concern for the perfection of his materials would become proverbial and the block for his *Bacchus* did not answer to his exacting standards.[28]

Michelangelo ran into other problems with his materials only a month or two later. In a letter of August 1497 to his father Lodovico, we find him referring to an abortive project to carve a sculpture for no less than the exiled Piero de' Medici, whose patronage he had enjoyed before the Medicean collapse of 1494. Michelangelo reports that Piero has let him down. He goes on to tell his father that he has bought a marble block for five ducats which proved a total failure; the artist, frugal throughout his life, laments the waste of money ('ebi buttati via que' denari'). He has purchased a second block for the same sum and is now working on this on his own account ('per mio piaciere').[29] His letter shows that his relations with Piero de' Medici lasted longer than we might infer from his later hostile judgement of Il Magnifico's son recorded in Condivi, where he is referred to as 'insolente e superchievole'. Months later, in March 1498, Michelangelo's bank account is debited with a sum of thirty ducats, to be paid back to Piero.[30]

These experiences with faulty material may have left a permanent impression on the young artist. For the *Pietà*, he would, a few months later, undertake the journey to Carrara himself and expend substantial time at the quarries in a personal search for his material. While a block of the scale he required may have proved difficult to find in Rome, the marble of the *Pietà* testifies to the lengths to which Michelangelo would go to find the quality of stone that satisfied him.

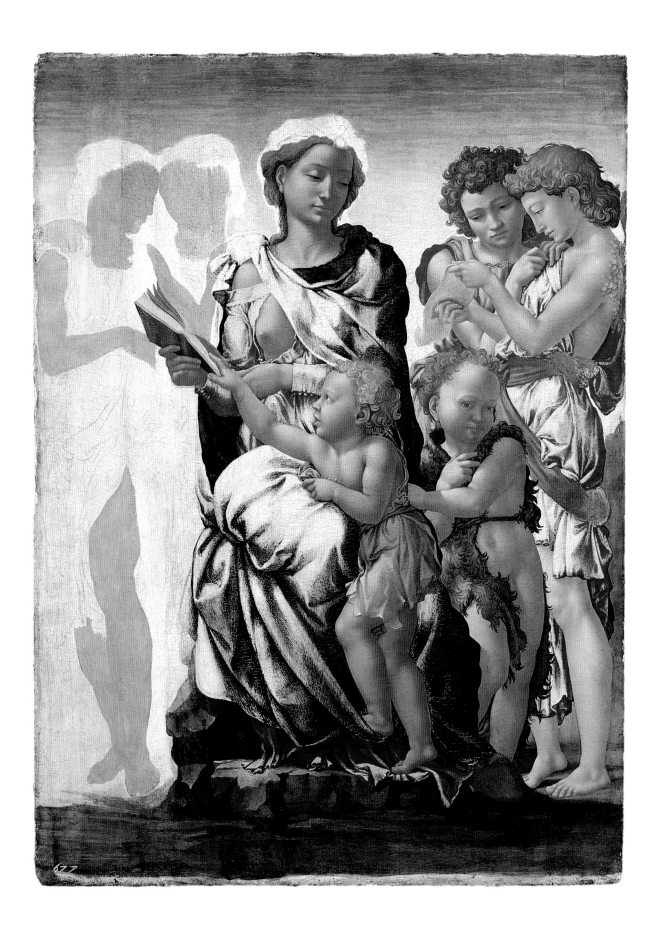

The *Manchester Madonna*

Before his payment for the *Bacchus* had been settled, Michelangelo had already turned his attention to other projects, including painting. On 27 June 1497, when the statue must have been finished, Michelangelo drew from his account a small sum to pay for a panel on which to paint: 'carlini 3 per 1º chuadro di legno per dipignerlo'. Hitherto unknown, it is the earliest notice we have of Michelangelo's activity as a painter.[1] No further references to the work appear in the account book, so that we cannot learn more about the nature of the painting. Three *carlini* is a small sum: therefore the project can scarcely have been a large one.[2] That costs in Rome at this time were low is indicated by the modest price of the block for the *Bacchus*. And we can find confirmation of this fact in the relatively small sum of sixty ducats agreed on as payment to Michelangelo for a large panel altarpiece commissioned from him three years later, which we shall turn to in a later chapter.

The later project for an altarpiece is clear evidence that Michelangelo's ambitions extended to painting in this Roman stay. This purchase of a panel in the summer of 1497 is a further confirmation. And, if we may believe the early sources, Michelangelo also made a cartoon during the year that he worked for Cardinal Riario for a member of the latter's household, a barber of the cardinal's, who carried out a painting in tempera of the Stigmatisation of Saint Francis, based on Michelangelo's design, for a chapel in San Pietro in Montorio. This is our earliest indication of Michelangelo making designs for other artists to carry out in paintings.[3]

That an unfinished devotional painting now in the National Gallery, London (Pl. 23), could be the work for which Michelangelo bought his panel in 1497 cannot, at this point, be proved. It must remain a hypothesis, but one with a good deal in its favour. The painting, since its most celebrated public exhibition in the nineteenth century inaptly called the 'Manchester Madonna', has long been a controversial work with regard both to authorship and dating. There can be little doubt that it is a painting referred to as early as 1700 as belonging to the Borghese collection. At that time hanging in the Villa Borghese, the work was stated to be Michelangelo's: its subject is described as a Madonna with the Christ Child, Saint John and four angels, not completely finished.[4] What is certainly the same painting is described in subsequent Borghese collection inventories. But the work disappears from sight after 1765, to re-emerge in a sale of paintings held in London in 1833.[5]

The fortunes of the painting after its arrival in England are noteworthy. The attribution to Michelangelo was abandoned in favour of one to Michelangelo's

OPPOSITE Pl. 23 Michelangelo, *Virgin and Child with Saint John and Angels ('The Manchester Madonna')*, perhaps 1497. Predominantly egg tempera on panel, 104.5 × 77 cm. London, National Gallery (NG 809).

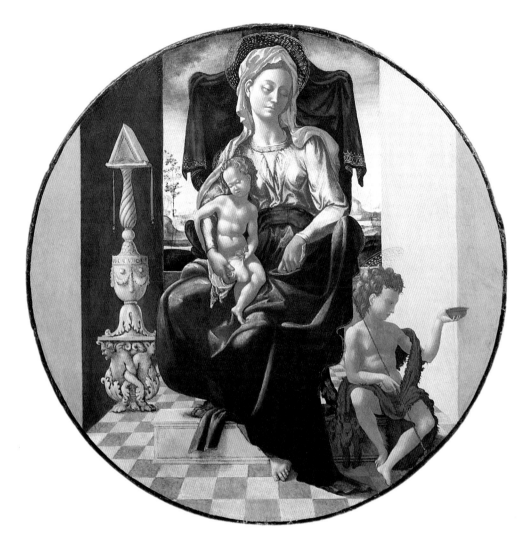

Pl. 24 Associate of Michelangelo, *Virgin and Child with Saint John*, late 1490s. Panel, 66 cm diameter. Vienna, Gemäldegalerie der Akademie der bildenden Künste.

earliest known master, Domenico Ghirlandaio; offered for sale to the National Gallery with this latter attribution in 1844, and again in 1845, the picture was declined. Subsequently, the attribution to Michelangelo was reaffirmed and it was as a work by Michelangelo that the painting was exhibited at Manchester in 1857. There was public protest at the National Gallery's failure to buy the work and, after a substantial interval, it was purchased for the Nation in 1870.[6]

Controversy has continued to dog the painting. Already in the late nineteenth century, reactions to it on the part of art historians were mixed. Some expressed their admiration and their acceptance of the work as a youthful product of Michelangelo's, while others declined to accept it. Discussion has become more confused in recent times, for the issue of its paternity has become entangled with that of other paintings which have been grouped with it. These paintings are of indifferent quality but a number of them bear unmistakable signs of contact, on the unknown artist's part, with Michelangelo himself. A group of paintings has, therefore, been created ascribed to the Master of the Manchester Madonna, with the National Gallery painting constituting the most significant work of the group.[7]

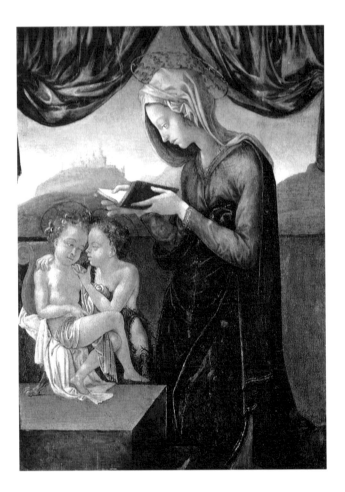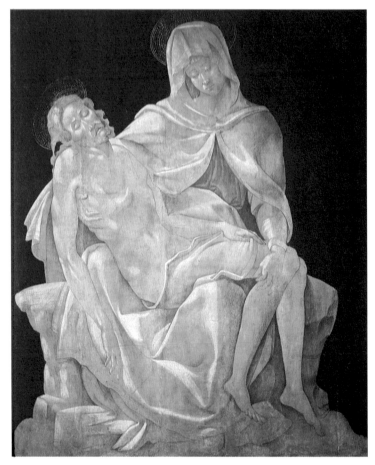

Pl. 25 Associate of Michelangelo,
*Virgin and Child with Saint John, c.*1500.
Panel, 64 × 54 cm. New York, Samuel
H. Kress Foundation.

Pl. 26 Associate of Michelangelo,
Pietà, perhaps 1499. Panel,
134 × 111 cm. Rome, Galleria
Nazionale d'Arte Antica di Palazzo
Barberini.

Scepticism about the qualitative coherence of this group of works has been expressed for some time, and there can be no serious doubt that the London painting is one conceived and carried out with an accomplishment nowhere evident in the other paintings associated with it.[8] The exhibition held at the National Gallery in the autumn of 1994 presents an opportunity for directly comparing the *Manchester Madonna* with a work of the painter responsible for other pictures of the group, a tondo of the Virgin, Christ Child and Saint John, now in the Akademie der bilden-den Künste in Vienna (Pl. 24). It bears clear signs of the painter's associations with the young Michelangelo (as suggested in the past) and it can be plausibly proposed that the figure of the Virgin in the Vienna painting is expressly based on a design of Michelangelo's. The figure pose reappears in later drawings by Michelangelo and the forms of the drapery over her breast are especially Michelangelesque. Of the group of associated works, it is this painting which most unequivocally bespeaks an *ad hoc* figure drawing provided by Michelangelo.

Nevertheless, the painter had some problems in following Michelangelo's intentions. It appears that the Virgin's right foot, resting on the platform of her throne, has been transformed into one of the gilt zoomorphic feet of her chair. Much in the painting is completely alien to everything in Michelangelo's art of this

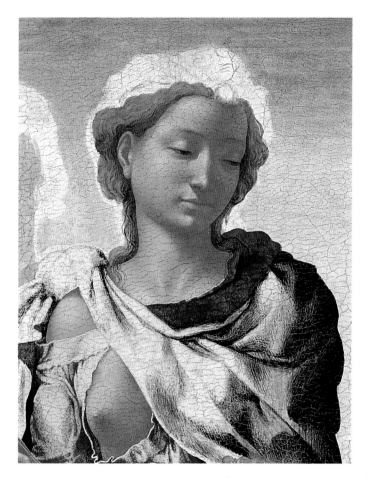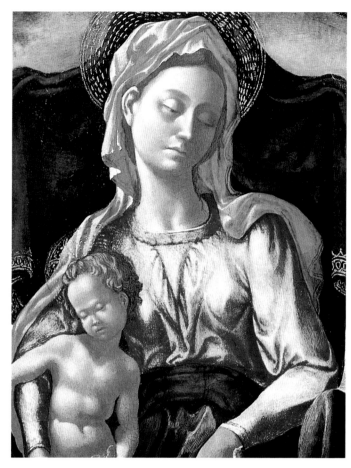

Pls 27 and 28 Detail of the Virgin from the *Manchester Madonna* (left) and detail of the Virgin and Child from Pl. 24 (right).

period – for example, the ornamental reading desk. Particularly striking, however, in the Vienna tondo are a number of unmistakably Ferrarese elements which we do not find in Michelangelo's autograph works in painting or in marble. The spindly, almost manikin-like children recall those of Cosimo Tura. And the form of the cloth of honour behind the Virgin is of a kind that we find in Tura's works.[9]

Two other works by the same artist seem to be a little later than the tondo. One of these is a Virgin and Christ Child and Saint John, now at the Kress Foundation (Pl. 25). Here, the subject is simpler than in the tondo and seems more coherently treated, but the children are similar in type. Most Michelangelesque is the inclined profile head of the Virgin, which is close to many similarly inclined heads in Michelangelo's drawings.[10] A third work, on a larger scale, convincingly given to the same painter, is a painted grisaille version (Pl. 26) of the marble *Pietà*, on which Michelangelo was at work from the late summer of 1498.[11]

In type and in the abstracted melancholy of the expression the head of the Vienna Virgin recalls Michelangelo's Virgin in the London painting (Pls 27 and 28). A comparison, while demonstrating the disparity of hands, suggests that the lesser work followed the other. As we have seen, to accept a date of 1497 for Michelangelo's painting must remain a hypothesis. But if we provisionally accept it, the presumption is strengthened that Michelangelo's association with this unknown

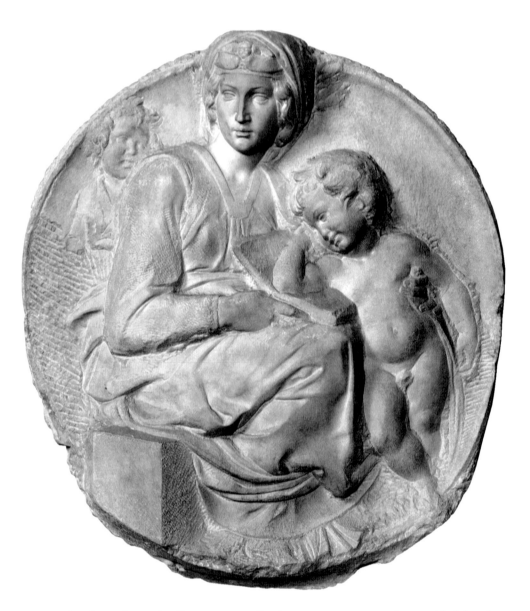

Pl. 29 Michelangelo, *Pitti Tondo*, between 1503 and 1506. Marble, 85.5 × 82 cm. Florence, Museo Nazionale del Bargello. The carved tondo that Michelangelo began for Bartolommeo Pitti returns to the motif of the seated Mother and standing Child. The Madonna shares the melancholy abstraction of the *Manchester Madonna*.

petit maître dates from the Roman stay. Further encouragement is provided by the existence of the painted copy of the *Pietà*.

To conjecture who this painter could be is perhaps rash.[12] Yet the circumstances bring to mind a name which has never been associated with these paintings, Michelangelo's own assistant in his Roman workshop, Piero d'Argenta. Piero came from Argenta, close to Ferrara, an origin which would explain the emphatic Ferrarese accents in the tondo. His presence in Michelangelo's workshop is attested in the payments in the Balducci bank-books. During Michelangelo's long absence in the winter of 1497–8 in search of marble for the *Pietà*, he wrote two remarkably lively letters to the absent master, one of which shows his close relations with Jacopo Gallo.[13] We cannot exclude the possibility that he had travelled to Rome in Michelangelo's company in the summer of 1496. Documents show that he stayed on after Michelangelo left Rome in 1501, only following his master to Florence in

August. He would join Michelangelo in Bologna when the sculptor was engaged on the great bronze statue of Julius II, undertaken in 1506.[14] We have no information about any activity as a painter, but it is perhaps not without significance that he went back to rejoin Michelangelo in Rome in 1508 as the master began work on the Sistine ceiling.[15] Further research might reveal whether the conjecture is a fruitful guess.

The issues presented by Michelangelo's *Manchester Madonna* are those which attend any attempt to trace a painter's work back to uncharted areas of his youth. In Michelangelo's case, we have no tangible evidence of his early activity as a painter. Nevertheless, his first master – perhaps his only master – was a painter, Domenico Ghirlandaio, and, as we have seen above, a recent discovery has shown that the youthful Michelangelo was a junior member of the workshop earlier than previously believed.[16] Attempts have been made to discern his apprentice hand in the great mural cycle by Ghirlandaio and his team of assistants under way in the choir of Santa Maria Novella during Michelangelo's association with the workshop, but these seem unrealistic.[17] We cannot rule out that he carried out some painting during his stay in Bologna between the autumn of 1494 and 1495. And it has been suggested that the *Manchester Madonna* could have been undertaken in this period. This cannot be excluded, but the allegedly Ferrarese aspects of the painting's colour seem based on a misunderstanding of its unfinished condition. It is important to realise that the eccentric blackish colour of the Virgin's robe is only an underlayer, preparatory to the blue to follow.[18] We should also recall that Michelangelo is described as a painter ('etiam pictor') as well as a sculptor in a book published in Florence in 1504 but probably completed in 1503, by a writer who seems to have been familiar with the artist's associates.[19]

We can do worse than turn back to the nineteenth century, to the period when the painting was still a public novelty. In a remarkable appreciation of the painting published in 1876, seemingly unread, indeed forgotten, the author saw that the painting was an early work by Michelangelo, proposed a date in the mid 1490s, and, while not uncritical of its shortcomings, recognised its kinship (above all in its colour) with the late works of Domenico Ghirlandaio such as his *Visitation*, now in the Louvre (Pl. 60). Of its quality and importance for an account of Michelangelo's early career the writer was in no doubt.[20]

In effect, the design of the painting could be translated into marble to create a relief which, as in the later *Pitti Tondo* (Pl. 29), achieves its greatest convexity in the centre.[21] The Virgin is seated on a rock and the setting is out of doors. But the land-scape has been effectively eliminated; no hint of hills or trees break the background plane of the azurite sky. Although the prominence of the Virgin is now exaggerated by the absence of the two angels on her right, her contours have been heavily emphasised by the painter – witness the shifting yet isolated right contour of her mantle. Some of the contours in the painting have, indeed, been given a particular stress by the scraping away of surrounding paint, creating almost a semblance of an

OPPOSITE LEFT Pl. 30 Michelangelo, *Bruges Madonna*, between 1504 and 1506. Marble, 128 cm high. Bruges, Notre Dame.

OPPOSITE ABOVE RIGHT Pl. 31 Michelangelo, detail of a standing infant from a sheet of *Figure studies*, c.1495–1500. Pen and brown ink, black and red chalk, 40 × 22 cm. Paris, Louvre. The pose is close to that of the infant Baptist in the *Manchester Madonna*.

OPPOSITE BELOW RIGHT Pl. 32 Michelangelo, *Virgin and Child with Saint Anne*, c.1501–5. Pen and iron gall ink, 25.7 × 17.5 cm. Oxford, Ashmolean Museum. The figure of the Virgin reflects that in the *Manchester Madonna*.

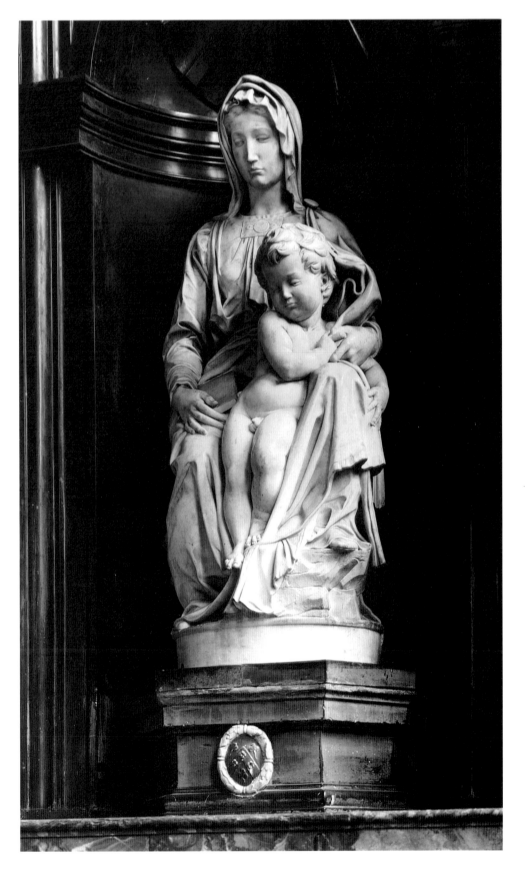

intaglio relief.[22] Critics who have rejected the work have seen in the group of Virgin and Child a reflection of the marble Madonna and Child sent to Bruges in 1506 (Pl. 30). But we should see in it, rather, a kind of preparation for the later sculpture. In fact, the way in which the Christ Child stands on the lower edge of his Mother's drapery anticipates the device, used more meaningfully, in the later marble group. The infant Baptist, in pose, recalls the satyr of the Bacchus group; his figure is also very closely paralleled in a later pen study of Michelangelo's on a sheet, now in the Louvre, which may well date from these Roman years (Pl. 31).[23] He could be regarded as the least purposeful figure in the painting, for the artist's disinclination to allow conventional symbols in his work, which has deprived the painting of haloes, may even have excluded the Baptist's cross.

Pl. 33 Detail of the feathers of the angel's wing in the *Manchester Madonna* (Pl. 23).

The painting is replete with features which can be matched elsewhere in Michelangelo's works, but it is a longstanding error to suppose that this fact suggests the work of an imitator. The artist has, for example, attempted naturalism by painting tiny feathers close to the shoulder in the passage describing the angel's wing (Pl. 33). He had already attempted this approach in marble a few years earlier, in the kneeling angel of the Arca of Saint Domenic in Bologna, in the intractable context of wings springing from drapery (Pl. 34), a form determined by the earlier pendant angel by Niccolò dell'Arca. Here, in our painting, he was free to choose and, characteristically, chose the naked form. We cannot fail to observe to what extent the painter has contrived to eliminate wings in his picture; Michelangelo's distaste for their inclusion was inveterate, as their absence in the *Last Judgement* notoriously shows.

This foremost painted angel's stance is full of movement and the drawn-back upper body and the slackened further leg recall similar features in the *Bacchus*. Even small details are characteristic of the artist. To give one example: the form of the nearer leg has been drawn without significant tapering at the ankle. It is a feature we encounter in many early works, including the marble *Battle of the Centaurs*; it is something that the artist had picked up from Bertoldo.[24] The gentle swing of the Virgin's body anticipates a more radical movement of the same kind in a celebrated drawing of the Virgin and Saint Anne, now at Oxford (Pl. 32).[25] Such references are not evidence of a pasticheur; they are testimony to those obsessive recapitulations which mark his long career.

Pl. 34 Detail of the feathers of the marble angel from the Arca of Saint Domenic (Pl. 12).

OPPOSITE Pl. 35 Francesco Granacci, *Rest on the Flight into Egypt with the Infant Saint John*, c.1494. Panel, 100 × 71 cm. Dublin, National Gallery of Ireland. (Before cleaning in 1994.)

To compare the National Gallery painting with the late works of Domenico Ghirlandaio and of his other leading pupils is to appreciate how Michelangelo here adhered to many of the means he had witnessed being employed in the workshop while pursuing a very different end. It is revealing, for example, to compare the *Manchester Madonna* with a very beautiful panel by Granacci (as we have seen, Michelangelo's friend and senior by a number of years), now in Dublin (Pl. 35). The two works are very nearly the same size and both would seem to be paintings made for private rather than public places. In both works, the Virgin is depicted out of doors and is seated on a rocky base. In both works, she rests one foot on this natural

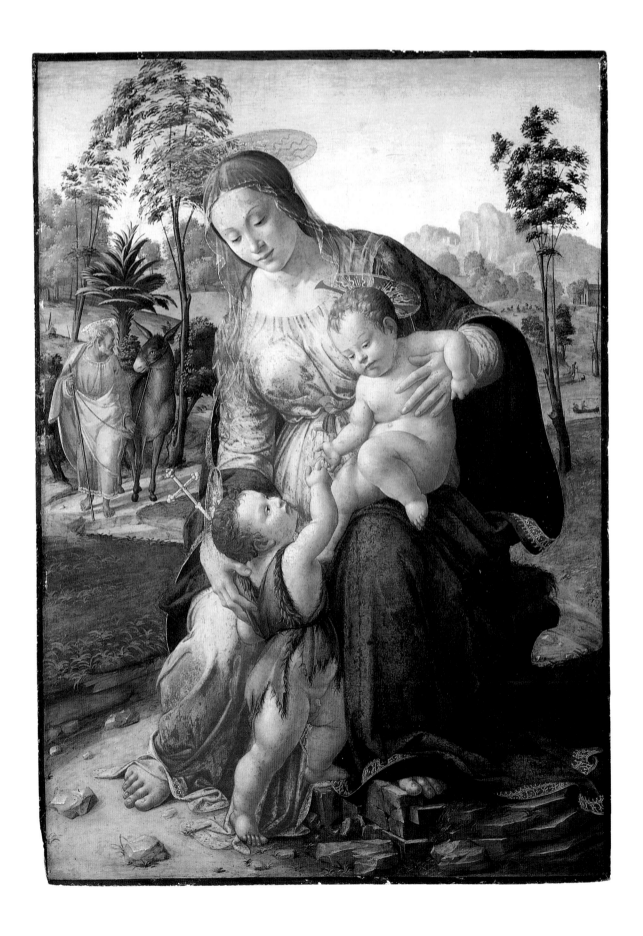

pedestal and lowers the other; but in Michelangelo's painting the lowered foot is placed on a tiny rocky outcrop as if the figure were in marble and required this stabilising support for the outstretched form.[26]

Both artists adopted the motive of a child reaching upward, but Michelangelo has assigned to his Christ Child an action more frequently given, as in Granacci's work, to the Baptist. Yet the common elements of the two paintings serve to underline the differences. Perhaps most evident is a contrast between, in the Dublin painting, a lively anecdotalism and, in the London one, a kind of hushed repose. It has been proposed that a design of Michelangelo's lay behind Granacci's work. But, in the light of Michelangelo's known works from the *Madonna of the Stairs* to the one which concerns us here, the suggestion seems impossible to accept. Granacci, it is true, never excelled the Dublin design in later work; perhaps, if painted before or shortly after Domenico Ghirlandaio's death in 1494, his master had a hand in the design.[27] In Michelangelo's painting, the Virgin turns her gaze towards the scroll which the angels have borrowed from the Baptist. They read, one of them with a sad expression, its message of sacrifice. These two angels (as well as those only blocked in on the other side) are clearly inspired by figures in Luca della Robbia's *Cantoria* in Florence Cathedral, but, typically, they do not sing as they hold their scroll, but meditate on the future.[28]

Colour, and even the nature of the brushwork in those parts of the *Manchester Madonna* carried far enough for us to draw conclusions, point back to Domenico Ghirlandaio (as clear-sighted critics of the nineteenth century observed). The manner in which the painting was blocked in, with areas specifically reserved by the painter for their own treatment, almost akin to mural *giornate*, recalls the practice of the Ghirlandaio workshop with its array of specialists. So does the character of the brush underdrawing on the two unpainted angels (to be more fully analysed in the second part of this book). This approach of piecemeal painting we shall find again in the National Gallery *Entombment*, another unfinished work, and points forward to the approach adopted in the consummately finished *Doni Tondo*.[29]

The conservatism of the London painting may seem to place it at a far remove from the audacities of the *Bacchus*. Yet, even if the date of 1497 which has been proposed here will prove to need amendment, it can scarcely have been painted by Michelangelo many years earlier. This conservatism is indicative of the disjunctions between sacred and profane art and between sculpture and painting still prevailing near the end of the century. It also points to the fact that Michelangelo's development as sculptor and painter did not proceed in step in this still youthful period. We can do no more than speculate as to why Michelangelo began the painting; that he undertook it without a patron, for his own 'piacere', seems, however, unlikely. Perhaps it was laid aside less from dissatisfaction than from the wish to engage with an ambitious new project in marble for a member of the Curia rather different in character from the exuberant Raffaele Riario.

IV

The Marble *Pietà*

THE speed with which Michelangelo sought new employment after completing the *Bacchus* is strikingly at odds with the assurance to his father that he would – once problems were resolved with his patron – return to Florence. Lodovico Buonarroti, a born complainer, faced financial problems in July 1497 incurred by the death of his second wife. Yet the loss of his stepmother did not prevail on Michelangelo to come home. She may have died of the plague, which, according to one witness, had reached a point in late July where those with country properties were abandoning the city. Food in Florence had been scarce for many months. On 18 June, Pope Alexander VI's excommunication of Savonarola was publicly promulgated in the city. Whatever his reasons, Michelangelo chose to remain in Rome.[1]

The decision was a happy one, for a very few months later he was asked to undertake the marble *Pietà* which effectively established his fame as a sculptor (Pl. 36). The circumstances of the commission are, however, virtually unknown. No informative letters of the artist have survived from the period following that to his father of August 1497.

His new curial patron was a Frenchman, Cardinal Jean de Bilhères-Lagraulas, who had come to Rome as head of a delegation from King Charles VIII to the papal court in 1491. Until close to his death in the city in 1499, he played a particularly prominent role in the furtherance of French interests. Although not young (he may have been born in 1429 or 1430) he was noted by contemporaries as an able and energetic diplomat and administrator, 'practico et animoso' in the words of a Florentine observer.[2] Cardinal Riario himself had appointed Bilhères governor of Rome during the *sede vacante* that followed the death of Pope Innocent VIII and he was among Pope Alexander VI's first creation of cardinals in September 1493. Although he took the title of Santa Sabina, he was nevertheless almost universally, although inaccurately, referred to as the Cardinal of Saint-Denis; we find him so described in the payments to Michelangelo for the *Pietà*.

The commission testifies to his preoccupation with his final resting place in Rome; by 1497, when Michelangelo was entrusted with the project, he may already have been in worsening health. The cardinal chose as burial site a place in a church replete with French royal associations, Santa Petronilla, one of the two late antique mausoleums situated on the south side of the old Constantinian basilica of St Peter's. Petronilla had become an object of particular devotion on the part of King Louis XI

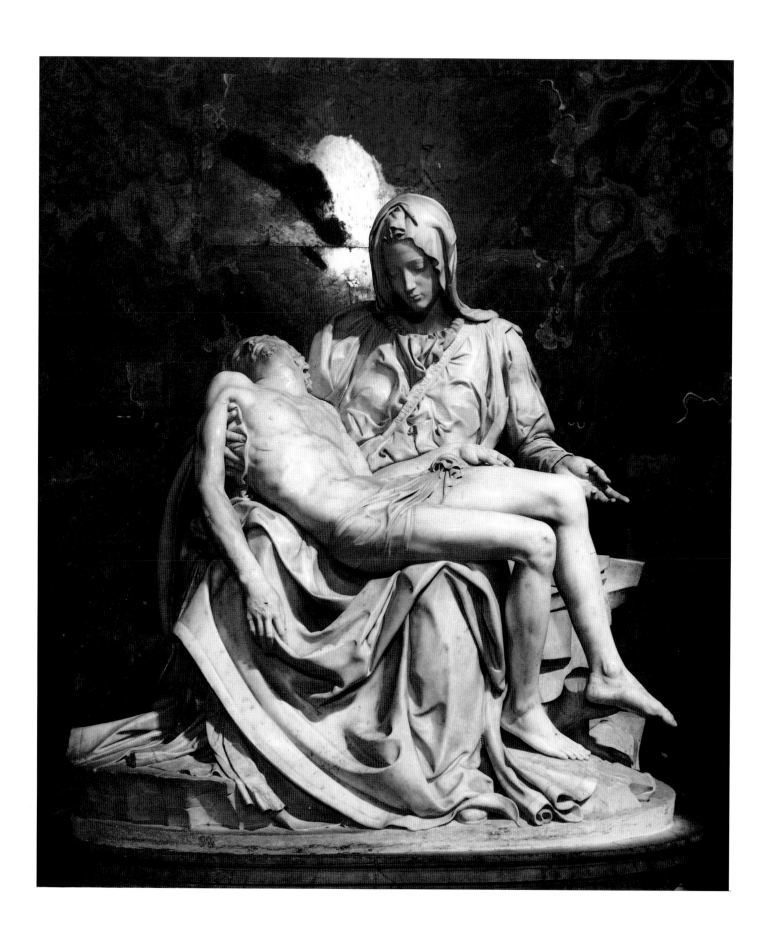

and his son, Charles VIII, and their patronage of the church had received official recognition by Pope Innocent VIII. As a consequence, the church came to be called the Cappella del Re di Francia. In choosing this site, Cardinal de Bilhères was, therefore, attempting to commemorate an almost life-long service dedicated to the French crown.[3]

Unhappily, when attempting to reconstruct the original setting of Michelangelo's masterpiece, the renaissance art historian is confronted with a situation more commonly encountered by the medievalist. The ancient mausoleum, dedicated to Saint Petronilla, survived the date when the marble *Pietà* was placed in it only briefly; it seems to have begun to be demolished before 1520, a victim of the construction of the new basilica of Julius II begun in 1505.[4]

A few facts are known. Santa Petronilla, a rotonda, connected with the basilica, at the time that concerns us possessed seven radiating chapels. The one which directly faced the entrance leading to the basilica was that dedicated to the saint herself. This chapel was the object of French royal patronage and cannot, therefore, have been the one that Cardinal de Bilhères decided to endow for himself. Which of them he selected still remains unknown but it is likely to have been one in the vicinity of that of the French crown.

Nor do we know how the *Pietà* group related to the chapel chosen by the cardinal. Two suggestions have been recently offered: one, that it was placed against one of the piers between the chapels, another that it was situated in a side wall of the chapel in question.[5] That it was planned for a niche, whatever the site may have been, can scarcely be doubted, as we shall see below. A recent investigation of the two mausoleums on the south side of the old basilica has led to the conclusion that the marble group was situated on a side wall of the cardinal's chapel. Each of the chapels in Santa Petronilla has been calculated as a little under four metres deep.[6] If, as we could expect, the altar was at the far end of the chapel, it would seem probable that Michelangelo's group was on the right wall as seen from the entrance, with Christ's head orientated towards the altar.[7] However, a location in a shallow niche behind the altar cannot be excluded.[8]

An examination of the sculpture shows that Michelangelo left areas of the marble, low down on each side of the group, still roughly chiselled (Pl. 38). The area on our left of the group extends further forward than that on our right, the side that would have been more prominent to the viewer if the *Pietà* were housed on the right wall of the chapel.[9] These 'unfinished' areas are, in themselves, sufficient evidence to show that Michelangelo's *Pietà* was housed in a niche. Examining the plan of the group from above (Pl. 37), we can also appreciate how the front curve of the block demanded the counter curve of a bay behind.[10] Every view of the group has its own significance, but it is, nevertheless, from a point a little to our right of centre of the carving (Pl. 39) that the Mother's gesture, one of the most familiar in the history of art, achieves its greatest eloquence.[11]

The agreement between patron and artist that survives is dated 27 August 1498,

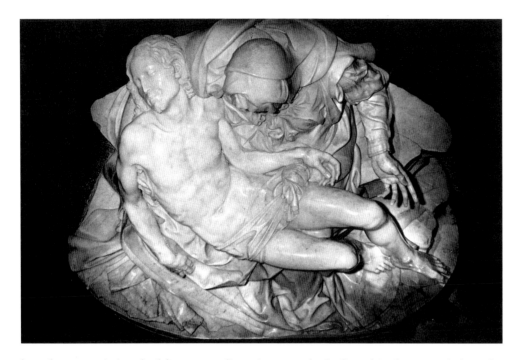

but the commission had been a reality nine months before this date. Michelangelo left Rome for the marble quarries at Carrara in the middle of November 1497. A substantial prepayment from the cardinal was made on an unspecified date in November. On 18 November, we find the artist credited with twelve ducats for the purchase of a horse, a dappled grey, on which to travel, with cash for other travelling expenses.[12] At the same moment, on 18 November, Cardinal de Bilhères wrote to the Anziani of the neighbouring city of Lucca, the city's governing body chiefly concerned with diplomatic correspondence; he expressed the wish that they will help the bearer of the letter ('Michele Agnolo di Ludovico statuario fiorentino') to obtain marble for the project he has in mind. The sculpture, he explains, is for a chapel that he intends to endow ('una certa Cappella quale noi intendemo fundare in San Piero di Roma nel luocho di Sancta Peronella').[13] The text of the letter shows that his agreement with the artist is a recent event, and the carving projected for his chapel is described in the letter in the words that will be adopted in the contract drawn up in the following August. It is a Pietà in marble, with a clothed Virgin holding the nude Christ in her arms ('una Pietà di marmo cioè una Vergine Maria vestita con Cristo morto nudo in braccio'). The contract of 1498 will specify that the sculpture is to be life-size.

Michelangelo did not return to Rome until March 1498; in his absence, the greatest surviving Italian sculptor of the preceding age, Antonio Pollaiuolo, had died in the city. At the very end of December 1497 he is documented in Florence. It is probable that he had already been to Carrara, for his assistant, Piero d'Argenta, in one of his letters to the absent master, complains of his total silence.[14] He was back there in early February, buying a harness and bridle for the horse that would pull the cart, the *carretto*, which would transport the marble from the quarry to the coast.[15]

Pl. 39 The *Pietà*, viewed from a little to the right of centre.

Michelangelo had returned to Rome a month later but the enterprise was not yet over, for in early April his patron, Cardinal de Bilhères, wrote to the Florentine government requesting the Signoria to intervene, for the marble had been held up on its way.[16] The marble arrived in Rome only in June. And it was not until 30 August that the artist drew ten ducats from his account for the transportation from the unloading point on the Tiber to his workshop ('per fare portare e' marmi a chasa'). The whole operation had taken nearly nine months.[17]

Three days previously, on 27 August 1498, the artist was credited with fifty ducats by the cardinal and the written agreement was drawn up and signed. Michelangelo's own copy survives, a relatively brief text written out in the vernacular in Jacopo Gallo's own hand. Gallo himself stands surety and promises that the group will be the most beautiful work in Rome ('sarà la più bella opera di marmo che sia hoge in Roma'). Michelangelo is expected to complete the sculpture within a year, a period only three months longer than that required for the protracted operation of obtaining his raw material.[18]

Michelangelo was asked to undertake a life-size group of the Virgin holding her dead Son in her arms. The subject had no Gospel sanction but nevertheless became one of the most popular of a wide variety of moments in Christ's Passion that late medieval painters and, above all, sculptors, undertook to represent. The portrayal, in sculpture, of Mother and Son alone, was of North European origin. It seems to have originated in German-speaking lands and subsequently spread to France and the Low Countries.[19] Many students of the subject have, therefore, convincingly argued that the French cardinal, Michelangelo's patron, chose for his mortuary chapel an image familiar to him because of his Northern background. The cardinal's widespread travels on the business of the French crown must have allowed him many opportunities

to encounter an extensive range of devotional images of just this kind.[20] Pietà carved groups were for the most part carried out in wood, but examples also survive in all kinds of stone, including alabaster; some were large and others could be very small, portable for private devotion. Many, made by German sculptors, had migrated to Italy. And there still exists a wooden *Pietà*, of German authorship, in the church in Bologna for which Michelangelo had executed his three marble statues in 1494–5 (Pls 9, 10 and 12).[21]

Michelangelo's group constitutes a kind of monumental summation of this long-standing tradition in the treatment of a subject that is not a narrative, exceptionally appropriate for the art of the sculptor.[22] The way in which he made it can also be regarded as a culmination of the ever developing refinement in the carving of marble exemplified in works of the late fifteenth century. In his group, sorrow is expressed by the Mother's bowed head (Pl. 40). Yet it is a sorrow contained by the knowledge of a higher purpose. She holds her dead Son with her right hand, which does not touch the flesh.[23] The outstretched left arm and extended hand involve the onlooker. We are thereby led to meditate on Christ's sacrifice and our hope of redemption, while, at the same time, to adopt the words of Alberti, grieving with the grief-stricken.[24]

The making of the group was an intensely calculated achievement, carried out no longer in Jacopo Gallo's house but in new quarters rented for the purpose. The fact reflects the scale of the new undertaking. Our most dependable measurements of the group are a width of somewhat over 166 cm and a depth of 103 cm.[25] The width is not very much less than that of the blocks for the allegories of Dawn and Evening in the Medici chapel. Like fellow Florentines, Michelangelo instinctively thought in terms of the Florentine *braccio*, a unit of measurement fractionally over 58 cm. Although for a Roman site (where the Roman *palmo* was employed) the block was to be quarried by Tuscans at Carrara and probably originally measured three *braccia* wide, three *braccia* high and two *braccia* deep. The height at which the *Pietà* was shown is a vexed issue. A proposed height of about 120 cm from the chapel floor seems too low; the base line of the group could well have been at a height approaching 160 cm.

To view the group in profile (Pl. 38) is to appreciate the shallowness of the block in relation to its width. This presupposes a space of a very confined depth; it adds further support to the argument that the sculpture was planned for a niche. It is therefore worth our noting that Michelangelo's encounter with shallow blocks did not begin with the famously narrow one for the giant *David*, his next assignment as a sculptor after his return to Florence.

Yet, from the front, the constraints that the block's dimensions imposed are concealed; it is only from close inspection that we can perceive that Christ's left arm, pressed against the Virgin's body, is cut almost as if in a relief. The powerfully plastic effect is achieved chiefly by the extraordinary wealth of folds falling from the Virgin's knees, a feature often ascribed to Michelangelo's study of Verrocchio but which can

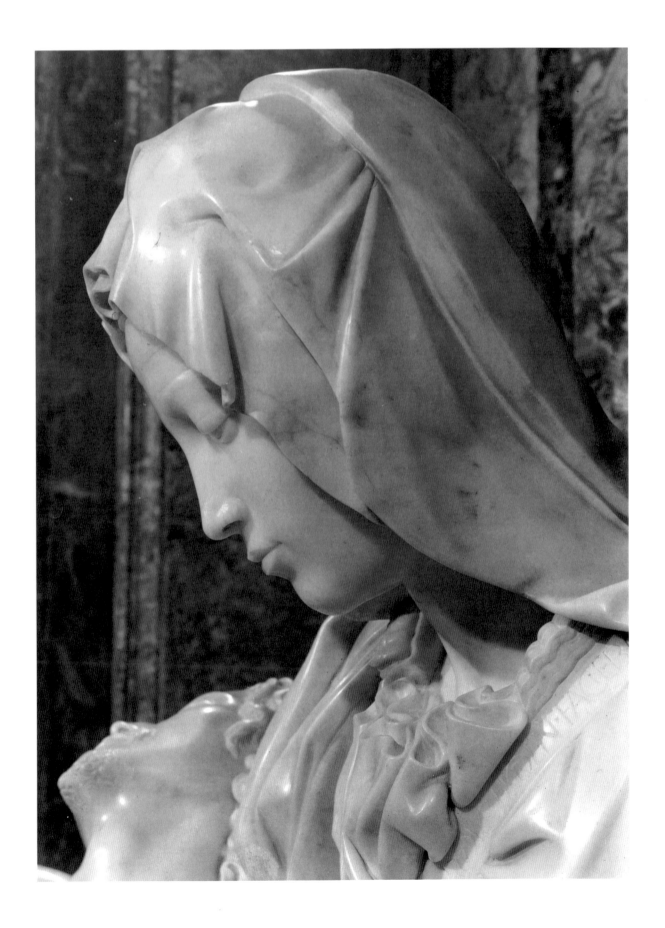

also be found in Ghirlandaio's monumental painted altarpieces. The folds act to hide the flattening out of the farther forms. The device recalls a very similar attempt to counter a shallow block adopted by Donatello in his carving of the seated Saint John the Evangelist for a niche for the façade of Florence Cathedral, a work made over eighty years earlier. The ratio of width to depth in the two sculptures is almost identical. Michelangelo's group is full of adjustments of scale and modelling. Some forms are very slight. Yet, we can insert hand and lower arm into the deep void beneath the shield-like arc of drapery which falls behind Christ's right arm; this arc-like form recalls a similar one in the *Saint Proculus* in Bologna (Pl. 9). Despite the stipulations that the group of Mother and Son should be life-size ('grande quanto sia uno huomo iusto'), Michelangelo's Christ is perceptibly smaller than the Virgin, a reflection of an old tradition in Pietà groups which may have recalled to informed observers the infancy of Christ when held in his Mother's arms.[26]

Pl. 41 Detail of Christ's hand.

The carving of the *Pietà* exemplifies an extreme refinement very different from the boldness in the treatment of the *Bacchus*; but, as we have seen, such disparities appear already in his works of a few years earlier in Bologna. Every detail of the *Pietà* group has been fashioned with loving care and the profusion of detail is unique in Michelangelo's work. Forms such as Christ's hair and beard have been rendered with great delicacy, and, to cite one example, the torn flesh around the wound in the inert right hand has been described with exceptional realism (Pl. 41). Signs of the use of a drill are here very few and where apparent are confined to subordinate areas of the sculpture like the root of the tree stump on which Christ's left foot rests. And this area was probably not even visible when the group was installed. The *Pietà* also exhibits that brilliance of surface so often remarked on, which can only have been achieved by indefatigable polishing. This surely was, in part, a response to the relative darkness of the interior of Santa Petronilla.[27]

Michelangelo signed his name and asserted his Florentine origin on the strap over the Virgin's breast, a feature never repeated in his carvings. Vasari gives us an elaborate anecdote to account for its presence, to the effect that visitors to the chapel had ascribed the *Pietà* to a Lombard sculptor and that Michelangelo had added his signature as a consequence.[28] Perhaps, however, Michelangelo was doing no more than following the example of Filarete, a Florentine predecessor, who had signed his name and added De Florentia on the monumental bronze doors of the basilica decades earlier.[29] Nevertheless, Michelangelo's signature does exhibit an eccentric aspect. He signed it:

MICHAEL·AGELVS·BONAROTVS·FLOENT·FACEBAT

He used the imperfect tense rather than the common FECIT and it has been acutely noted that this rare usage points to his Florentine Medicean background, and specifically to Poliziano, who, we will recall, had given the young artist the subject of the Battle of the Centaurs (Pl. 8).[30]

In the *Pietà*, to a degree perhaps unprecedented in the city since antiquity, the beauty of the invention was now matched by the beauty of the marble from which it was made. The place where Michelangelo found his marble for the group was not forgotten. Almost twenty-six years later, one of his stone-cutters at Carrara, searching for marble for the tombs of the Medici at San Lorenzo, wrote to Michelangelo in Florence to tell him that his colleague had excavated a beautiful block close to where that for the *Pietà* had been found by the artist ('cavato sotto alla Pietà che faceste a Roma').[31]

The period of one year allowed the artist for the completion of a sculpture of this complexity and refinement may seem amazingly brief. Payments to him from Cardinal de Bilhères continued in October and December 1498.[32] Then money specifically related to the commission ceases to appear in the account. However, one very large payment made as late as 3 July 1500 can be fairly firmly connected with the *Pietà*. On that day, Michelangelo is credited with 230 ducats by the Sienese banking house of Ghinucci and this goes far to prove the connection.[33] For the dead cardinal's executors, dealing with his affairs following his death in August 1499, had used the Ghinucci bank to pay for his funeral expenses.[34]

Perhaps this last payment signalled Michelangelo's completion of his work. Such a date agrees well with the fact that his next recorded commission, an altarpiece for the church of Sant'Agostino in Rome, would be undertaken in September 1500, just two months later.[35] On the other hand, we cannot altogether exclude the possibility that, because of the patron's death, he had had to wait for a settlement with the executors. The issue cannot, at present, be resolved. But before leaving it, we may note an intriguing payment by Michelangelo himself on 6 August 1499, of the substantial sum of over three ducats to a mason ('a Sandro muratore') whom we meet with nowhere else in his account. If, as has been cautiously suggested, this payment to the 'muratore' was for the installation of the marble group, it would follow that the artist succeeded in meeting his deadline. By a strange coincidence, the cardinal died on the very same day.[36]

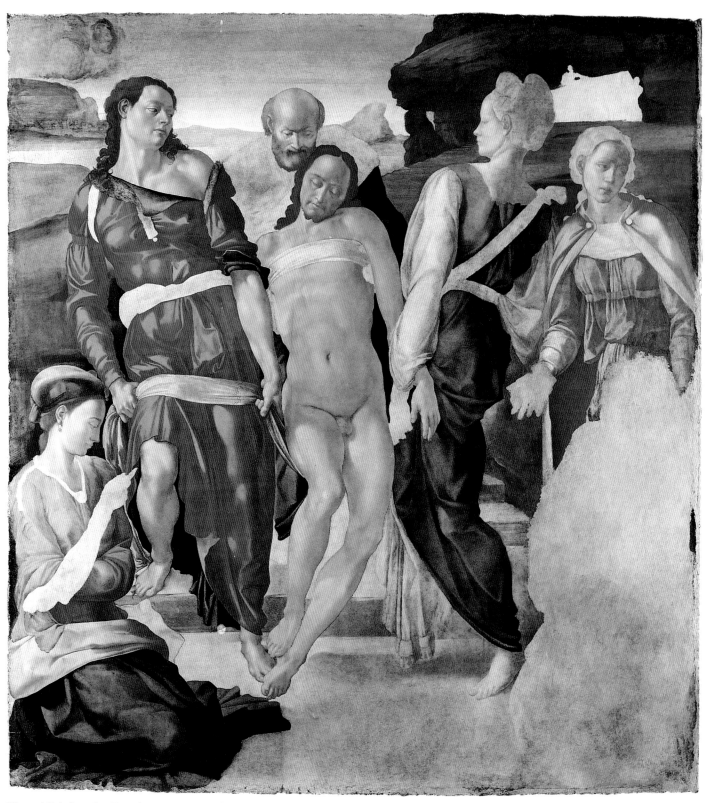

Pl. 42 Michelangelo, *Entombment*, 1500–1. Oil on panel, 162 × 150 cm. London, National Gallery (NG 790).

V

The *Entombment*

IN the last nine months of his stay in Rome, Michelangelo turned once more to painting. The project is nowhere discussed by his biographers and Michelangelo never referred to it in later life in any of the records known to us. The commission remained, in fact, entirely unknown until 1971 when the discovery of a number of documents first brought it to light and added a few details about the circumstances that surrounded it.[1] Now, just over twenty years later, the story can be told in greater detail, and the suggestion that the painting which resulted from the commission is the unfinished *Entombment* in the London National Gallery (Pl. 42) can be advanced with confidence.[2]

What led to this remarkable discovery were a few entries in Michelangelo's account in the Balducci bank-books, so often referred to in this survey of his stay in Rome. From a brief entry in the artist's account, made on 2 September 1500, we find that he is credited with sixty ducats for a panel painting for the church of Sant'Agostino in Rome ('a Michelagnolo schultore per 1ª Tavola di pittura fa in Santo Aghostino').[3] A corresponding entry elsewhere in the same book confirms that the payment had been made by the Augustinian friars of the church.[4]

Later entries in the Balducci bank-books shed light on what happened to Michelangelo's undertaking. Before, however, considering these, we need to turn to a different set of account books, those of the church of Sant'Agostino, a substantial number of which are preserved in the Rome Archivio di Stato. In one of these, recording financial income and outgoings of the *frati* in the period which concerns us, we find a confirmatory notice of the payment to Michelangelo. He is recorded as being paid sixty gold ducats for the painting, here described as an altarpiece ('per la depintura dell'ancona ad Michele agnolo da fiurenza').[5] Unfortunately, neither the church account book nor the bank-book now in Florence, tells us the subject of Michelangelo's painting. But the church's accounts are more discursive and we learn from them a good deal about the circumstances of the commission. Michelangelo's painting is for a chapel of the deceased Bishop of Crotone (a town in Calabria), called Giovanni Ebu. The total endowment for the chapel amounted to the substantial figure of five hundred ducats, a major part of which came from the sale of the dead ecclesiastic's house. We are also told of some of the people involved in carrying the project through, especially the two men who most closely supervised it. One of them was none other than Jacopo Gallo, Michelangelo's constant friend and, it does not seem too much to claim, his true Roman protector. The other, Bartolommeo de

Dossis, was a notable advocate and closely connected with Cardinal Riario, Michelangelo's first Roman patron.[6] These two men oversaw the financial provisioning of the chapel. Details in the church documents allow us, in turn, to glean more from the Balducci bank-books; once the identity of the dead bishop is established, we can learn from the latter that it was no less than Cardinal Riario himself who was in charge of disposing of the dead bishop's property in the summer of 1500.[7]

The church's account book provides us with a fairly thorough list of the expenses incurred in setting up and embellishing the chapel and its altar. These need not detain us here. But it is worth noting that the making and gilding of the frame in which Michelangelo's altarpiece was to be placed was costed at nearly as much as the sum allowed the artist for his painting: twenty-four ducats for the construction, and twenty-six ducats for its gilding.[8]

Near the close of his first residence in Rome, therefore, we find Michelangelo still moving in the circle which had introduced him to the city four years before. Excluding the marble *Pietà* made for Santa Petronilla at St Peter's, all his works (including the lost *Standing Cupid* for Jacopo Gallo) were concentrated in a relatively small area of the city.[9] Sant'Agostino was only a stone's throw from the palace that Cardinal Riario had occupied while waiting to move into the Cancelleria, and, in turn, the banking house of the Balducci brothers (with which Jacopo Gallo was affiliated) was only a few yards from the cardinal's vast new palace in course of construction. Cardinal Riario had become Protector General of the Augustinian Order in 1483[10] and it may well have been he who had encouraged the Bishop of Crotone to choose Sant'Agostino for his chapel. The inscription on the church's façade bears the date 1484; at the time which concerns us, it was awaiting chapel endowments and decoration. By 1500, the church and adjacent convent had become a well-known centre of Roman intellectual life.[11]

Once more, despite his repeated reassurances that he would soon return to Florence, Michelangelo took on a new Roman assignment. His brother Buonarroto had visited him in the autumn of 1500, one of a great number of pilgrims who flocked to Rome for the Jubilee Year; he reported to their father that the artist was living in poor conditions.[12] It was probably Jacopo Gallo who saw to it that Michelangelo received his payment for the projected altarpiece in a lump sum, before he had put brush to panel. The fact reflects the confidence in the master who had lately completed the marble *Pietà*, for which Gallo had been guarantor.[13]

We know of no rival projects which might have diverted the artist from proceeding with the picture in the succeeding months. But Michelangelo would abandon Rome for Florence in March 1501.[14] We can be certain that his picture never reached the chapel of the Bishop of Crotone. For, months after he had left Rome, entries in his Roman bank account show that Michelangelo is paying back the money he had received for the commission. These repayments begin in November 1501 and continue, in an irregular sequence, until the mid-summer of 1502. Some of the money is paid back directly to the church, some to a 'Maestro

Andrea' who has undertaken to provide a painting on panel for the church.[15]

As we can see, the friars of Sant'Agostino waited for some time before looking elsewhere for the altarpiece still wanting in their chapel. They were probably hoping for Michelangelo's return, but such expectations were, in effect, futile, for in August 1501 Michelangelo had signed the contract for the giant marble *David*; there could be no return to Rome in the foreseeable future.[16]

Michelangelo's successor is more than a name in an account book. Maestro Andrea was a man of many trades, painter, designer of theatrical sets, poet and buffoon, who would, years later, achieve some fame in the court of Leo X. Venetian in origin, he was known to two of the greatest literary figures of the century, namely Pietro Bembo and Pietro Aretino; he makes an appearance in some of the latter's writings. He was to die a miserable death in the sack of Rome in 1527.[17] His emergence as the painter who took on the altarpiece that Michelangelo had failed to supply seems to be his first known appearance in history. We know that, unlike Michelangelo, he completed his painting and that it was put in place in the chapel.[18] We can also establish, from the documents, that he was paid a lesser sum than that allowed to his predecessor.[19] Maestro Andrea's painting has been lost sight of and seems to have been removed from the chapel early in the seventeenth century. It is worth noting that its size probably followed that of Michelangelo's painting, for there is no indication that the expensive frame made for the latter had to be substituted by another.[20]

Paradoxically, however, all the circumstantial evidence suggests that the painting which never reached its destination is a very familiar one, the unfinished *Entombment* in the National Gallery in London. No document gives us the subject of Michelangelo's painting (or that of Master Andrea's substitute). Only the original contract, which has been looked for without success, would, in all likelihood, have told us what it was. But it has recently been established that the dead bishop's chapel was that immediately on our left when we enter Sant'Agostino and, more importantly, that this chapel was dedicated to the Pietà. The appropriateness of the London *Entombment* is, therefore, confirmed.[21] Physical aspects of the painting provide further encouragement for the thesis. The lighting in Michelangelo's painting is from the left, in keeping with its situation, close to the church door and the rose window in the façade. Its measurements agree well with the present width of the chapel bays in the church.[22]

The National Gallery painting has been much discussed ever since its acquisition in 1868. The debate intitiated by its purchase is full of interest but a comprehensive account of all the views that have been subsequently expressed would be out of place here. Put very simply, some art historians have denied Michelangelo's responsibility for the painting altogether and have proposed alternative attributions, some have accepted that it was painted by Michelangelo himself, and a few others have advanced the view that it is the work of two hands, Michelangelo and an assistant or follower.[23]

The documents concerning Michelangelo's commission in 1500, which are, by any reckoning, abundant, offer a very complete explanation for the London painting's existence, its scale, and its subject. Continued doubts about the work's status require a reasoned justification. Its manifestly unfinished state, conversely, explains the sequence of events recorded in the documents, ending with another painter having to be called in. The National Gallery panel lacks one of its most important figures, the mourning Virgin, and could never have taken its place in the dead bishop's chapel in Sant'Agostino in the condition in which Michelangelo left it.

The Roman provenance of the London painting can be traced back to 1649; an inventory of that year documents its presence in the Farnese collection.[24] The entry in the inventory unhesitatingly attributes the painting to Michelangelo and describes what is happening in it with commendable accuracy: it is called 'Christ carried to the Tomb'.[25] It remained in Rome until purchased by the dealer who would subsequently sell it to the National Gallery.[26] Its whereabouts between the moment when Michelangelo broke off work on it in the spring of 1501 and its seventeenth-century citation in the Farnese collection remain the one obscure episode in its history. We cannot rule out the possibility that the Farnese acquired it in the artist's lifetime.[27]

Those writers who have recognised that Michelangelo painted the *Entombment* have seen that it is an early work, but opinion has inevitably differed as to what this term means. Very few scholars ventured a date quite so early as that now established by the documents.[28] Once we recognise that the painting was begun in the winter of 1500, we have to acknowledge the sheer boldness of Michelangelo's imagination at the age of twenty-five. The chapel's dedication to the Pietà did not lead him to recapitulate the perfected marble group made for Cardinal de Bilhères. It is a testimony to the wealth of the artist's resources that, instead, he created a work which some modern critics have deemed unthinkable without knowledge of the *Laocoön*, the heroic antique marble group discovered in a Roman vineyard some years later in early 1506.[29]

While the scale of the panel was prescribed by its intended setting, the decision to paint a narrative must have been agreed on by the parties concerned, the artist, Jacopo Gallo, and the friars. As we saw, the 1649 inventory describes the subject as 'Christ carried to the Tomb', a title rather more precise than the generic one of *Entombment* with which we are familiar.[30] Christ's lifeless body is being lifted by three members of the group prior to his being carried away up a long flight of steps to the tomb indicated – but not painted – in the distance to our right. Recently scholars have sought to establish the exact moment more precisely, the removal of the corpse from the Virgin, the moment after the Lamentation.[31] Yet it is easy to overemphasise the narrative elements in Michelangelo's painting. The Mary seated in the left foreground does not even turn her head to witness the heart of the event, the lifting of the body. She impassively contemplates the crown of thorns, missing from the painting but which we know, from a drawing which will be discussed later (Pl. 52), she was to hold in her right hand.[32]

Pl. 43 Fra Angelico, *The Dead Christ before the Tomb*, central panel of the predella of the high altarpiece of S. Marco, Florence, *c.*1438–40. Panel, 38 × 46 cm. Munich, Alte Pinakothek.

The precedents on which Michelangelo drew for his painting remind us that this was an altarpiece with iconic requirements. These precedents have been discussed for many years and take us back to his Florentine roots. Probably the most decisive influence among these earlier images was Fra Angelico's small panel, now in Munich (Pl. 43), representing the dead Christ held upright before the tomb supported by a figure who is identifiable as Joseph of Arimathea. Both arms are extended, still reflecting the Crucifixion, and his Mother and Saint John bend over the hands. The painting was one of the predella panels of the high altarpiece in the church of San Marco commissioned by Cosimo de' Medici, located, therefore, only a few steps from the Medicean sculpture garden of San Marco where, as we have seen, Michelangelo's early biographers situate his real beginnings as an artist. Sometimes misleadingly described as an Entombment, Fra Angelico's small masterpiece is in no sense a narrative; it is an iconic presentation of the dead Saviour to the

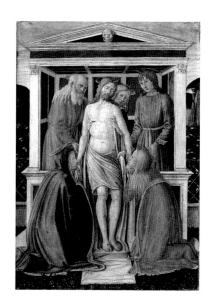

viewer, a subject often called the *Imago Pietatis* but which here, in the emphatic presentation represented, could also be called an *Ostensio Christi* – a display of the body of Christ.[33] This particular panel was almost certainly the one in the centre of the predella. In other words, it occupied a place of Eucharistic significance above the reserved Host on the altar.[34]

Another painting that has frequently been proposed as a source for Michelangelo's interpretation is a Netherlandish one, executed in the orbit of Rogier van der Weyden, which is now in the Uffizi (Pl. 44). It may be an altarpiece which is known to have been at the Medici villa of Careggi by 1492; the subject given in the well-known inventory of Lorenzo de' Medici, made after his death, agrees well with that of the Uffizi panel.[35] Here, as in Fra Angelico's predella, the dead Christ is held upright before the tomb. More figures have been added and a special prominence given to the Magdalen who kneels before the lifeless Saviour. This picture moves a little closer to a narrative. Yet its dependence on the example of Fra Angelico's painting is still close. The approach adopted is so different from the kinds of Lamentation subjects familiar in Rogier's workshop that it is probable that the Northern painter was sent instructions to follow a form established in the San Marco predella panel or in some other, now lost, Italian prototype.[36]

What has received less attention is a revival and refashioning of Fra Angelico's invention by Florentine painters in the later fifteenth century. It is an interesting episode but reference may be confined here to two examples. One of these is an altarpiece (Pl. 45) which has been recently ascribed to David Ghirlandaio, brother of

Pl. 46 Cosimo Rosselli, *The Dead Christ before the Tomb*, late 15th century. Panel, 50.5 × 33.5 cm. Berlin, Gemäldegalerie.

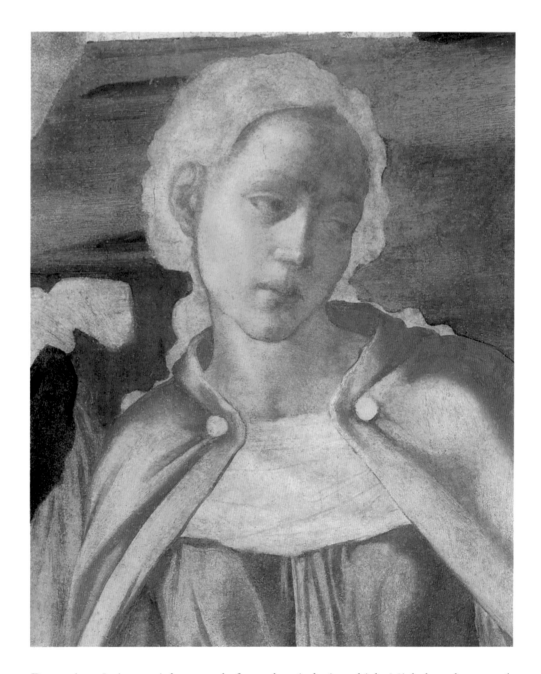

Domenico. It is certainly a work from the circle in which Michelangelo moved
when still a lad. Here, as in Fra Angelico's painting, a bearded figure holds the
Saviour from behind and, as in the San Marco high altar predella, Mary and Saint
John hold the hands. Two further kneeling saints have been introduced into the
foreground.[37] A different variation can be found in a painting in Berlin (Pl. 46),
ascribed to Cosimo Rosselli, where the upright dead Christ is held before a tabernacle-
like tomb. Here, the Virgin and the Magdalen kneel before him and contemplate the
body.[38]

It is in keeping with these precedents that Michelangelo's interpretation of his
subject is one of marked emotional reticence. Gestures such as the outflung arms or

Pl. 48 Michelangelo, *Crucified Christ*, *c.*1492–4. Wood, 135 cm high. Florence, Casa Buonarroti. The Crucifix, rediscovered in the 1960s in S. Spirito, Florence, can be identified as the work referred to by Condivi that Michelangelo made for the church.

OPPOSITE Pl. 49 *Entombment*, detail of Christ and Saint Joseph of Arimathea.

clasped hands employed by many painters and sculptors since the fourteenth century have been altogether excluded. The female witness on the far right indicates the Saviour with a 'pathos' gesture that recalls that of the Virgin in the marble *Pietà*, so recently completed. But her face is the only one in the painting which expresses a truly overt sadness (Pl. 47). The expression of the other participants is almost impassive.[39] The contrast with Raphael's celebrated *Entombment*, of a few years later, is profound. This restraint is, again, completely at odds with the rendering of grief and anguish in the marble *Laocoön* group with which Michelangelo's work has been misleadingly associated.

One of the most impressive features of Michelangelo's design is the extent to which he has succeeded in retaining a sacramental focus in a narrative painting. The lifeless body occupies a place near the centre of the panel. There is an almost elegant refinement in the delineation of the body and the fall of the inanimate limbs, yet it is the corpse, its slender build recalling his earlier wooden Crucifix (Pl. 48), which nevertheless dominates the painting.[40] It bears little trace of the profound sufferings it has undergone.[41] Designed on a vertical axis at mid-point over the altar, where the reserved Sacrament was probably placed, Christ's body, the Corpus Domini, is lifted upward immediately before the celebrant at the altar, who would, in turn, elevate

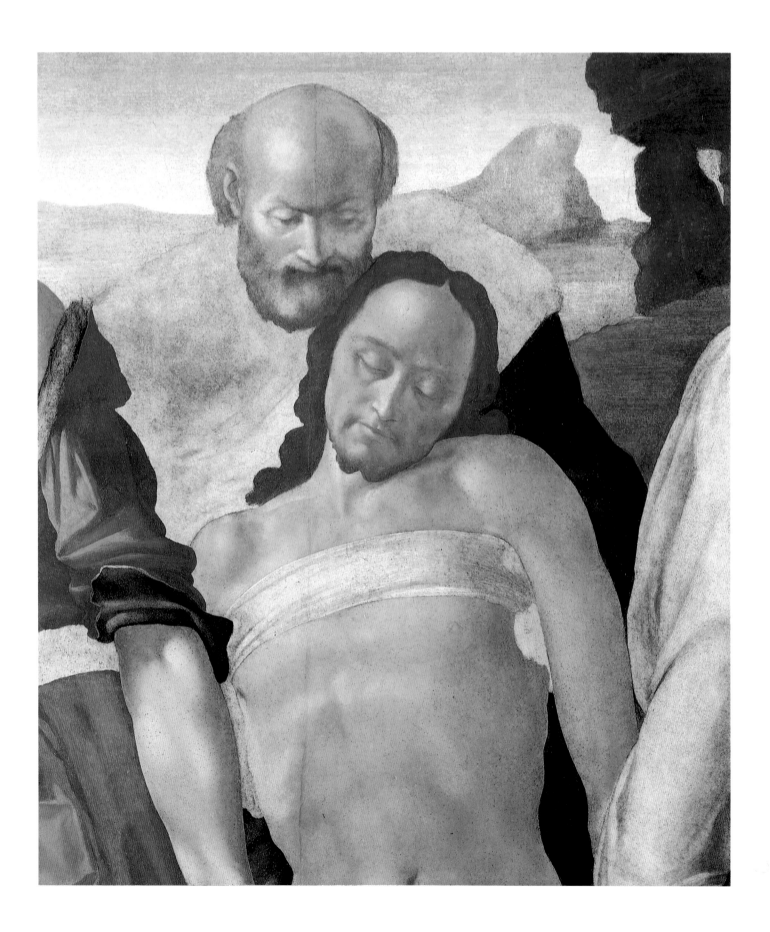

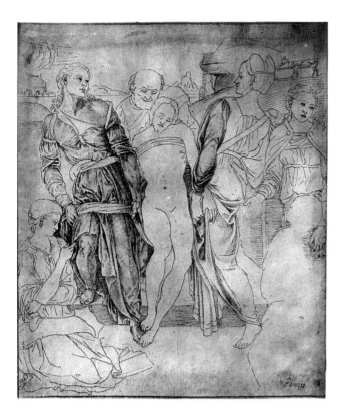

Pl. 50 *Copy of the Entombment*, probably 17th or 18th century. Pen and ink over metalpoint, 23.5 × 21 cm. Siena, Biblioteca Comunale degli Intronati.

the Corpus Domini, the Host, at every Mass held in the chapel.[42] More clearly than the marble Christ dead on his Mother's lap in Santa Petronilla, this Christ is a Eucharistic image. It was an entirely appropriate one in a chapel dedicated to the Pietà, in a church dedicated to Saint Augustine, who had himself evoked the Eucharist as *sacramentum pietatis*.[43]

Michelangelo's Christ is being carried to the tomb in that brilliant noonday light that we find in so many of Domenico Ghirlandaio's altarpieces, not least in his Innocenti painting (Pl. 3) on which, as mentioned in the first chapter, he was engaged when Michelangelo was in his workshop.[44] A similar light will envelop the figures in the later *Doni Tondo* (Pl. 125). Yet the subject could never have been an easily accessible one to the unsophisticated viewer, even had the work been finished; the motif of Christ borne up hewn steps is undeniably idiosyncratic. That there has been uncertainty about the identities of the figures around Christ is partly a consequence of the picture's unfinished condition, but this is not a complete explanation. Disagreement has even extended to the sex of one of the two foremost bearers of the body. The one attendant figure about whose identity we can be certain is, paradoxically, the one who has been left unpainted, the Mater Dolorosa in the right-hand corner, seated or, more probably, kneeling on the ground with her back turned to us, contemplating her dead Son being taken from her.

That the heavily built figure to the left of Christ, clad in vermilion, is the youthful Saint John the Evangelist, was proposed in earlier accounts of the *Entombment* and is surely correct. He wears the traditionally canonical colour of the

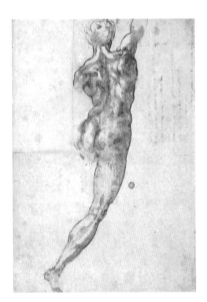

Pl. 51 Michelangelo, *Study of a male nude*, *c.*1500. Black chalk and pen and ink, 40.9 × 28.5 cm. Florence, Casa Buonarroti.

saint and his long hair adds further confirmation of the identification.[45] It is the bearer to the right of Christ who has presented the greatest difficulties. This is partly a consequence of condition. But it has also been doubted that the act of carrying could have been given to one of the Maries. In fact, the mourning women are expressly involved in the carrying of the dead body in a text as widely used as the *Meditations on the Life of Christ*,[46] and women bearers are conspicuous in his later drawings of similar Passion scenes (see, for example, Pl. 54). A drawn copy of the painting (Pl. 50), made at a time when the surface was perhaps less worn, also points to an identification as female.[47] The young woman who gestures towards Christ is probably Mary Magdalene.[48]

Michelangelo's choice of participants is not, therefore, eccentric. He presents us with the Virgin, Saint John, the three Maries (two of them half-sisters of the Virgin) and the elderly man whose type indicates that he is the wealthy Joseph of Arimathea, the covert follower of Christ who surrenders his own tomb for the burial of his master.[49] But, as in so many of his later creations, Michelangelo does not make things easy for his public; even here he is sparing in his bestowal of signs.

The National Gallery painting is unfinished and damaged. Michelangelo painted it in an oil medium, a decisive step away from the almost exclusive use of tempera in the *Manchester Madonna* (see pages 111ff.). But both the discoloration of the pigments and substantial losses combine to produce visual anomalies. Most seriously, the colour balance across the painting is now substantially upset. This leads to extensive prominence of some areas, such as the figure of Saint John; originally, the green garments of the corresponding bearer on the other side, the Mary, were much stronger and brighter. Some features of the painting can be misinterpreted in photographs, for example, the riser of the foremost step. The unpainted sash around Saint John's waist can be mistaken for one piece of material with the band across Christ's breast.

What is most easily appreciated today is the display of drawing, of the *disegno* bred in Florentine workshops, so evident in the figures of Saint John and Christ. Saint John has little in common with the traditional slender ideals of the earlier Quattrocento. Even in the surviving works by Michelangelo of the 1490s there is little to prepare us for this massive figure, one shoulder bared, the forms articulated with insistent modelling and an astonishingly virtuoso display of mastery in the contours.[50] Daringly, Michelangelo painted Christ entirely naked except for the cloth band wound tightly across the chest, an idea he would return to in the *Dying Slave*, now in the Louvre. The tall proportions of the Mary who helps carry him have often been taken as indicative of a later date, and it is true that this tall and slender ideal recurs in works up to the early 1530s. But we can find it already in drawings by Michelangelo of the early years of the sixteenth century. One of these, a celebrated drawing now in the Casa Buonarroti (Pl. 51), is a very free interpretation of an antique carved prototype and must have been made before 1504; it may date from the latter part of this first stay in Rome.[51] That in this female bearer

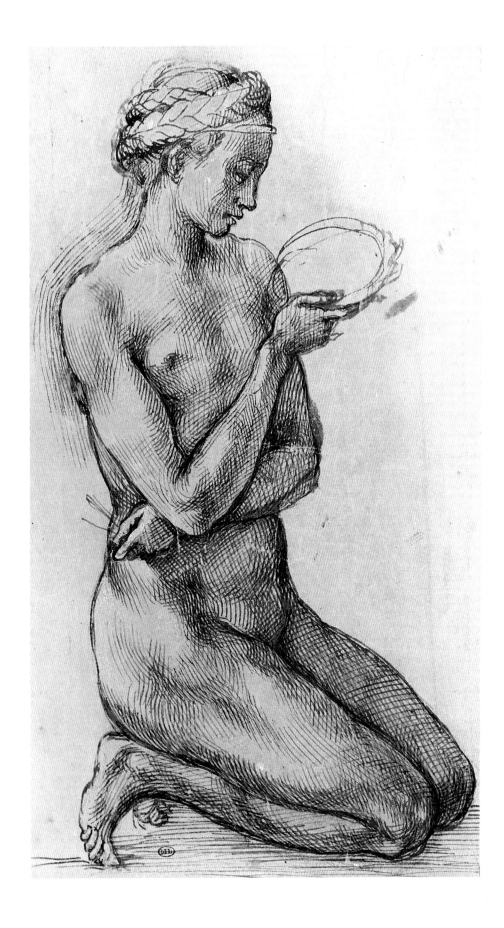

Pl. 52 Michelangelo, *Kneeling nude girl*, study for the *Entombment*, *c*.1500–1. Black chalk, pen and ink and white highlighting on pink prepared paper, 26.6 × 15.1 cm. Paris, Louvre.

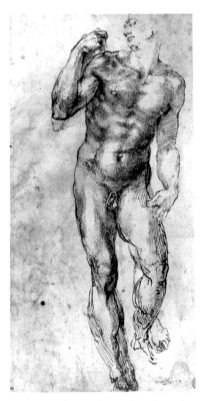

Pl. 53 Michelangelo, *Male nude*, study for the *Entombment*, *c*.1500–1. Pen and ink, 37 × 19.5 cm. Paris, Louvre. At this stage Michelangelo seems to have considered placing the figure of Saint John on the right of Christ.

Michelangelo was adopting an idea from antique art may account for what is, in effect, the least successful feature in the painting.[52]

Michelangelo's preparations in designing a painted narrative of the scale of the National Gallery altarpiece must have been extensive. In fact, it is the earliest work for which any graphic preparation survives, for no studies for the *Bacchus* and the *Pietà* have come down to us. Two drawings can be connected with the painting, one with complete certainty, the other with every probability; both are in the Louvre.[53]

The former is a drawing made from life for the kneeling Mary in the lower left corner of the panel (Pl. 52). Exceptionally, Michelangelo here employed a young girl as his model. The study was made with great care, drawn in pen and ink in two successive stages over a light preparatory drawing in black chalk. He added a few touches of white body colour for certain details and, a rare feature in his life studies, he drew a few lateral pen strokes to indicate the ground. There is a faint black chalk vertical line to the left of the figure, denoting the left edge of the panel. He introduced the attributes which he failed to add in the unfinished painting, the crown of thorns held in the left hand and the nails in the right. The use of the pen, especially the cross-hatching, points to Michelangelo's training in the Ghirlandaio workshop. The pink ground on which he made the study is still redolent of late Quattrocento Florentine practice and occurs, indeed, in one of Domenico Ghirlandaio's most well-known drawings.[54] What is uncharacteristic of his erstwhile master is the decision to study the model in the nude. Yet, when he came to clothe the figure in the altarpiece, memories of the Ghirlandaio workshop once more came to the surface; the beautiful fanned-out spread of the drapery on the ground recalls a similar feature in Domenico's *Visitation* of 1491 (Pl. 60).

The other drawing which can be connected with the painting is a rapid pen drawing of a nude man (Pl. 53). The suggestion that the study was made for the figure of Saint John at a stage in the planning when Michelangelo was considering placing him on our right of the dead Christ rather than on the left, as finally adopted, is convincing. The action of the drawn figure is that of a bearer; the glance is downward, as in the painting. This drawing is made with much greater freedom than the other, suggesting that it came earlier in the design process.

The National Gallery *Entombment* is a staggering invention for a twenty-five-year-old artist, and is one which Michelangelo would never forget. The vertical dead Christ which he introduced into the painting is an idea to which he would return repeatedly, even in the carved Pietà groups of his old age. Later drawings (Pls 54, 55 and 56), some of which would never be taken further, insistently echo the motif; one drawing in particular, datable around 1530, almost literally repeats features of the painted Saviour in the panel.[55]

Michelangelo brought the picture quite far to completion during the six winter months that followed the commission in September 1500. An explanation for the non-completion of at least part of it may be proposed. For the most prominent area

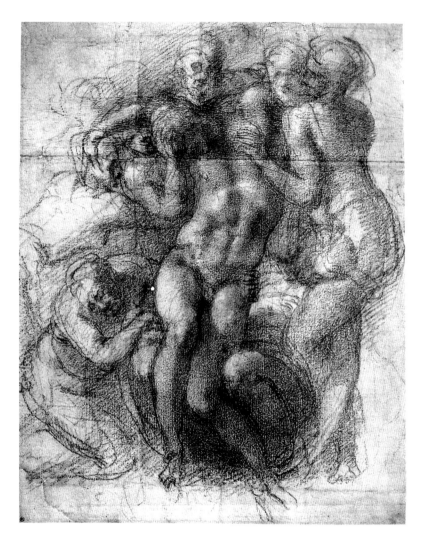

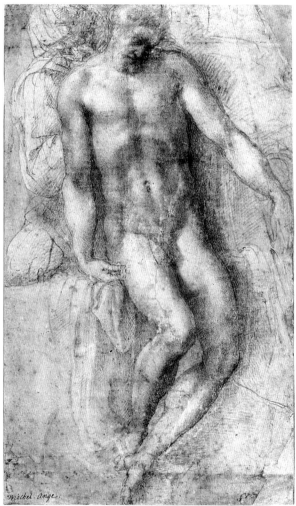

of the painting which he left untouched, the missing Mother of Christ, was one demanding a substantial amount of expensive lapis lazuli blue. Always concerned with his materials, Michelangelo may have been kept waiting for its delivery from Florence.[56]

Nevertheless, for the biographer of the artist, the National Gallery painting constitutes a threatening portent. It is the first of his monumental works which he abandoned incomplete. Up to this moment, his record of achievement in Rome had been prodigious; the long series of major unfinished works and frustrated patrons still lay in the future. Michelangelo may have decided to leave Rome for Florence fairly precipitately. In late February, we find him assigning to his staunch friend Jacopo Gallo what must have been a substantial amount of marble; in return, Michelangelo received from the banker a loan of eighty ducats.[57] There can be no doubt that this marble was for a new commission accepted by Michelangelo, a series of marble statues for Siena Cathedral. His new patron was the Sienese cardinal, Francesco Piccolomini, who had served as one of the executors of Cardinal de Bilhères, the

Pl. 54 Michelangelo, *Dead Christ supported by mourning figures*, 1530s. Red chalk, 31.9 × 24.8 cm. Vienna, Albertina.

Pl. 55 Michelangelo, *Dead Christ supported by a mourner*, 1530s. Red chalk with a little black chalk, 40.4 × 23.3 cm. Vienna, Albertina.

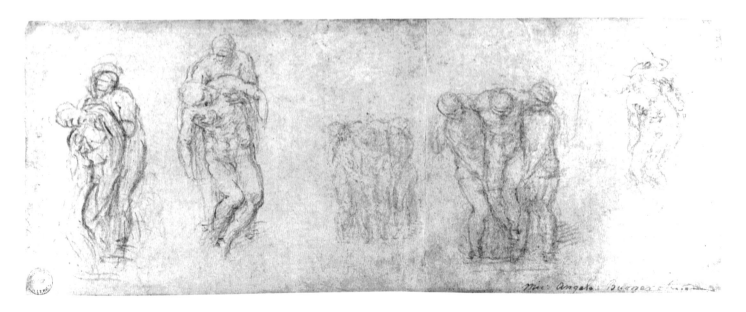

Pl. 56 Michelangelo, *Studies of the Dead Christ supported by mourners*, 1550s. Black chalk, 10.8 × 28.1 cm. Oxford, Ashmolean Museum.

patron of the marble *Pietà*; we know, from later documents, that Gallo was once more involved in this commission.[58]

Michelangelo could have left Rome for Florence in connection with this new project but the facts tell against the supposition, for the marble remained in Rome, and the artist's later delays in proceeding with the project would return to haunt him. As has been frequently argued, his move was probably actuated by his wish to procure the great block of marble now being offered by the authorities of Florence Cathedral. The huge and long-neglected block was a prize for any sculptor and attracted more than one claimant. The events of the summer of 1501, following Michelangelo's home-coming, are obscure, but by August he had secured the project for himself. To the creation of the giant *David* he brought a mind enriched by nearly five years of exposure to antique sculpture in Rome, which had begun immediately after his arrival with his visit to Cardinal Riario's collection.

Chapter 1: The Sculptor of the *Sleeping Cupid*

1. *Carteggio*, I, pp. 1–2. The letter is dated 2 July 1496 and is addressed to Lorenzo di Pierfrancesco de' Medici. It is the first of Michelangelo's letters to have survived and shows that the ties between the two were close. It has been commented on repeatedly in the Michelangelo literature.

2. Condivi 1746, p. XIII.

3. Vasari (ed. Barocchi, I, pp. 6–7) gives us the texts of the two editions printed together.

4. Cadogan 1993, pp. 30–1.

5. The painting and its fluctuating fortunes of attribution are discussed in Chapter III.

6. This aspect of the relationship has been a familiar topic for nearly 100 years. For a brief assessment, see Hirst 1988, pp. 4–5, 46 and 59.

7. Elam 1992, *passim*, but esp. pp. 58–61. For the cultural scene in this period, see *Il Giardino di San Marco*, 1992, esp. the important contributions of Agosti, pp. 21ff., 97ff. and 125ff.

8. The bibliography devoted to the relief cannot be reviewed here. It remained unknown to Vasari in 1550 and to Condivi in 1553; its fame only followed Michelangelo's death in 1564. It is worth recalling, in view of this obscurity, Milanesi's suggestion that it was this relief which was the 'Nostra Donna di marmo' that Michelangelo asks his father to place out of sight in a letter of 31 January 1506 (*Carteggio*, I, p. 12). For the fact that its technique does not slavishly follow Donatello's, see, most recently, Hirst in *Il Giardino*, 1992, pp. 86ff., and Weil-Garris Brandt 1992, p. 28.

9. The sculpture cannot be assessed in all its aspects here. For the present writer's view that the relief remains 'un'opera *sui generis*', see Hirst in *Il Giardino*, 1992, p. 61. For a similar recent conclusion, Weil-Garris Brandt 1992, p. 28.

10. The depth of the snow was 'più di un braccio, e in luoghi dove il vento soffiava ancora 2. e 3. braccia' ('Ricordanze di Tibaldo d'Amerigho de' Rossi', in *Delizie degli eruditi Toscani*, XXIII, Florence 1785, p. 286). Perkins had noted the relevance of the date, without adducing his source, in his much neglected book of 1864 (II, p. 8).

11. For this suggestion, see Hirst 1985, p. 155, and Elam 1992, p. 60; Elam also reaffirms the likelihood of Piero's patronage in this period, which is confirmed by other evidence; see the following note. A still unpublished letter of Lorenzo Strozzi's to Buonarroto Buonarroti of 20 June 1506 (forthcoming in *Carteggio Indiretto*, II, Appendix 2 and note 1, pp. 497–500) suggests that the Strozzi owned the *Hercules* by 1506. The present writer there presents the argument for Piero de' Medici's original patronage at greater length.

12. For the account, see Condivi 1746, pp. 9–11. The dreams are alluded to in words entirely characteristic of the artist himself as 'delusion diabolica o predizion divina'. As Spini (1966, pp. 129–30) shrewdly noted, the passage was too much for the Medicean Vasari, who omitted the entire episode in his Life of 1568. That Michelangelo was in Piero's service in 1494 is confirmed by the fact, recorded in an exactly contemporary letter, that Piero took

13. his unauthorised departure very badly: 'l'abia auto molto male'; for the letter, first published by Poggi, see now Elam 1992, p. 58.

13. There can be little doubt that this period in the house of Gian Francesco Aldovrandi was an important one in Michelangelo's formation. Condivi omits the *Saint Proculus*; as frequently pointed out, Michelangelo may have forgotten it.

14. That the facial type of Michelangelo's angel reflects those in the 13th-century reliefs of the Arca is very clear; the fact was pointed out by Lisner in 1964 and elaborated on by Luchs 1978, pp. 222–5. But Michelangelo's stylistic accommodation to the surrounding sculpture was already noted by Perkins 1864, II, pp. 8–9. Thus, what Michelangelo turned to as exemplary was not Niccolò dell'Arca's recent work but carvings he believed to be by the Pisani, as Luchs observed.

15. We read in Condivi (1746, p. 11) that Michelangelo's stay in Bologna was interrupted by the threatening behaviour of an unidentified Bolognese sculptor; he was also prepared to return to Florence 'massimamente essendo acquietate le cose, e potendo in casa sua sicuramente vivere'.

16. For Lorenzo di Pierfrancesco, see Pieraccini 1924, I, pp. 350ff. For his family background, Brown 1979, pp. 81ff.; and for his role as a patron, Shearman 1975, pp. 12ff. Frey (1907a, pp. 223ff.) believed it likely that Michelangelo lived with Lorenzo di Pierfrancesco on his return from Bologna.

17. See the evidence of Shearman 1975, pp. 19 and 25.

18. Vasari, ed. Barocchi, I, p. 13. He calls it simply 'un fanciullo di marmo'.

19. Condivi 1746, pp. 11–12.

20. See pp. 31–2.

21. The intuition of Frey (1907a, pp. 286–7) is, therefore, fully confirmed.

22. Vasari, ed. Barocchi, I, p. 15. We should note that Vasari was unaware of Riario's purchase of the *Cupid* in his extremely sketchy report of the affair in 1550.

23. First published by Tiraboschi, the brief life was republished by Frey 1887, pp. 403–4, and recently reprinted (with Italian translation) by Barocchi 1971, pp. 11–12. Giovio explicitly states that the *Cupid* was sold to Riario for a high price after it had been buried to achieve an antique appearance. Giovio's Life seems to have been composed between 1525 and 1532 (see Price Zimmerman 1976, pp. 408ff.) Another early writer familiar with the episode was the Florentine Giovanni Battista Gelli (see Gelli, ed. Mancini, p. 36). We should not, therefore, follow Frommel (1992, p. 453), who has dismissed Riario's role as a later invention.

24. Archivio di Stato, Florence: Eredità di Lemmo Balducci (hereafter Balducci), II, c. 17 *verso* (1496, 18 July): 'E de' dare carlini trenta per la postura del cavallo di Michelagnolo e le spese per la via......ducati 3.' (Published in Hirst 1981, p. 593.)

25. Balducci, II, c. 10 *recto* (1496): 'Lo Reverendissimo Cardinale di San Giorgio de'avere a di 5 di magio ducati 200 di charlini 10 per ducato avuti da......ducati 200.' Condivi explicitly states that Riario got his money back while surrendering the *Cupid*: 'riavuti indietro i suoi danari'. (Condivi 1746, p. 12.)

26. Most accessibly printed in Vasari, ed. Barocchi, II, p. 152. The letters were communicated to Frey by Luzio; see Frey 1907b, pp. 136–7. The following text is from Luzio 1909, p. 854, note 3: 'et è uno pucto cioè uno Cupido che si ghiace et dorme posato in su una sua mano, è integro et è lungo circa IIII spanne, quale è bellissimo: chi lo tene antiquo et chi moderno; qualunque se sia è tenuto et è perfectissimo.'

27. Luzio 1909, p. 854, note 3: 'Quel Cupido è moderno, et lo maestro che lo ha facto è qui venuto, tamen è tanto perfecto che da ognuno era tenuto antiquo: et dapoi che è chiarito moderno, credo che lo daria per manco pretio, ma non volendo la S.V. non essendo antiquo non ne dico altro.' Isabella's correspondent was Count Antonio Maria della Mirandola, who died in Rome only a few years later, in 1501.

28. *Carteggio*, I, pp. 1–2. Michelangelo refers to his *Cupid* as 'el bambino'. He identifies the dealer as Baldassare (hence confirming Vasari's identification of 1550) and writes of Baldassare: 'Lui mi rispose molto aspramente e che ne fare prima cento pezi, e che e' bambino lui l'avea chonperato e era suo.' Michelangelo's humdrum description of his carving is echoed in Gelli's later account; he refers to 'il Bambino fatto di mano di Michelagnolo Buonarroti' (Gelli, p. 36). Baldassare del Milanese deserves following further; for a brief reference in a different context, see Maffei 1973, p. 39.

29. Much of the correspondence concerning the *Cupid* is conveniently republished in Vasari, ed. Barocchi, II, pp. 150ff. The sentence here quoted, with one minor change of text, can be found on p. 152. Unfortunately, the whole correspondence has never been published in its entirety in one place. Brown 1976, p. 350, note 57, provides a complete list of all the letters but not their texts, which make absorbing reading.

30. Isabella's letter of refusal, a masterpiece of casuistry, omitted in Barocchi's notes, is in Luzio 1909, p. 855, note 1.

31. See the Excursus which discusses the later fate of the *Cupid*, pp. 24–8.

32. For a useful summary, see Agosti and Farinelli 1987, pp. 43–4. For the supremacy of antique over modern art, exemplified in the whole *Cupid* episode in Rome, see, for example, Pietro Bembo's paradigmatic remarks in his *Prose della Volgar Lingua*, first published in 1525 (Bembo 1966, pp. 182–3).

33. For this episode, see Marcantonio Michiel, *Notizia d'opere di disegno pubblicata...da D. Jacopo Morelli*, ed. G. Frizzoni, Bologna 1884, p. 181: 'la quale è stata venduta più fiate per opera antica a gran prezio'. The artist, Pietro Maria da Pescia, is described by Vasari (ed. Milanesi, V, pp. 369–70) as 'grandissimo imitatore delle cose antiche'. For recent discussions, see the various comments of Kurz, in his editions of 1961 and 1967; the episode of the porphyry vase is discussed in the latter, p. 119. Kurz points out that imitation, even deceptive forging of classical sculpture, was hailed 'as a supreme and enviable achievement', a judgement borne out by Riario's rejection of the *Cupid* and his summoning of the artist to his service.

34. For the issue of the forging of literary texts, see Sabbadini 1905, I, pp. 172–82. He discusses the case of Alberti's 'Philodoxeos' on p. 177. Another composition of Alberti's had turned into a work of Lucian before 1500; see Whitfield 1966, pp. 16ff.

35. The problem of the appearance of Michelangelo's *Hercules* has been discussed on many occasions; for a survey and some suggestions, see Joannides 1977, pp. 550ff., and 1981, pp. 20–3.

36. For further discussion, see the Excursus on the *Sleeping Cupid*, pp. 24–8.

Excursus: The *Sleeping Cupid*

37. For these texts, see Venturi 1888, p. 7, and, most recently, Ferino Pagden 1994, pp. 282ff. Venturi was unaware of the two letters of 1496 about the *Cupid* but his study remains fundamental. He also gives us a number of literary texts in prose and poetry relating to the two *Cupids* but no literary evocations conclusively establish the appearance of Michelangelo's statue. The inventory is among the notarial acts of O. Stivini of 1542 in the Archivio Notarile, Mantua: 'Inventario delle Robbe si sono ritrovate nell'armario di meggio che è nella grotta di Madonna in corte vecchia.'

38. The texts follow those of Venturi 1888, p. 7.

39. Venturi 1888, p. 7.

40. Luzio 1913, p. 165.

41. See the articles of Norton 1957, esp. pp. 255ff., and Scott-Elliot 1959, pp. 218ff. The sheet is Windsor, Royal Library, no. 8914. The origin of the paper appears to be French (information kindly provided by Martin Clayton); this is appropriate, given the French nationality of Daniel Nys.

42. Luzio 1913, p. 160: 'et con primo corriero mandarò li disegni delle statue' (letter to Lord Dorchester, 2 February 1629).

43. See, most recently, Ferino Pagden 1994, pp. 310ff.

44. See Bober and Rubinstein 1986, no. 51, p. 89. It has frequently been argued that this Uffizi *Cupid* is the one sent from Naples as a gift to Lorenzo the Magnificent; for a different proposal, see note 49.

45. Luzio 1913, p. 157: 'È gionto...la barca et ho avuto la robba, ma vi sono solo duo puttini che dormono et ne ha da essere quattro; manca quel di Prasitele et quello di Michiel Angelo che in tutte maniere bisogna mandare.'

46. A German visitor to Mantua, who saw the statue in 1599, described Michelangelo's *Cupid* as almost life-size, 'fast Lebens gross' (Venturi 1888, p. 7).

47. These problems have only recently been recognised; see Rubinstein 1986, pp. 257–9. It is also worth our notice that the Hercules-type Cupid, no. 29 on the Windsor sheet, does not agree with any of the four Cupids listed in the 1627 inventory.

48. For an exhaustive discussion of this remarkable piece, see Morricone Matini 1991, pp. 259ff., a contribution seemingly entirely overlooked in the latest literature.

49. Morricone Matini 1991, pp. 259ff. The suggestion had already been made by Parronchi (1981, pp. 27ff.). Vasari described the Neapolitan gift – through the mediation of Giuliano da Sangallo – in his life of the latter; see Vasari, ed. Milanesi, IV, p. 273: 'un Cupido che dorme, di marmo, tutti tondi'.

50. See Wilde 1932, p. 53, and Tolnay 1943, pp. 201–2, for a quotation of the same figure in a painting by Tintoretto. There is a further quotation in a *Holy Family* in the Borghese collection attributed to Annibale Carracci, no. 64. It is worth noting that this type, with the attribute of the torch, does agree with one of the Cupid types listed in the 1627 inventory quoted above, that with 'un funerale in mano', the one given the highest value of the four.

51. The piece is currently ascribed to Michelangelo at Corsham and has been cautiously considered as a possible candidate for Michelangelo's original by Tolnay 1971, pp. 8–9. It is, however, carved from Greek marble (a conclusion shared by A. Radcliffe and N. Penny) and is therefore incompatible with the description of Michelangelo's piece as made of Carrara marble in the *c*.1542 inventory cited in the text above.

52. For the Cupids in the Commonwealth Sale list, see Millar 1972, pp. 139ff.

53. See, for this material, Vertue 1758, pp. 101ff.

Chapter II: The *Bacchus*

1. Vasari's texts in his two editions can be compared in Vasari, ed. Barocchi, I, p. 16.

2. Condivi 1746, p. 13.

3. Maffei (Volterrano) 1506, fol. CCC *verso*: 'Item quamque profanum attemen operosum Bacchi signum in atrio domus Iacobi Galli.' Maffei also mentions the marble *Pietà* and the *David*.

4. Wilde 1932, pp. 53–4, who wrote: 'Der trunkene Bacchus ist, wie ich glaube, die Figur, die er gleich nach seiner Ankunft in Rom im Auftrage des beschwindelten Käufers seines Amor, des Kardinals Riario, in Arbeit genommen hat und mit der er in einem Jahr fertig geworden ist; sie ist vom Kardinal zurückgewiesen worden.' The argument was accepted by Tolnay 1943, p. 145, and on occasion followed more recently.

5. *Carteggio*, I, p. 1: 'Dipoi el Chardinale mi domandò se mi bastava l'animo di fare qualchosa di bello. Risposi ch'io non farei sì gran chose [a reference to the statues he had seen] ma che e' vedrebe quello che farei. Abiamo chonperato uno pezo di marmo d'una figura del naturale, e llunedì chomincerò a llavorare.'

6. Riario's titular church was San Giorgio ad Velum Aureum, i.e. San Giorgio in Velabro. This explains his description as 'Cardinale di San Giorgio' in the documents transcribed here. There is a brief biography in Schiavo 1960, pp. 414ff., and an extended discussion of the palace and its owner in Schiavo 1964, *passim*. For the palace (whose architect is still unknown) see also Frommel 1989, pp. 73–85. For his role in the Vitruvian revival, Bruschi 1969, pp. 842ff. And for a fine discussion of the appearance of the Cancelleria and its relation to Riario's humanist circle in particular, Daly Davis 1989, pp. 442ff. Riario also owned a 'vigna' on the site of the present Palazzo Corsini, close to the site of Agostino Chigi's Farnesina; its history remains to be written; account books show that he had turned his attention to it after 1512.

7. Michelangelo specifically refers to the great scale of the sculpture he had seen in the letter cited in note 5. For the drawing, Bober and Rubinstein 1986, fig. 39b, and for comments on Riario's sculpture, Lanciani, I, p. 94.

8. Balducci, II, c. 17 *verso* (1496, 18 July): '[Lo Rmo Cardinale di San Giorgio de' dare] a di detto ducati diecj di carlini per lo marmo che si fa la figura per mano di Michelagnolo......ducati 10.' (First published in Hirst 1981, p. 593.)

9. Balducci, II, c. 21 *verso* (1496, 23 August): '[Lo Rmo Cardinale di San Giorgio de' dare] a di 23 detto ducati cinquanta d'oro larghi paghati a Michelagnolo per chonto del suo lavoro......ducati 61.50.' (Hirst 1981, p. 593.)

10. Balducci, II, c. 46 (1497, 8 April): '[Lo Rmo Cardinale di San Giorgio de' dare] di 8 d'aprile ducati cinquanta d'oro larghi paghati a Michelagnolo per chonto di suo lavoro......ducati 61.50.' (Hirst 1981, p. 593.)

11. Balducci, II, c. 63 (1497, 3 July): '[Lo Rmo Cardinale di San Giorgio de' dare] addi detto ducati cinquanta d'oro in oro larghi paghati a Michelagnolo schultore per resto di pagamento del bacho......ducati 61.50.' (Hirst 1981, p. 593.) A similar sum recorded on c. 50 *verso* is the same payment paid in by Michelangelo on the same day.

12. *Carteggio*, I, p. 3: 'non vi maravigliate che io non torni, perché io non ò potuto ancora achonciare e' fatti mia col Cardinale, e partir no' mi voglio se prima io non son sodisfatto e remunerato della fatica mia; e con questi gra' maestri bisognia andare adagio, perché non si possono sforzare.'

13. A tabernacle door made for the Siena Baptistery by Donatello was turned down by the cathedral *operai* in 1434, but the reasons are not clearly stated in the document, for which see Milanesi 1854, II, pp. 159–60. There may have been objections to the casting. A notorious case of rejection more relevant for us is that of Rosso Fiorentino's first altarpiece (Franklin 1994, Chapter II). However, cases of this kind would inevitably be suppressed where possible by the artist; Michelangelo's case is a flagrant example.

14. At this time, Cardinal Riario was living in the palace of the deceased Cardinal d'Estouteville (died 1483) whose important office of Papal Camerlengo he had acquired, along with that of the Protector General of the Augustinian Order. The palace, called Palazzo Santa Prassede, was very close to the church of Sant'Agostino, which d'Estouteville had founded and where Michelangelo will be involved in 1500.

15. Balducci, II, c. 27 *verso* (1496, 19 September): 'de' dare [lo Rmo Cardinale di San Giorgio] carlini 40 per barili 2 di Fiano per rimesso in chasa messer Jachopo per Michelagnolo......ducati 4.'

16. That Riario and Michelangelo adopted a 'spoglia' inevitably comes to mind. The marble itself appears to be from Carrara (observations of A. Parronchi and N. Penny); the veins over the base are characteristic. However, marble long exposed to neglect could have led to problems different from those Michelangelo in effect did encounter (see below). Marble prices in Rome at this point are not easy to establish.

17. Conveniently reproduced in Tolnay 1943, fig. 169, and in many other studies about the *Bacchus*.

18. Of Michelangelo's method, Cellini writes: 'di poi che uno ha disegnato la veduta principale, si debbe per quella banda cominciare a scoprire con la virtù de ferri, come se uno volessi fare una figura di mezzo rilievo, e così a poco a poco si viene scoprendo'; the passage, in his *Trattati* published in 1568, is quoted in Vasari, ed. Barocchi, II, p. 231.

19. An observation of L. Curtius recorded in Lanckoronska 1938, p. 5, note 3.

20. Condivi 1746, p. 13.

21. Larrson, in a fine appreciation of the *Bacchus* seemingly unknown to Michelangelo specialists (1974, pp. 7off.), has proposed that the drunken interpretation refers to a vexed passage in Pliny's *Natural History* (XXXVI: 20) referring to the bronze *Bacchus* of Praxiteles, a point repeated in Summers 1981, p. 265. However, see below for further comments.

22. See the characterisation by Bottari in Vasari, ed. Bottari, III, p. 200, note 2. Riario's reaction to these aspects of the statue may well have anticipated that of Canova; see the latter's letter to Cicognara of 1815, in Cicognara 1823, pp. 114–15: 'opera non degna di un tanto uomo, per la mancanza di stile, di buone forme, e soprattutto d'insieme'.

23. Vasari, ed. Barocchi, I. p. 16. For fine comments on the 'soft style' of the statue, see Larrson 1974, pp. 72–3: 'er hat es in virtuoser Weise verstanden, dem Marmor den Character von weicher Haut und Fleisch zugeben'.

24. For an accessible account, see the Appendix on Maenadism in Dodds 1973, pp. 270ff., and a more extensive discussion in Farnell, V, pp. 278ff.; also the remarks on bisexual divinities in Delacourt 1958, esp. pp. 39ff.

25. Dodds 1960, p. xii, emphasises that to understand Dionysiac religion we must unthink Titian and Rubens, 'forget Keats and his "god of breathless cups and chirping mirth"...and remember that to celebrate the mysteries of Bacchus...is not to "revel" but to have a particular kind of religious experience – the experience of communion with God'. He himself forgot to except Michelangelo's statue, so completely at odds with the smiling anodyne *Bacchus* created by Jacopo Sansovino. The destructive nature of Bacchus is still brought out by Ovid; see his recapitulation of the story of Pentheus, ending in his dismemberment at the hands of Bacchus' following, in *Metamorphoses*, III, 672ff.

26. See *Tomo Secondo de le Lettere di Marsilio Ficino Tradotte in Lingua Toscana…*,Venice 1548, pp. 166–7 *verso*: 'La ebrietà di Dionysio, gl'antichi Teologi la diffinirono essere uno eccesso di mète [mente] segregata da le cose mortalii, e che penetra i segreti misterij de la divinità.' Spini (1966, pp. 133–4), whose comments are not acceptable *in toto*, nevertheless properly saw that the statue 'non è...un ammonimento contro l'ubriachezza, ma un'esaltazione della forza misteriosa del nume'. For Ficino's source, see the *Phaedrus*, esp. 265B. We should recall that Ficino himself corresponded with Riario over many years.

27. As Wind recognised (1958, p. 184), the leaves are not, as Condivi believed, vine leaves but ivy. Ivy was sacred to Bacchus and may have preceded the more celebrated attribute of the wine; see Farnell, V, pp. 118–19, and Trapp 1958, p. 232.

28. The marble flaws are mentioned in Hirst 1985, p. 154; that Frey (1907a, p. 294) had already noticed them is there overlooked.

29. *Carteggio*, I, p. 4. Whether the faulty block was acquired for Piero's statue has been debated in the literature. That the sculpture he is now working on for his own pleasure became the *Cupid* for Jacopo Gallo mentioned above, cannot be excluded, but the price seems low for a block to accommodate a standing figure.

30. Balducci, II, c. 97 *verso* (1498, 26 March): '[a Michelagnolo Bonaroti] adi 26 ducati trenta a carlini 12 per ducato, volse per rendere a Piero de' Medici......duc. 30.' (Hirst 1985, p. 156.) A recent suggestion (Perrig 1991, pp. 148ff.) that this project in Rome was the *Hercules* later owned by the Strozzi in Florence is highly improbable. The repayment may have been for money advanced for a statue which was not carried out. For the argument that Michelangelo's expressed antipathy for Piero was a later attitude influenced by republicans like Jacopo Nardi, see Frey 1907a, p. 155.

Chapter III: The *Manchester Madonna*

1. Balducci, II, c. 63 *verso*: 'Adi 27 di giugno, a Michelagnolo carlini 3 per 1º chuadro di legno per dipignerlo......ducati___[bolognini] 22½.'

2. Some idea of wood prices in Rome can be gained from the building accounts of the new church of Sant'Agostino. For example, a number of years earlier, eight pieces of wood 'per fare le lecture in sacrestia' cost only a little more than Michelangelo's panel, 32 *bolognini*.

3. For this episode, see the 1550 and 1568 texts of Vasari in Vasari, ed. Barocchi, II, pp. 158–9. In his amended account of 1568, Vasari dated it in the year of Michelangelo's association with the cardinal; Condivi, understandably in view of Michelangelo's attitude to Riario, passes over it in silence. In the second edition, Vasari states that the design was Michelangelo's, but not the painting; we cannot exclude, therefore, that Michelangelo's purchase of a panel in July 1497 was connected with the project. The work is probably the tempera painting in ruined condition referred to as still in the church in the 17th century (see a neglected comment in Celio, ed. Zocca, 1967, p. 27, brought to my notice by G. Agosti). For a pre-Vasarian reference to the work, see Frey 1892, p. 129.

4. Della Pergola 1954, pp. 47–8. Her important find was the following passage in D. Montelatici's *Descrizione di Villa Borghese fuori di Porta Pinciana*, Rome 1700, p. 210: 'dipinto dal Buonaroti, benché non del tutto terminato, in cui viene figurata Maria Vergine con Giesù bambino, e S. Giovanni Battista in mezzo à quattro Angioli.' A further text, an inventory of 1725, also published by Della Pergola, reads: 'Un quadro in Tavola con la Madonna, Gesù Cristo e S. Giovanni con quattro altre figure, cioè due dipinte e due disegnate.' The Rome provenance might be

interpreted as helpful in identifying the London painting as one made in Michelangelo's Roman stay, but the diversity of sources that contributed to the Borghese collection by 1700 seriously weakens the argument.

5. For the sale, Gould 1975, p. 149. For a Roman provenance showing Alexander Day had purchased the picture there, see the passage from von Rumohr's *Italienische Forschungen* quoted by Gould. Rumohr thought the painting both earlier ('wohl ältere') and more beautiful than the *Doni Tondo*.

6. Gould 1975, p. 149.

7. The now classic formulation was that by Zeri 1953, pp. 15–27. For an earlier attempt to give both the *Manchester Madonna* and other paintings in a block to Michelangelo, see Fiocco 1941, pp. 5ff., and Longhi's rejoinder, op. cit., p. 136. Zeri did propose that Michelangelo had a greater role in designing the *Manchester Madonna* than the other paintings in his group. His article added to the group the Barberini grisaille *Pietà*, discussed in the text below. Among earlier rejections of Michelangelo's authorship of the London painting, the most weighty was that of Wölfflin in 1891.

8. Von Holst (1971, esp. pp. 10–11) expressed doubts about the homogeneity of the group. See, most recently, Conti 1986, pp. 64–5, and Mancinelli 1992, pp. 21–2.

9. These Ferrarese accents were rightly emphasised by M. Fleischer in a discussion of the Vienna tondo after its recent restoration. The writer is much indebted to her comments. Holmes had already noted Ferrarese features in the Vienna tondo. For comparisons with Tura, see especially his *Madonna and Child* in the Accademia Carrara, Bergamo. The Vienna Virgin's pose very closely anticipates one in a Michelangelo drawing probably of a date as late as 1531 (Tolnay, Corpus, II, no. 245).

10. See, as one example, the well-known drawing now in Berlin, dating from after Michelangelo's return to Florence, Tolnay, Corpus, I, no. 27 *recto*. The fall of the drapery behind the inclined Virgin's head in the Kress work is remarkably similar to the motif in Michelangelo's carved *Taddei Tondo*; a general parallel was already noted by Zeri 1953, p. 20.

11. Zeri's conclusion that this *Pietà* is by the same hand as the Vienna and Kress panels is completely convincing. However, it is arguable that the Kress picture is the latest of the three. To discuss other paintings which have been included in the group lies outside the scope of the present study.

12. A number of names have been proposed, including that of Jacopo dell'Indaco; see Zeri's remarks on the attributional problem (1953, pp. 25ff.). The least credible proposal yet offered is that of a Portugese painter, Pedro Nunyes, advanced by N. Dacos (see now *Bollettino d'Arte*, LXXVII, 1993, pp. 29ff.). E. Buzzegoli, the restorer of the *Doni Tondo*, has no doubt about Michelangelo's authorship of the *Manchester Madonna* and a date prior to the London *Entombment*.

13. For the letters and the brilliant identification of the writer, see Poggi 1942, pp. 117ff.; one is reprinted in *Carteggio Indiretto*, I, 1988, p. 1. Piero undertakes tasks in the workshop such as paying the rent (Balducci, II, c. 149, and III, c. 14 *verso*). Michelangelo's father reports the excellent account of him that the artist's brother has brought back from Rome (letter of December 1500, *Carteggio*, I, p. 10): 'è buono giovane e ch'egli ti porto fede e amore', and continues that he understands that Michelangelo treats him like a son.

14. *Carteggio*, I, pp. 27 and 31.

15. *Carteggio*, I, p. 86; Michelangelo's father informs him on 7 October 1508 that Piero d'Argenta will leave for Rome in two or three days time. We should also note that when Michelangelo was anxious to get a letter to Piero d'Argenta two years earlier, in 1506, he asked his father to send it to him by way of the Gesuati, the foremost suppliers of pigments to painters in Florence; Michelangelo tells Lodovico that Piero frequently visits them: 'perché spesso vi suole andare di que' frati' (*Carteggio*, I, p. 12). For the Gesuati, see below p. 123. As late as 1530, Piero offered Michelangelo sanctuary at a moment of acute crisis in the artist's life (*Carteggio*, III, pp. 286–7).

16. The recent discovery of Cadogan is referred to above, p. 14.

17. They have been appropriately described by Zeri 1953, p. 19, as 'impresa quasi disperata'.

18. For a dating in the Ferrara stay, see Holmes 1923, esp. p. 32, and his 1907 article, esp. pp. 235–6. Some of Holmes's observations are, none the less, acute, and his suggestions cannot be completely ruled out.

19. See the *De Sculptura* of Pomponius Gauricus. A less noted fact is that one of the book's dedicatees is Lorenzo Strozzi, owner with his brother of Michelangelo's marble *Hercules* not later than 1506 and business partner of Michelangelo's own brother, Buonarroto Buonarroti. Circumstantial (but not conclusive) evidence suggests that Gauricus had been in Rome prior to his book's publication.

20. The passage, by Paul Mantz (1876, pp. 126ff.), deserves partial quotation: 'une conjecture ne vaudra jamais un document. Ce n'est donc qu'à titre provisoire et d'une manière approximative que nous daterons de 1495 ou 1496 une peinture dont la célébrité est encore récente...elle est encore de XVe siècle, mais combien elle le dépasse...A certain égards, la conception générale semble plus forte que l'exécution, et ce sont là autant de raisons de croire que cette peinture...est bien l'oeuvre d'un pinceau jeune encore...Ce qui domine dans le dessin et dans le sentiment, c'est la force, avec le désir, déjà visible, de pousser au caractère, d'agrandir les choses et de les transfigurer.' Mantz notes the very Ghirlandaiesque nature of the colour, specifically comparing it with that of Domenico's Louvre *Visitation*; at the same time referring to the acerbities explicable in an unfinished painting: 'Si Michel-Ange avait terminé son tableau, il aurait sans doute apaisé certaines tonalités un peu tapageuses et discipliné ses accents.' At the start Michelangelo 'est encore fidèle, comme coloriste, du moins, aux méthodes qu'il a vu mettre en pratique dans l'atelier de Ghirlandaio. Pour le style, c'est autre chose. Dès le premier pas, il est un maître...Et, en effet, malgré le caractère un peu boiteux de la composition inégalement pondérée, malgré les témerités d'une coloration hasardeuse, la Vierge de Manchester est une oeuvre magnifique et de la plus haute inspiration...Dans les parties

terminées, la modèle resemble à celui du Bacchus.'

21. Its relief-like character has been remarked on many times; see, for example, Holmes 1923, p. 82: 'The design...is that of a bas-relief.'

22. A similar scraping away of paint surrounding contours is present in the National Gallery *Entombment*. For a full discussion, see below, pp. 103–5 and 125–6.

23. Tolnay, Corpus, I, no. 20 *verso*.

24. The idiosyncratic form is well exemplified in Bertoldo's bronze group of *Bellerophon and Pegasus* now in Vienna. It is also a striking feature of the wooden *Crucified Christ*, ascribed to Michelangelo and identified as the work made for Santo Spirito, now in the Casa Buonarroti (Pl. 48).

25. Tolnay, Corpus, I, no. 17 *recto*.

26. We might cite as a parallel the way in which Christ's extended left foot is anchored to a tree stump in the marble *Pietà* group.

27. Von Holst suggested (1971, p. 130) that Michelangelo could have had a part in the designing of the Dublin painting. Granacci's painting remains something of a mystery for its evident fame led both to autograph replicas and copies (op. cit., pp. 130–1). Michelangelo's *Manchester Madonna*, on the other hand, seems to have left no trace of influence at all. What we should not exclude is the possibility that Michelangelo knew Granacci's painting and painted his own as a radical reinterpretation of the Virgin seated on a rock, out of doors. Cima explored the subject on lines of his own in very much the same period.

28. The link with della Robbia is, again, a commonplace in the literature, although Michelangelo's interpretation of his source has been less discussed.

29. That the *Doni Tondo* was carried out in much the same way was explained by E. Buzzegoli, its recent restorer, in a rewarding discussion of its technique; each part, was, essentially, reserved for its own treatment.

Chapter IV: The Marble *Pietà*

1. For conditions in Florence, see the successive entries in Luca Landucci's Diary from May 1497 (Landucci, ed. I. del Badia, 1883, pp. 150ff.).

2. For a still useful biography of the patron, see Samaran 1921, *passim*.

3. For further details about the French context of Santa Petronilla and Michelangelo's patron, see Weil-Garris Brandt 1987, which is the most sustained recent examination of the patronage and hypothetical site of the *Pietà*.

4. Weil-Garris Brandt 1987, p. 87. The group was then moved to the neighbouring mausoleum, commonly called Santa Maria delle Febbre.

5. Weil-Garris Brandt 1987, pp. 84 and 86.

6. For this reconstruction, see Biering and von Hesberg 1987, pp. 169ff. For their reconstructed plans of the two destroyed mausoleums, correcting those on a 16th-century plan, Uffizi 4336A, see p. 156, and for their conclusion as to the *Pietà*'s placement on a side wall, p. 181, note 139.

7. For this point about the traditional orientation of Christ's body in sculptural groups, one militating against a suggested location on the left wall of the chapel, see Forsyth 1970, p. 3. His observations about French sculptured Entombment groups are relevant for our concerns here: 'Most Entombments, too, seem to have been commissioned by private donors, often when they were near death, to be placed near an altar at which Masses for their souls were to be said, and near which they and their family were to be buried.'

8. For a parallel involving a Pietà group housed in a niche behind the altar, see Montorsoli's burial chapel of Andrea Doria in San Matteo in Genoa (an observation of N. Penny). For the shallowness of Michelangelo's group, see the text below.

9. These rough areas, never completed by Michelangelo, were noted by Weil-Garris Brandt 1987, p. 84. They are evident in photographs of the group taken in profile.

10. All these features, both archaeological and stylistic, are incompatible with a reconstruction of the *Pietà*'s setting recently offered by Wallace (1992, pp. 244–55); his proposal lacks plausibility. The group probably stood on some form of low plinth; this would explain why documents relating to the transportation of Michelangelo's material, to be cited below (note 17), refer to 'marmi' in the plural.

11. These points do not, in themselves, solve the problem of the site, but do require a line of vision where the gesture is readily accessible. It was, interestingly, this view of the *Pietà* that Parmigianino held in his mind when he reinterpreted Michelangelo's group in a drawing made soon after its first change of location (see Popham 1971, no. 311, pl. 213). When seen from the front, the forms in Michelangelo's *Pietà* incline to the left, a feature traditional in such sculptured groups from the 14th century. This caused problems for the artist who painted the grisaille copy which we have alluded to above (Pl. 26). If the artist was, as has been conjecturally suggested, Michelangelo's assistant, Piero d'Argenta, he could have begun to copy the group even before it left the workshop; the high viewpoint the painter adopted encourages the hypothesis.

12. The prepayment was of '133½ fiorini di Reno', approximately 100 ducats (Balducci, II, c. 50 *verso*). The other payments are in op. cit., II, c. 97 *verso* (published in Hirst 1985, p. 156).

13. For the letter, Milanesi 1875, p. 613, note 1; reprinted in Weil-Garris Brandt 1987, p. 105.

14. *Carteggio Indiretto*, I, p. 1. Both he and Messer Jacopo (Gallo) are amazed that they have not had a line from the artist.

15. Balducci, II, c. 115 (Hirst 1985, p. 156).

16. Milanesi 1875, p. 613, note 1; reprinted in Weil-Garris Brandt 1987, p. 105. The Florentines acted on the cardinal's behalf; see the letters published by Frey 1907b, p. 140. For the probable cause of the hold-up, Hirst 1985, p. 155.

17. Balducci, II, 149 (30 August 1498): '[Michelagnolo etc.] anne auto a di 30 d'aghosto ducati dieci d'oro larghi in carlini 12 bolognini. 2½ per ducato per fare portare e' marmi a chasa......ducati 10.' (Hirst 1985, p. 156.) The high cost reminds us of the scale of the

block, to be discussed below.

18. The contract is in Milanesi 1875, pp. 613–14; reprinted in Weil-Garris Brandt 1987, pp. 105–6. It is not a formal notarised contract; the text itself uses the word 'scripta'. Nevertheless, it is the first written agreement of its kind concerning Michelangelo to have survived. For the payment of 27 August, Balducci, II, c. 149, see Hirst 1985, p. 156.

19. The bibliography is extensive. Much of it is noted and commented on in Belting 1986, pp. 73ff. For a recent stimulating discussion on rather different lines, see Ziegler 1992; the book's title does not do justice to its range.

20. On de Bilhères's travels, see Samaran 1921, pp. 40ff.

21. For German Pietà groups in Italy, see the still fundamental article by Körte 1937, pp. 1–138; the example in San Domenico in Bologna, dated by Körte to c.1380, is discussed on p. 118, no. 12, pl. 12. It enjoyed a reputation as a miracle-working image.

22. For general issues, see Ziegler 1992, esp. pp. 153ff. The most relevant painted image of the dead Christ on his Mother's lap preceding Michelangelo's group is the now destroyed altar painted by Jacopo Sellaio for the church of San Frediano in Florence. Commissioned in 1483, it is reproduced in Berenson 1963, II, pl. 1100.

23. The motif of the cloth held between the hands and the dead body we find in works as disparate as Rogier van der Weyden's *Descent from the Cross* (Madrid) and Jacopo Pontormo's Santa Felicità altarpiece (Florence). It reappears in Michelangelo's own late 'Florence' *Pietà*. For further comment, see Weil-Garris Brandt 1987, p. 91.

24. See the passage in Alberti's discussion of the painted 'istoria', cited in Belting 1986, p. 52, note 4: 'Nature provides...that we mourn with the mourners, laugh with those who laugh, and grieve with the grief-stricken.' Alberti adds a comment particularly relevant for Michelangelo's group, that, in those who mourn, the brow is weighed down, the neck bent (Alberti 1972, p. 81). On Mary's *compassio* and our own involvement, see in particular Suckale 1977, p. 144: 'Marie zeigt Christus vor, sie präsentiert ihm, sie ist Mittlerin zwischen ihren Sohn und dem gläubigen Betrachter.'

25. For these measurements, see Weil-Garris Brandt 1987, p. 83. That Michelangelo had turned to renting accommodation is proved by an entry in his account, Balducci, II, c. 143, dated 21 August 1498; he pays rental of nine ducats for the following six months. Similar payments follow later.

26. The Virgin's diagonal strap has been convincingly likened to the kind employed in the period for supporting a child; see Tolnay 1943, p. 91, and, recently, Shearman 1992, p. 237 (giving the same examples).

27. The lighting within the deep chapels of Santa Petronilla can never have been more than an indirect one; see the elevation of the rotonda proposed in the reconstruction of Biering and von Hesberg 1987, p. 160.

28. Compare the texts of his two editions in Vasari, ed. Barocchi, I, pp. 17–18.

29. Filarete's doors, completed by 1445, are signed OPUS.ANTONII.

DE FLORENTIA.

30. See the important brief article by Juřen 1974, pp. 27ff., brought to my attention by K. Weil-Garris Brandt. He discusses Poliziano's observation of the usage of the imperfect on an antique fragment on his visit to Rome (with Piero de' Medici) in 1488, and his subsequent written resumé of its significance one year later. He draws attention, in addition, to its classical antecedents and Poliziano's recognition of a relevant passage in Pliny's *Natural History*, for whom the usage showed that art was something begun and never finished, or, alternatively, a sign of modesty on the part of the artist. We find Andrea Sansovino following Michelangelo's use of the imperfect on his two della Rovere tombs in Santa Maria del Popolo not many years later.

31. The text is in *Carteggio*, III, p. 98; for the point, see Hirst 1985, p. 156.

32. Balducci, II, c. 160, on 29 October for 25 large ducats, and, on the same page, on 21 December for another 25 similar ducats (Hirst 1985, p. 156). Possibly, a further credit of 25 ducats on 18 March 1499 could be for the *Pietà*, but there is no mention of the cardinal and the context remains conjectural.

33. Balducci, IV, c. 26 *verso*: '[Da Michelagnolo Bonarroti] addi 3 di luglio [1500] ducati dugiento trenta dua d'oro in oro larghi a carlini 13 per ducato auti da Ghinucci......ducati 232.' Specific payments identifiably for the *Pietà* are (1) 133 fiorini (about 100 ducats) in November 1497, (2) 50 ducats on 24 August 1498, (3) 24 ducats on 29 October 1498, (4) 25 ducats on 21 December 1498, and (5) 232 ducats on 3 July 1500. The contract had prescribed the sum of 450 cameral ducats as payment.

34. For this fact, see Burchard, ed. Celano, II, p. 157, note 2; the payment was made on 20 September 1499.

35. Cardinal de Bilhères's tomb marker, originally in his chapel's pavement, is dated 1500 but does not effectively date the completion of Michelangelo's group; it could only have been ordered after his death in August 1499.

36. Balducci, III, c. 32 *verso*: '[Michelagnolo Bonarroti anne auto] addi 6 d'aghosto [1499] ducati 3 bolognini II paghati a Sandro muratore......ducati 3 bol. II.' Giovanni Poggi noted against his own never published transcription: 'per murare la Pietà?' To complete a group like the *Pietà* in 12 months may strike us as an impossible feat, yet, when we review Michelangelo's astonishing speed of work in other contexts (for example, the second part of the Sistine ceiling), his capacity to comply with the contract need not be doubted. Vasari himself (ed. Milanesi, VII, p. 151) specifically states that the *Pietà* was carried out 'in pochissimo tempo'. Again, to argue for a completion date of 1499 leaves us with a full year before the artist's next commission of 1500. But we must recall that, somewhere in Michelangelo's curriculum in these Roman years, we have to find time for his carving of the lost *Standing Cupid* made for Jacopo Gallo, referred to more than once above (for the sources, Vasari, ed. Barocchi, II, pp. 159ff.). He may well have made it as a present, given Gallo's hospitality and sustained support; there seems to be no specific reference to the project in the Balducci bank-books.

Chapter V: The *Entombment*

1. See Mancusi-Ungaro 1971, esp. pp. 7–8 and 153ff. The statement that the project was unknown requires the qualification that Giovanni Poggi knew the Balducci payments but never published them.

2. For a detailed account, see Hirst 1981, *passim*. For a further important additional piece of evidence, see now Nagel 1994, pp. 164ff., alluded to below. Mancusi-Ungaro was the first writer to connect the documents with the *Entombment* now in the London National Gallery (1971, pp. 7–8, and esp. note 38).

3. Balducci, IV, c. 86: 'E addi 2 di settembre [1500] ducati sesanta d'oro in oro di chamera paghati a Michelagnolo schultore per 1ᵃ tavola di pittura fa in Santo Aghostino...ducati 60.' (Mancusi-Ungaro 1971, pp. 152–3; Hirst 1981, p. 590.)

4. Balducci, IV, c. 97 *verso*: '[Michelangnolo di Lodovicho Bonarroti] de'avere ducati 60 d'oro di camera auti per lui da frati di Sancto Aghostino per 1ᵃ tavola di pittura debitori detti frati in questa a c. 86......ducati 60.' (Mancusi-Ungaro 1971, pp. 152–3; Hirst 1981, p. 590.)

5. Archivio di Stato di Roma, Agostiniani in Sant'Agostino (hereafter Agostiniani), 108, Introitus et Exitus 1496–1503, c. 43 *verso* (Introitus Mensis Martii 1501): 'Item sexanta ducati d'oro in oro...dati missere Iuhanni Bartolomeo e missere Jacopo Gallo per la depintura dell'a[n]cona ad Michele angelo da fiurenza.' The accounts of the church run substantially behind events, unlike those in the Balducci bank ledgers (Hirst 1981, p. 590).

6. These events are reviewed in detail in Hirst 1981, pp. 582–4; de Dossis had a fine house, with sculpture in his garden, situated near Sant'Agostino.

7. The evidence is in an earlier bank-book, Balducci, III, c. 86 *recto*; the entry is dated 30 July 1500; see Hirst 1981, p. 589. Bishop Ebu had died in 1496; for the reasons for the delay in endowing his chapel, see Hirst 1981, p. 583. His will has not been found.

8. Agostiniani, 108, c. 43 *verso* (Hirst 1981, p. 590).

9. This extraordinarily close network of relations between Michelangelo's patrons in this Rome stay offers an exceptional example of what could be called 'nuclear' patronage.

10. See Chapter II, note 14.

11. Hirst 1981, p. 583, for further literature. Michelangelo had already enjoyed close relations with the Augustinians at Santo Spirito in Florence, for whom he had made his wooden Crucifix (Pl. 48). They were among the most eloquent opponents of Savonarola. For an assessment of the character of Sant'Agostino's neighbourhood, one of some ill-repute, see Esposito Aliano 1981, pp. 495ff., and Nagel 1994, p. 166.

12. *Carteggio*, I, p. 9.

13. The church documents spell out quite clearly that, of the money available for the chapel's establishment, 60 cameral ducats are set aside for the painting. Hence, this modest sum is not a preliminary payment on account, with more to follow.

14. The date, hitherto a subject of speculation, can be approximately fixed by Michelangelo's transferral of credit to his Florentine bank on 18 March 1501. See Balducci, V, c. 4: '[Michelagnolo di Lodovicho Bonaroti anne auto] addì 18 di marzo ducati 260 d'oro in oro larghi li faciemo paghare a Firenze a Bonifazio Fazi......ducati 260.' Such transferrals almost inevitably signal a move by the artist. As noted above, Piero d'Argenta, his assistant, stayed on in Rome for several months before following him. At this moment, in March 1501, de Dossis and Jacopo Gallo made two payments amounting to nearly 100 gold ducats to the friars of Sant'Agostino for the 'manifattura d'un tabernacolo d'altare' (the payments are both on Balducci, V, c. 31). A 'tabernacolo' could well imply a ciborium, but no mention of one is found in the detailed list of expenses relating to the chapel in the church account books. *Tabernacolo* can also, however, signify a frame; see, for this usage, documents relating to Rosso in Franklin 1989, p. 826. If a frame, the outlay is almost double that mentioned in the church account for the *fornimento*, i.e. frame (see the text above, p. 58). The items cannot be related to the change of painter for the altarpiece, for they anticipate the appearance of Maestro Andrea. Their exact significance must remain an open question.

15. Some of these repayments were published by Mancusi-Ungaro 1971, pp. 7–8 and 156ff., and were analysed at length in Hirst 1981, p. 52. Michelangelo's Rome account was credited with 78 ducats di carlini (the equivalent of the 60 ducats di camera he had originally received) in November 1501 (Balducci, V, c. 60 *verso*) in order to make good his debts. On 13 November the account is debited with five ducats paid to his successor, Maestro Andrea, 'per parte di manifattura della tavola à tolto a fare in Santo Aghostino'. Later that month, a further 20 ducats are debited, paid directly to the church (all on Balducci, V, c. 60 *verso*). Two further debits, totalling 53 ducats, followed, one of them, of 48 ducats, paid directly to the church (Balducci, V, c. 128 *verso*). From this sum, two payments are made to Maestro Andrea in 1502, one on 4 January for blue pigment for the work in progress, another of 42½ ducats on 18 June 1502 to complete the payment for his painting, 'per resto della tavola fatta in Santo Aghostino' (both in Balducci, VI, c. 13 *verso*). Maestro Andrea actually signed a receipt in the account book. As we can see, he received most of his money only on completion; after their mishap with Michelangelo, those involved were taking no more chances.

16. The contract with the Operai of Florence Cathedral was signed on 16 August 1501. The statue was almost completely finished by the end of March 1504. But already in 1503, while working on the *David*, Michelangelo had agreed to carve a series of 12 large marble apostles for the cathedral.

17. There is an inadequate account of Maestro Andrea's career in the *Dizionario Biografico degli Italiani*, IV, p. 124, *voce* Andrea Veneziano. Already noted as a furniture painter in Julius II's pontificate, he was a leading member of that circle of 'entertainers' around Leo X so contemptuously portrayed by Domenico Gnoli (1938, pp. 369ff.). His career is succinctly outlined in Marucci et al. 1983, II, p. 1011, with excellent bibliography (reference owed to G. Agosti).

18. This is demonstrated by further documents in the Sant'Agostino

archive recently published by Nagel 1994, p. 167.

19. This is confirmed in the church's own account book, Docs. cited in note 5, 108, Exitus, c. 129 *verso*. Sixty cameral ducats had been assigned to Michelangelo; his successor is receiving 56 of the less valuable 'ducati di carlini' (Hirst 1981, p. 590).

20. For an account of the chapel's fortunes in the period following Michelangelo's removal from Rome, see now Nagel 1994, pp. 164ff. He has established that the rights to the chapel had been acquired by Fiametta, a celebrated courtesan, by 1506, and that its dedication was changed to that of the Magdalen. Perhaps this happened because of the death in 1505 of Jacopo Gallo, who had expended so much time and energy in supervising the chapel established in memory of the Bishop of Crotone.

21. For this highly valuable corroborative evidence, Nagel 1994, p. 164.

22. Hirst 1981, p. 587. Contrary to earlier assertions, recent examination of Michelangelo's panel shows that three of its edges are intact; the painting has been cut down only at the bottom.

23. There is a brief survey of published opinion in Gould 1975, pp. 147–8, and a much more comprehensive one in Vasari, ed. Barocchi, II, p. 241. An eloquent passage in favour of Michelangelo's authorship is Berenson's (1938, I, pp. 195–6). Berenson noted the left-hand bearer's resemblance to the marble *Saint Matthew*. His conclusion that the painting was done *c*.1504 was followed by Wilde. The proposal recently advanced (see, for example, Gould, op. cit.) that Michelangelo began the painting in one period and resumed work on it at a later date is rendered highly improbable by the facts now established; Michelangelo had repaid the money he had initially received and a different painting had been put on the altar in Sant'Agostino.

24. The inventory is in Naples, Archivio di Stato, Carte Farnesiane, Busta 1853 (II), p. 154 (information from Charles Hope).

25. 'Uno in tavola grande cornice di noce, dipinto un Christo condotto al sepolchro dalle Marie San Giovanni e Cireno mano di Michel Angelo Buonarota, con tela rossa con frangio attorno per coperta.' Only the identification of the elderly man as Simon the Cyrenian, identified in the Gospels of Mark and Luke as the bearer of Christ's cross, is confused. For later inventories, see Hirst 1981, p. 584, note 41.

26. For the later provenance and its purchase from Robert MacPherson, who seems to have acquired it for very little, see Gould 1951, pp. 281–2, also Chapter VII, note 11.

27. The painting does not appear in the detailed inventory of work in Michelangelo's house drawn up in Rome in February 1564 after his death. As more than one unfinished work is there listed, the absence of the *Entombment* seems significant.

28. Holmes (1907, pp. 23ff.) suggested that Michelangelo could have begun work on the *Entombment*, as also on the *Manchester Madonna*, during the Bologna stay and carried it further on his return from Rome to Florence. Most of those who have accepted the work have seen in it a painting that preceded the *Doni Tondo*. The scholar who came closest to the truth was Gamba who actually suggested that Michelangelo broke off work on it in 1501 – 'alla partenza da Roma' (1948, p. XIV).

29. Smart 1967, pp. 850ff.; the argument was accepted by Gould 1975, p. 146.

30. This more correct definition of the event was already formulated in the 19th century without benefit of access to the Farnese inventory by William Boxall.

31. See, most recently, Shearman (1992, pp. 79ff.), an assessment fairly closely anticipated by Smart (1967, pp. 846–7). Shearman's conclusion that an exactly similar moment is represented in an *Entombment* by the Master of the Virgo inter Virgines now in Liverpool (his fig. 63) is surely mistaken. Every aspect of the Northern painting points to a different one, when the dead Christ's body is brought to his Mother. Friedländer already reached this conclusion in a beautiful analysis of the picture (1969, p. 39).

32. This drawing is discussed below, p. 69.

33. There is an excellent discussion of many of these issues in Belting 1986, pp. 73ff. For the use of the term *ostensio*, see his note 55, p. 100.

34. For a fine assessment of the San Marco high altarpiece, see Hood 1993, pp. 97ff., and particularly p. 110. Hood has pointed to the relative rarity of close public access to the painting (p. 46); but the revival of the predella's subject matter in the later Quattrocento suggests that artists had opportunity to study it. In this respect, Michelangelo probably enjoyed a privileged position, given his close Medicean connections.

35. The entry reads in part: 'Una tavola d'altare chon cornice...dipintovi drento el sepolcro del Nostro Signore e il Nostro Signore schonfitto di crocie e cinque altre fighure' (see Spallanzani and Bertelà 1992, p. 133). The relation between the Uffizi painting, frequently wrongly ascribed to Rogier himself, and Michelangelo's London altarpiece was pointed out by A. Goldschmidt as early as 1903 (see *Kunstgeschichtliche Gesellschaft*, Sitzungsberischt VIII, Berlin, 1903, pp. 56–8, with added comments by Warburg). The landscape in the Netherlandish painting was copied by a Florentine painter before 1500. Recently, it has been argued that a further reflection is evident in one of the earliest paintings by Domenico Ghirlandaio, Michelangelo's own master (see Rohlmann 1992, pp. 388–96).

36. There was a painting by Fra Angelico of *Christ carried to the Tomb* in Palazzo Medici and described in the inventory of 1492 as 'Una tavoletta, dipintovi il Nostro Signore morto chon molti santi che lo portono al sepolchro.' (Spallanzani and Bertelà 1992, p. 33.)

37. The painting's relevance for Michelangelo's altarpiece was referred to in Hirst 1981, p. 589, note 58. Its relation to the painting from Rogier van der Weyden's circle in the Uffizi is mentioned by Rohlmann 1992, p. 393.

38. The writer is indebted to David Franklin for a discussion of this precedent. Its relevance has been independently observed by A. Nagel.

39. In an admiring passage about the painting by Frizzoni first published in 1879, only just a decade after its purchase, the author remarked on the picture's lack of obvious charm and beauty, 'quella profondità di vita sprezzante di ogni grazia'.

40. The emphasis is accentuated by the number of lines leading the

eye towards the body, especially those of the belts and sashes on the two prominent bearers. The painting's unfinished state may exaggerate this effect, but even the contour of the turned-down vermilion tunic serves this end.

41. The unmarked body was remarked on by A. Venturi in a passage quoted in Hirst 1981, p. 589. The present writer there pointed out the absence of the wounds, but a renewed examination of the panel shows that even Saint John and Christ have been left at a stage quite far from completion and, as J. Dunkerton and E. Buzzegoli have remarked, they could have been added at the final stage. Nevertheless, the lack of any indication is puzzling.

42. We now have a fine discussion of the development of the elevation in Rubin 1991, esp. pp. 55ff.

43. Augustine, *Tractatus in Joannis Evangelium*, XXVI, 13.

44. This episode has been discussed above, p. 14.

45. He is described as Saint John in the *Descriptive and Historical Catalogue* of the National Gallery, 1913, pp. 463–4; the identification was accepted by Holmes 1923, pp. 89–90. The prominence of the breast in the figure is a consequence of a change in the pigment; where the vermilion has turned black we now find a factitious plasticity.

46. See Ragusa and Green 1961, p. 344.

47. The drawing, published by Gould 1951, pp. 281–2, is in Siena, Biblioteca Comunale degli Intronati, Album S.I.4, fol. 40. The head-dress sketched in the drawing, if accurate, would confirm the identification as female. Unfortunately, the copyist seems also to have added inventions of his own (such as a third figure at the distant tomb) and the detail of the extended hand of the Mary on the Virgin's back is suspect (information from Jill Dunkerton following a close examination of the sheet).

48. This was proposed by Smart 1967, p. 847, and accepted in Hirst 1981, p. 589, note 61. The colour of the dress and the long hair support the identification.

49. We find exactly the same number of figures in Botticelli's well-known *Lamentation* now in the Poldi-Pezzoli Museum in Milan. He included Christ's Mother, three Maries (the Magdalen easily identifiable at Christ's feet), Saint John, and an elderly man who holds the crown of thorns and the nails, who could be either Joseph of Arimathea or Nicodemus.

50. Comments of Charles Holmes (1923, p. 90), a great admirer of the painting, are worth quoting here: 'There is undeniably something incongruous in the employment of a figure so robust and dynamic in a scene of which the keynote is sorrow too intense for words. In after years this very subject was to be the one of all subjects which Michelangelo felt most keenly, and of which in sculpture he has left us the most noble and profound realisation [i.e. the *Pietà* in Florence].... Our picture is, so to speak, Michelangelo's "Prix de Rome" composition.' For Michelangelo's technique of scraping away paint along the contours, see the discussion by Jill Dunkerton below; its presence in the *Manchester Madonna* has been alluded to above.

51. For the comparison of the drawing, Casa Buonarroti 73F, with the painted figure, see Hirst 1981, figs. 2–3, and comments on p. 588.

52. A derivation from an antique sarcophagus in the Pisa Camposanto has been proposed by Butterfield 1989, pp. 390–3 (where the identifications of Michelangelo's figures seem confused). The action of this Mary has always presented difficulties because neither her right leg nor right arm are represented. In fact, as pointed out by E. Buzzegoli, the right arm must have been raised to hold the band at shoulder height – close to the knot on the right shoulder. We find Michelangelo adopting this motif in his drawing reproduced in Pl. 53.

53. They are Louvre, Cabinet des Dessins, nos 726 *recto* and 689 *recto*. They have recently been discussed in Hirst 1988, pp. 63–4.

54. The Ghirlandaio study, made for a celebrated painting in the Louvre, is Berenson 1938, II, no. 890B.

55. The sheet is Vienna, Albertina, no. 103 *recto*; see Tolnay, Corpus, II 1978, no. 432, where it is dated much too late. The correspondence of the drawing with the National Gallery painting was already pointed out by the then Director, F.W. Burton, in a letter to *The Times* dated 1 September 1881: of the Vienna drawing he commented: 'however late we may place the drawing, the fact remains that the idea and the *motif* are those of the dead Christ in our picture' (quoted in J.P. Richter, *Italian Art in the National Gallery*, London, 1883, p. 41).

56. This suggestion was made in Hirst 1981, p. 589. Michelangelo probably ordered the lapis he needed from the Gesuati in Florence. He had recourse to the same source before beginning work on the Sistine Chapel ceiling (see his letter to Frate Iacopo di Francesco of May 1508, in *Carteggio*, I, pp. 66). For the Gesuati as suppliers to artists, see Bensi 1980, pp. 33ff., and p. 123 below.

57. Balducci, V, c. 4: '[Michelagnolo di Lodovicho Bonaroti] de'avere addi 27 di febraio [1501] ducati ottanta d'oro in oro larghi fattoli buoni per messer Jachopo Ghallo per li sua marmi li a chonsegnati chome fralloro son d'achordo......ducati 80.' (For a corresponding entry, V, c. 298 *verso*.) The connection with the Siena project was already realised by Giovanni Poggi, and the entry published by Mancusi-Ungaro (1971, pp. 154–5), without appreciating that the money was a loan. This is made clear by a later transaction in January 1506 when Michelangelo reacquired his marble from Gallo's heirs, less two pieces which Jacopo had sold in the meantime to Pietro Torrigiano together valued at eight ducats. For the evidence, see Balducci, XLIV, c. 75, quoted by Mancusi-Ungaro 1971, pp. 166–7, but also Balducci, XXXI, c. 162 *verso* (omitted by Mancusi-Ungaro) which specifically refers to the credit as a loan.

58. The formal contract was drawn up after Michelangelo's return to Florence, in early June 1501. Fifteen marble statues, each a little over 115 cm high, were stipulated; the total payment was to be 500 gold ducats. The sum may have provided for more than the artist's labour and the material for the figures. The altar had been begun by Bregno and his workshop years earlier, but it has escaped notice that the two lowest flanking tabernacles cannot be by Bregno and his team. As will be argued elsewhere, these tabernacles, with their sophisticated dolphin capitals and fluted pilasters, are Michelangelo's own first work in architecture.

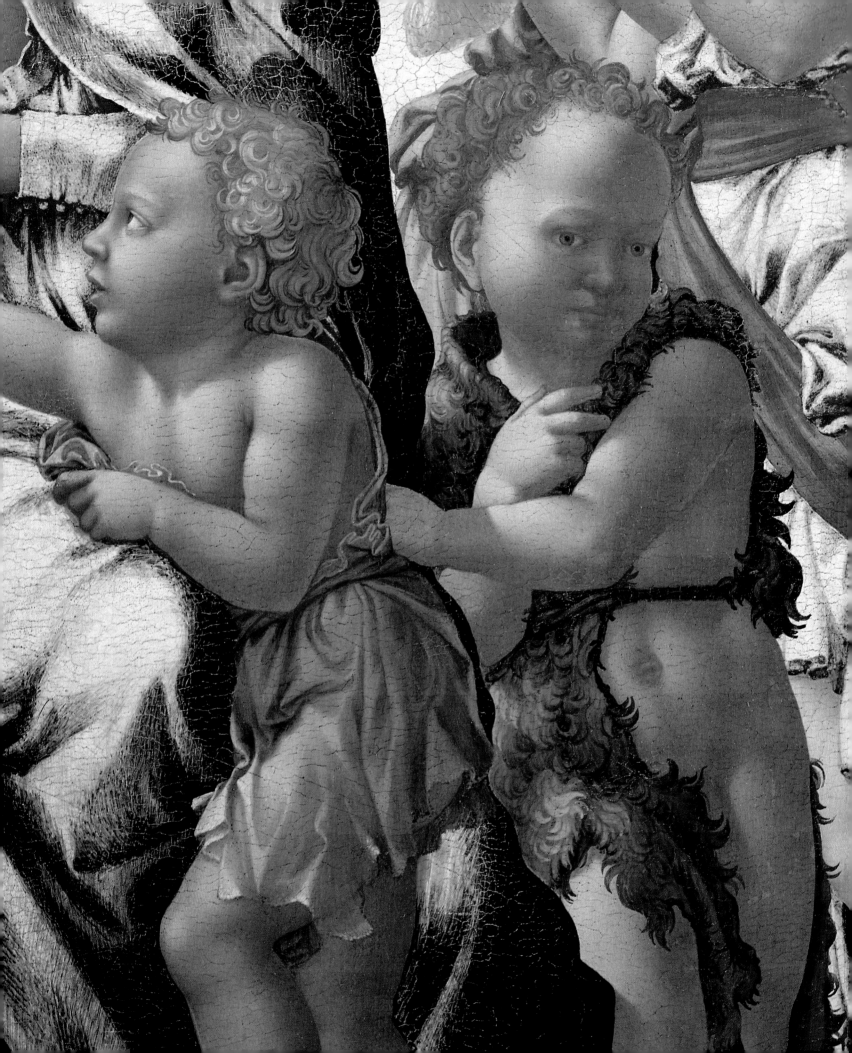

The Painting Technique
of the *Manchester Madonna*

SINCE both the *Manchester Madonna* and the *Entombment* are unfinished and therefore exhibit the means by which they were made, it might be thought that little could be added to our knowledge of their technique by examination with modern scientific and photographic methods. Nevertheless in the 1960s each was the subject of important and indeed pioneering technical studies.[1] Subsequently, however, improved methods of examination, such as infra-red reflectography, have been introduced and more precise and specific analytical techniques adopted by laboratories. In addition, scientific and technical evidence, like historical evidence, continually needs to be re-examined and, if appropriate, re-interpreted in the light of new discoveries. Thus, as the results of the investigation of other paintings of the same period are made available, it becomes more possible to distinguish between those features of an artist's technique which are part of common contemporary practice and those which are remarkable and may be peculiar to that painter. Most important of all for any study of Michelangelo's panel paintings is the publication in 1985 of the cleaning and examination of the *Doni Tondo* (Pl. 125).[2] In these chapters it will be demonstrated how the National Gallery panels, while they can be numbered among Michelangelo's many abandoned projects, are also important stages in the evolution of his painting technique towards the refinement and near flawlessness of the *Doni Tondo*.

Michelangelo and the Ghirlandaio Workshop

The origins of this technical perfection lie in Michelangelo's training in the workshop of Domenico Ghirlandaio. There is now considerable evidence, including the similarities in technique and palette between the frescoes painted by Domenico and his workshop in the Tornabuoni Chapel in Santa Maria Novella, Florence, and those of Michelangelo on the Sistine Chapel ceiling and lunettes (Pls 58 and 59),[3] to indicate that Michelangelo's association with Ghirlandaio was both more extended and more lasting in its influence than the early biographical sources might suggest (see pages 13–14). In any case, by the end of the fifteenth century an apprenticeship is no longer likely to have included the many years of concentration on the craft aspects of painting proposed by Cennino Cennini a century before in his well-known treatise *Il Libro dell'Arte (The Craftsman's Handbook)*, even then probably an ideal not attained in actual practice.[4] Much of Michelangelo's time as an apprentice is likely to have been spent in learning about design and draughtsmanship, skills leading naturally to

OPPOSITE Pl. 57 *Manchester Madonna,* detail of the Christ Child and Saint John the Baptist.

the disciplines of the tempera painting techniques still practised as the principal easel painting method in the Ghirlandaio shop.

 That Michelangelo progressed to painting panels while still attached to the workshop is suggested by Vasari's and Condivi's accounts of his painting of a *Temptation of Saint Anthony*, based on the engraving by Martin Schongauer.[5] Nevertheless, it is likely that most of his experience in painting was gained by observing and assisting in the execution of the several ambitious projects undertaken by the Ghirlandaio brothers in the time that he was associated with them. These included

Pl. 58 Domenico Ghirlandaio and Workshop, detail from the *Birth of the Baptist*, 1486–90. Fresco. Florence, S. Maria Novella, Tornabuoni Chapel.

OZIAS

IOATHAM

ACHAZ

Pl. 59 Michelangelo, *Ozias, Joatham, Achaz*, 1511–12. Fresco, 340 × 650 cm. Rome, Vatican, Sistine Chapel. Both Domenico Ghirlandaio and Michelangelo worked mainly in true fresco (*buon fresco*) and used identical palettes based on intensely coloured red, yellow and brown earth pigments with green earth, lime white and for the blues, smalt and lapis lazuli.

not only the walls of the Tornabuoni Chapel and its great double-sided high altar-piece (Pls 100 and 101), but also other major altarpieces – for the Ospedale degli Innocenti (Pl. 3), the *Visitation* of 1491 for Santa Maria Maddalena de' Pazzi, Florence, now in the Louvre (Pl. 60), and the altarpiece for the Badia di San Giusto near Volterra, now in the Pinacoteca at Volterra. At the same time the workshop was engaged in the production of lesser altarpieces – often apparently with little or no intervention by Domenico himself – portraits, paintings for furniture or to be set in the panelling of rooms, and countless small devotional panels, the most popular designs frequently repeated and adapted, and continuing long after Domenico's death in 1494.[6]

Even when the execution is not Domenico's, the original invention, the controlling mind behind the compositions, whether large fresco cycles or small Madonnas, can usually be shown to be his. If Michelangelo participated in the paint-ing of some of these works his contribution should probably be sought in areas of drapery or in repeats of architectural detail rather than in the design of individual figures. By imposing a uniformly high standard of technical accomplishment and by careful planning involving large numbers of preliminary drawings[7] Domenico ensured that the products of the workshop appear, initially at least, remarkably homogeneous in style and execution. Nevertheless, on closer inspection, it is often possible to distinguish the various hands. In recent years the identity and stylistic traits of several members and associates of the workshop have been more clearly

Pl. 60 Domenico Ghirlandaio and Workshop, *Visitation*, 1491. Panel, 172 × 165 cm. Paris, Louvre. The monumentality of the central group and the disposition and vibrant colours of their draperies are features of Domenico's work that were important for the young Michelangelo.

established; most importantly those of the young Granacci and, in all probability, of David Ghirlandaio, Domenico's brother and business partner.[8]

Although none of the major altarpieces from the Ghirlandaio workshop has been investigated by scientific methods, a panel in the National Gallery, the *Virgin and Child* (Pl. 61), confidently re-attributed to Domenico following recent cleaning,[9] seems representative of the panel painting methods employed in all but the earliest years of his career. In addition, the *Virgin and Child with Saint John* (Pl. 62), now given to David, demonstrates the idiosyncrasies – most obviously, a tendency to left-handed hatching – which enable his contributions to the workshop collaborations to be more readily identified.[10]

Michelangelo later encouraged his biographer Condivi to play down the importance of his training in such a large and efficient workshop, but it can be shown to have had a significant effect on the production of his panel paintings. The description of the panel bought in the summer of 1497, possibly for the *Manchester Madonna* (see page 37), suggests that it had already been assembled by a carpenter and

Pl. 61 Domenico Ghirlandaio,
Virgin and Child, c.1480.
Predominantly egg tempera on
panel, 92.3 × 58 cm (including
modern addition at the top of the
arch). London, National Gallery
(NG 3937).

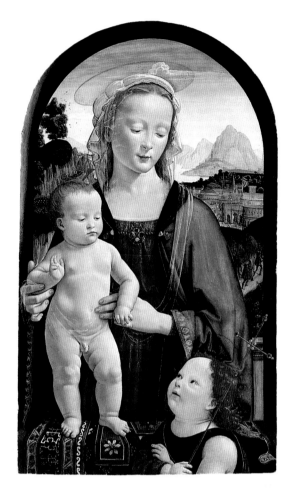

even at this early stage in his independence as an artist Michelangelo probably had some assistance in the routine preparations for painting. (If Piero d'Argenta was also a painter (see pages 41–2), he may have assisted Michelangelo in the production of his panel paintings as well as his sculpture. However, his contribution is likely to have been limited to mundane tasks such as applying and smoothing gesso and grinding pigments.)[11]

The Panel and Ground of the *Manchester Madonna*

The poplar panel of the *Manchester Madonna* is solid (approximately 3.8 cm in thickness – thicker than the much larger *Entombment*) and well-constructed, consisting of one wide vertical board, slightly tapering in width towards the bottom, extended on either side by narrower planks (Pl. 63). This form of construction ensures that potentially vulnerable joins do not run through the most important central part of the composition and that, in the event of warping, the curvature of the panel is likely to be dictated by that of the central plank. The same construction occurs in the panel for Domenico Ghirlandaio's *Virgin and Child*, but it can sometimes be found in other Italian panels. In the case of the *Manchester Madonna* the wood-grain of the central plank is erratic with several knots and flaws which, judging by their opacity in

Pl. 63 *Manchester Madonna*, back of the panel.

Pl. 64 Composite X-radiograph.

Pl. 65 Detail of the right edge showing dribbles of gesso. These confirm that the edges of the panel have not been cut.

X-radiographs (Pl. 64), were filled with a putty, either by the panel-maker or in the artist's workshop before the application of the ground. Despite this precaution they have caused cracking and distortion of the gesso and paint layers, most evident in the Virgin's head-dress, the drapery over her right shin and in the Child's left hand.

The panel was originally reinforced with two horizontal battens, recessed into dovetailed channels (now filled with balsa wood). Apart from the loss of these battens, some woodworm damage and the slight opening up of the joins, especially that on the left (as seen from the front), the panel has survived in good condition and almost unaltered, retaining its original thickness and uncut at the edges. At the upper and lower edges the limits of the composition are indicated by unpainted bands of ground and at all four edges dribbles of gesso can still be seen (Pl. 65). The white smears on the reverse of the panel must come from pools of liquid gesso running off

the edges onto the flat surface upon which the panel was placed. That the gesso was brushed on is confirmed by the discovery, when examining the unpainted areas of the picture surface under low magnification, of several very fine curved and looped grooves about 2–3 cm long, easily mistaken for lines lightly incised into the gesso. Still embedded in one such groove is a hair from the moulting gesso brush (Pl. 66).

When gesso is applied with a brush, rapid and over-vigorous brushing can make the mixture foam, introducing air bubbles. So too can the overheating of the liquid gesso in its pot. The surfaces of the *Manchester Madonna*, the *Entombment* and, to a much lesser extent, the *Doni Tondo*, are pitted with small craters caused by the bursting of air bubbles in the ground. The application of perfect gesso grounds was evidently not insisted upon in the Ghirlandaio workshop since similar air bubbles occur in the ground of Domenico's National Gallery *Virgin and Child* (which is further flawed by wrinkles of the type usually caused when a coat of gesso is applied over previous layers which are not sufficiently dry).[12] In common with the grounds on many paintings of Florentine or Umbrian origin, the gesso of the *Manchester Madonna* consists predominantly of the roasted anhydrite form of calcium sulphate, with a lesser amount of the dihydrate form, either because of incomplete roasting of the mineral gypsum or because some slaked calcium sulphate, Cennino's *gesso sottile*,

Pl. 66 Macro detail of the unpainted gesso showing a hair or bristle from the gesso brush. Craters from air bubbles in the gesso can also be seen, particularly along the cracks.

Pl. 67 Macro detail of the thinly painted area of drapery to the right of Christ's thigh showing fine scratches in the gesso made by an abrasive, probably a fish skin.

Pl. 68 Macro detail of two lines of underdrawing in the drapery immediately above the arm of the angel on the far left. Air bubbles from the foaming of the diluted drawing medium, probably egg tempera, can be seen at the ends of the strokes.

Pl. 69 Detail of the unpainted angel on the left showing characteristic underdrawing.

was used. Were the painting to have been made north of the Apennines (see page 42), unburnt or slaked gypsum of the dihydrate form alone would be more probable at this date.[13] The ground of the *Manchester Madonna* is exceptionally hard and has developed a distinct craquelure, made more marked by the pin-hole effect of the craters. Often a hard and heavily cracked ground can be attributed to a high proportion of glue in the mixture, which with age discolours to a golden yellow, but here the gesso is notably white, both on the surface and in cross-sections.

Close inspection of the surface of the ground reveals several areas of fine scratch marks, best visible on those areas of the Virgin's mantle where they are thinly covered with grey paint (Pl. 67). Although their general direction is random the scratches often run parallel, indicating that the surface of the gesso was polished with some form of abrasive, either pumice or more probably the skin of a fish of the shark family, employed in the finishing of sculptures and plaster, but also traditionally by gilders to ensure a smooth ground for the application of bole and gold leaf. Since few other panel paintings offer such large areas of unpainted or thinly painted gesso for comparison, we are unlikely ever to know whether the ground of the *Manchester Madonna* is unusual in having been polished in this way, the gesso presumably having been first scraped with a straight-edged metal spatula as described by Cennino. Neither Cennino, in his detailed instructions for preparing panels, nor later Vasari, refer to the use of abrasives but it is possible that they were too obvious for mention.[14]

The Underdrawing

Over the gesso is a careful underdrawing. The drawing visible on the unpainted tunic of the angel on the far left (Pl. 69) seems characteristic of the underdrawing of the draperies in general: comparable underdrawing is revealed by infra-red photography which readily penetrates the red lake of the Virgin's dress and the angel on the far right (Pls 70 and 71). In the Virgin's mantle the drawing is obscured by the black of the undermodelling but some drawn contours are visible, for example along its lower right edge. Michelangelo's long, fluent lines were evidently drawn with a

Pls 70 and 71 Infra-red photographs revealing underdrawing beneath the red lake of the Virgin's dress and the tunic of the angel on the right.

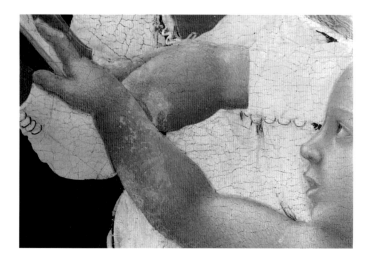

brush and a dilute black paint, probably in an egg tempera medium judging by the air bubbles caused by the foaming of the medium where the paint accumulates at the end of each stroke (Pl. 68). The carbon black pigment, of vegetable origin but not necessarily charcoal,[15] appears identical to that of the black paint of the undermodelled robe (see page 100). The complex drapery folds are rendered with schematic interconnecting curves and hooks and without any shading to indicate volume or the fall of light.

Pls 72 and 73 Infra-red reflectograms showing the underdrawing of the feet and the features of the angels on the left.

In the completed areas of flesh painting the combination of flesh tones and underpainting with green earth (among the pigments more impenetrable to infra-red) means that no underdrawing can be detected, even with the better penetration of infra-red reflectography. However where green earth alone was applied a precise outlining of the limbs with long confident sweeps of the brush is visible with the naked eye, while details such as the angel's toes are clarified by reflectography (Pl. 72). In the heads of the angels (Pl. 73) infra-red reflectography reveals a summary, almost diagrammatic, positioning of their features (the abbreviation of the nose is very like that in some of Michelangelo's drawings on paper), but drawn in sufficient detail to confirm the angels' absorption with one another rather than with the central group.

The assurance and precision of the underdrawing – and the fact that the few pentimenti made during the process of painting are relatively minor – indicate that the design had been rigorously planned. No drawings survive that can be associated with the *Manchester Madonna*, nor is there any evidence on the painting for the trans-

Pl. 74 Domenico Ghirlandaio, *Virgin and Child*, infra-red photograph of the Virgin's dress, showing characteristic underdrawing.

Pl. 75 David Ghirlandaio, *Virgin and Child with Saint John*, infra-red photograph of the head of Saint John the Baptist.

fer of a full-scale cartoon by mechanical means such as pouncing or indentation with a stylus. (There are incisions in the paint and ground but, as will be demonstrated, these were made during the application of the paint layers.) Drawings for the *Manchester Madonna* are likely to have consisted of initial compositional sketches followed by detailed studies for specific areas, with perhaps further compositional studies to clarify the complex relationships between the intertwined groups of figures, and then finally a modello, not necessarily on the same scale as the painting, from which the underdrawing was made. Such a sequence would relate closely to Domenico Ghirlandaio's design process, which can to a certain extent be reconstructed from surviving drawings.[16] In the case of his National Gallery *Virgin and Child* detailed figure studies must once have existed, for the Child reappears in exactly the same pose – but balanced somewhat precariously on the Virgin's knee – in an altarpiece executed by the workshop for the church of San Gerolamo in Pisa.[17] Moreover, the underdrawing of the Virgin's head-dress and red robe, revealed by infra-red examination of the National Gallery panel (Pl. 74), is boldly simplified in a way which suggests it dependence upon a preliminary study. The sketching-in of the landscape details seems more improvised and the underdrawing is not always followed as closely in the painting as that of the *Manchester Madonna*; but the fluid brush technique and the delineation of folds by long curved lines terminating in loops and flourishes is strikingly similar. It should not be surprising to find Michelangelo modelling his underdrawing style on that of Domenico, just as he adopted other elements of his graphic technique (see pages 14–17).

As yet there are few other published underdrawings by Ghirlandaio or the workshop for comparison, apart from *sinopie* of wall paintings and the occasional passage of drawing visible with the naked eye, usually in red lake draperies as in, for example, the altarpieces for Volterra and for San Giusto alle Mura, Florence, now in the Uffizi, and, in fact, the National Gallery *Virgin and Child*. However, the assumption that other members of the workshop are likely to have employed much the same technique is supported by the underdrawing found on the *Virgin and Child with Saint John* attributed to David Ghirlandaio (Pl. 75). Although there are differences, such as the much broader lines – in places almost a wash – used to construct the principal forms, the use of line without shading and the graphic abbreviations for the drapery folds are comparable.

The underdrawing revealed by infra-red reflectography of the tondo of the *Virgin and Child with Saint John* in Vienna (Pl. 24), which has been linked with the *Manchester Madonna* (see pages 38–42), is sufficiently different to raise doubts as to whether its painter was ever associated with the Ghirlandaio workshop.[18] In the tondo the lines of underdrawing are broken and hesitant and in places have a jagged angularity which suggests the use of a quill pen, as well as the brush, to outline the principal forms. These are often revised in a manner consistent with someone attempting to comprehend and enlarge a design not of his own invention. In addition, the shadows of the folds of the blue robe are roughly indicated by diagonal parallel hatched strokes of underdrawing which are quite distinct from the much fuller undermodelling used to establish volume and form in the *Manchester Madonna*. Another feature of the Vienna tondo which seems foreign to Ghirlandaio workshop practice, and in fact to Florentine tempera painting practice in general, is the golden yellow colour of the gesso ground, partly the result of the addition of some ochre pigment but also because of the high proportion of glue in the mixture. Although a monochrome, the Barberini *Pietà* (Pl. 26) – apparently by the same artist as the Vienna tondo – has a yellow-brown undertone which implies that a similar preparation may be present. In the case of the Vienna tondo, cross-sections also show that the ground has been coated with yet more glue to reduce its absorbency, an advisable precaution for oil painting but not necessary for tempera. Both the colour of the ground and the glue layer would not be incompatible with the suggestion that the works were produced by a painter with some knowledge of North Italian painting techniques (see pages 40–1).[19]

The *Manchester Madonna*, on the other hand, has no detectable sealing layer, nor is there an *imprimitura* (a pigmented layer to modify the colour and absorbency of the ground). The slightly grey appearance of the unpainted angels on the left seems to be the result of grease and engrained dirt on the polished surface of the gesso rather than the application of a pigmented wash.[20] Other areas appear cleaner and whiter but this is because the skin-like upper surface has been damaged by a liquid, probably water, which at some time in the past ran down the left third or so of the picture surface (Pl. 76), and, judging by the stains, soaked the back as well. While the

exposed gesso was badly eroded, especially between the heads of the incomplete angels, the areas painted in tempera were more resistant and, in the case of the profile of the angel on the far left, survived virtually undamaged (the tip of his nose may have been marginally reduced). However the water damage evidently caused some flaking – the largest loss runs from the Child's outstretched arm down through the Virgin's lap – and the affected areas of paint sometimes appear slightly blanched because of leaching of the gesso with its water-soluble glue medium up through fissures in the paint film. The rest of the painting is mostly well preserved with only a few scratches and scattered small flake losses. Certain areas have suffered some reduction of legibility, either because of the heavy craquelure or because of the various forms of pigment deterioration and changes in transparency of the paint layers, which are discussed below.

The Flesh Painting

In considering the application of the paint layers of the *Manchester Madonna* perhaps the most immediately remarkable aspect is the piecemeal nature of the execution. Parts of the painting have been brought to virtual completion while others have progressed no further than the preliminary underdrawing. This suggests obvious

parallels with the *giornate* of fresco painting, but may also relate to the ordered partitioning of details and colour areas of altarpieces among members of the Ghirlandaio workshop. In the Santa Maria Novella altarpiece, for example (Pls 100 and 101), it is possible to distinguish at least four if not five separate hands. At his busiest Domenico must have alternated projects, occasionally, for instance, leaving the scaffolding of the Tornabuoni Chapel to insert heads – especially important in the case of his celebrated portraits – and other significant details into the altarpiece for the Innocenti.

The tempera technique, with its hard-edged and precisely defined colour areas, is well suited to this approach and it encourages the completion of a passage of painting in a single session. The rapid initial drying of the medium (by the evaporation of the water) means that there are no delays waiting for layers to dry as in those oil painting techniques based on superimposed glazes. For the same reason, once the egg yolk has been combined with the pigment the paint must be used within hours (depending to some extent on the quantity of paint made up).[21]

Although the Ghirlandaio workshop was not alone among Florentine workshops in its continued use of an essentially egg tempera technique for panel painting, it does seem to have made a particular feature of retaining the traditional green earth underpaint for areas of flesh.[22] The blocking-in of flesh areas with a green under-

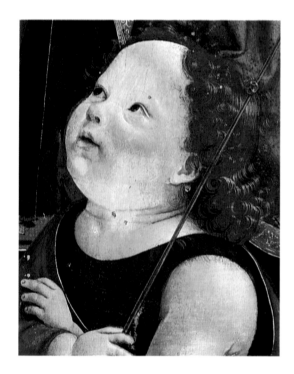

Pl. 79 David Ghirlandaio, *Virgin and Child with Saint John*, detail of Saint John before restoration. The abrasion to the upper paint layers has exposed the green earth underpaint.

Pl. 80 *Manchester Madonna*, detail of the unfinished angels.

paint must have clarified the division of labour in an altarpiece, but Domenico was also able to exploit its optical potential to masterly and economical effect. On the National Gallery *Virgin and Child* (Pls 77 and 78) his typically long, hatched brush-strokes form a rather open mesh which allows the green undertone to play its part; as a warm olive green where thinly covered with semi-transparent brown shading (probably a pigment mixture similar to Cennino's *verdaccio*), for example in the beautifully observed modelling of the Child's belly, or as a cold blue green in the lighter areas, where it adds a pearly quality to the pale, almost white highlights. Over the white are thin touches of pink, based on lead white and vermilion, as opposed to a fugitive red lake, hence the rosy complexions.

The green earth pigment used for the *Virgin and Child* is of the same exceptionally pure blue-green tint, without a trace of brown, as can be seen in Ghirlandaio's frescoes. It is mixed with some lead white, probably as much to improve its covering power as to reduce its saturation. The same green earth can be seen in countless other panels by painters associated with the workshop, including David Ghirlandaio's *Virgin and Child with Saint John* – where the broad sweeps of the brush are particularly evident on the face of Saint John because of the abraded condition of the flesh tones (Pl. 79),[23] Granacci's *Rest on the Flight into Egypt* (Pl. 35) and, of course, the *Manchester Madonna*.

As in the David Ghirlandaio *Virgin and Child with Saint John*, the green earth underpaint of the *Manchester Madonna* is applied with long strokes of a fairly large, loaded brush (Pl. 80). The paint accumulates at the outer edges of the strokes and especially where the brush carefully follows the drawn outlines, giving a sense of volume to these essentially flat areas.[24] At least two applications of colour have been

applied everywhere except over the oddly posed fingers of the angel with his arm on his partner's shoulder. They are thinly washed in, implying a possible lack of commitment to this aspect of the design.

Michelangelo's flesh tones are very much more densely modelled than Domenico Ghirlandaio's so they register relatively strongly in the X-radiograph (Pl. 64). His brushstrokes are shorter and less open, and, where the description of the form demands, are almost stippled. The green earth underpaint is barely evident but still contributes to the optical complexity. Exactly as in Domenico's *Virgin and Child*, the highlights of the paler flesh tones, for example those of the Christ Child (Pl. 57), are built up with lead white made opalescent by the green colour underneath and then slightly tinted with strokes of a warmer pinker hue – almost certainly vermilion with lead white (the flesh is generally too well preserved for the taking of paint samples). The shadowed areas are probably painted with the traditional combination of ochres with white and perhaps a little black. The painting sequence is such that, with the exception of the deepest shadows and some of the contours of the figures, a slightly lighter tone usually passes over a marginally darker one. This produces exceptionally smooth and even transitions from shadow through to highlight (the individual brushstrokes, unavoidable in tempera, only become distinguishable when seen close to).[25] Furthermore, because the strokes of tempera are inevitably thin and therefore translucent, even when containing lead white, the underlying darker tones (and the green earth beneath them) give the final touches a cool, slightly smoky appearance. The effect can be seen in passages of flesh painting in Domenico's *Virgin and Child*; but in the *Manchester Madonna* Michelangelo has exploited it to the fullest possible extent to produce the impression of polished marble so often commented upon in his flesh painting.

Such optical subtlety is easily disrupted by the tendency for tempera paint to become more transparent with age. A diminution of covering power in the upper paint layers may explain the rather dull and grey tinge to the shadows and mid-tones of the Virgin's flesh areas (Pl. 27). The modelling of the ruddier-complexioned infant Baptist seems to have sufferered both from optical changes and from a deterioration and blackening of the vermilion, which has also affected some of the draperies (discussed below). This now makes his features appear vague and unformed, especially when compared with those of Christ. Christ's eyelids, with their centrally placed eyelashes, are depicted exactly as in Joseph's right eye in the *Doni Tondo*,[26] or in Michelangelo's drawing of an eye made much later as an exemplar for a pupil to copy (Pls 81, 82 and 83).

The fine detail and optical complexity of the flesh tones in the *Manchester Madonna* are remote from those of the Vienna tondo, even though the painter of that work also employed a green earth underpaint (Pls 24 and 28). While allowance has to be made for the abraded condition of the tondo, the technique for painting flesh is simple and direct. The harsh and sometimes cross-hatched white and pale pink highlights are barely blended into the brick red mid-tones, and the shadowed areas are

Pl. 81 *Manchester Madonna*, macro detail of the eye of the Christ Child showing the characteristic central placing of the eyelashes.

Pl. 82 Michelangelo, *Doni Tondo* (Pl. 125), macro detail of Saint Joseph's right eye.

Pl. 83 Michelangelo, detail from *Studies of heads and eyes*, 1520s. Red and black chalk. Oxford, Ashmolean Museum.

painted with an almost transparent hot red brown, particularly evident on the legs of the Baptist. Around the contours of his limbs and those of the Christ Child, the flesh is a particularly brilliant pink, suggesting that the green earth underpaint does not extend to the edges of these forms; whereas on the *Manchester Madonna* the underpainting tends to cover a rather larger area than that eventually completed with flesh tints. With the exception of the red of the Virgin's robe, the handling of the paint of the Vienna tondo is quite unlike that of the *Manchester Madonna*. The diagonal strokes of white highlighting on the folds of the Virgin's mantle – also to be seen on the Barberini *Pietà* (Pl. 26) – are directionless, serving only to indicate the fall of light. Nowhere do they define volume.

The Draperies and Background

In the *Manchester Madonna*, on the other hand, the length and direction of the hatched strokes vary and adapt according to the form depicted, just as in Michelangelo's early drawings. On the Virgin's mantle some of the brushwork is quite rough and free (Pl. 84), but this must be regarded as underpainting intended to be completed in blue.[27] Such an extensive black underpainting has not been reported on other Italian panels of the period, but again Michelangelo's use of the

Pl. 84 *Manchester Madonna*, detail of the rock and the Virgin's mantle.

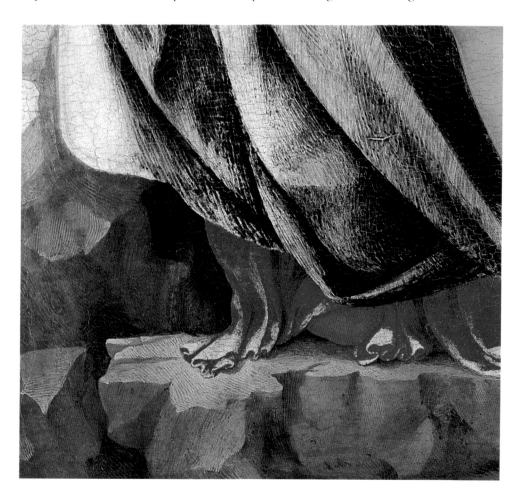

technique may have its origins in the Ghirlandaio workshop. In the damaged areas of the dark blue robe in Domenico's *Virgin and Child* there are indications of a dark blackish-brown underlayer in the shadows, and in infra-red some dark hatched lines can be seen (Pl. 74), although unfortunately the azurite chosen as the blue pigment also registers as dark. Whether the layer can be considered as an undermodelling for this specific colour area, or whether it is just an extension of the underdrawing, it is nothing like as comprehensive as that in the *Manchester Madonna*, which has been built up in the shadows with several applications of tempera paint.[28] A possible explanation for the extent of this underpainting is that Michelangelo, impatient for supplies of blue pigment which may have had to be ordered from specialist suppliers (a problem discussed more fully in the next chapter), used black as a substitute to model up the folds of the Virgin's mantle to their full tonal values so that he could explore the relationship between her drapery and the pose of the Christ Child, rather as he would in a relief sculpture. It can be assumed that the tonality of the blue, whether it was to be ultramarine or azurite (a low grade of which was used to rough in the sky), was to be deep and dark; and, perhaps like that of the Domenico Ghirlandaio *Virgin and Child*, it was to be applied in oil rather than tempera.[29] The folds of the dark green lining of the robe are shaded with black and so must always have been intended to be dark, but some discoloration from a reaction between the paint medium and the natural malachite pigment is likely to have occurred.[30]

Malachite is also employed extensively in the landscape of the *Manchester Madonna* (Pl. 85), sometimes mixed with lead-tin yellow to produce a bright grassy green (very like that in the foreground of the *Doni Tondo*), and then modelled in the foreground with thin layers of a darker green. While there is no certain evidence that this is a 'copper resinate' type of green,[31] it does seem to have discoloured and is therefore no longer so well differentiated from the intentionally brown areas of the foreground and rock. The dark greens and browns are reminiscent of the stratified rock platform of Ghirlandaio's Volterra altarpiece, but the structure of the rocks in the *Manchester Madonna*, faceted with parallel hatched strokes like the marks of a claw chisel, and with the highlights of dense lead pigments, opaque to X-rays, can only be the invention of Michelangelo. 'Copper resinate' which has retained more of its colour can be seen on the belt of twisted vines worn by the Baptist (Pl. 57). Here the glossy intensity of the oil-based glaze contrasts with the more matt and desaturated tempera of the rest of the painting.

The red lake used for the dress of the Virgin and the tunic of the angel on the right (Pl. 85) has some of the transparency and depth of tone of oil paint, and analysis shows that the egg yolk was indeed enriched by the addition of some walnut oil.[32] However, the paint was still an emulsion of oil in water, retaining handling properties closer to those of egg tempera than of oil paint, and the richness of effect is as much the result of the layer structure and method of application. Over an underpaint of lead white applied to enhance the reflective properties of the ground, the folds are modelled with hatched and stippled strokes of pure red lake, containing principally

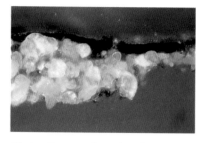

Pl. 85 Cross-section taken from where the hem of the robe of the angel on the far right overlaps the green of the grass, showing a thin layer of red lake over coarsely ground particles of natural malachite. The large, partially rounded particle at the lower right edge of the section exhibits the characteristic banded pattern to be seen on pieces of polished malachite. No gesso is present in the sample. Magnification 160×.

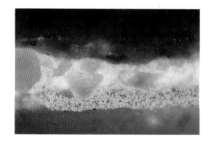

Pl. 86 Cross-section taken from the red and green *cangiante* sash of the angel on the far right, showing natural malachite and lead white over vermilion. A trace of gesso is visible at the bottom of the sample. At the top are residues of old varnish. Magnification 405×.

the dyestuff extracted from lac, a species of scale insect.[33] The relief is achieved by varying the density of the colour, as in the technique of modelling by glazing in oil painting. These draperies must be almost complete since the rims of the buttons on the Virgin's sleeve have been picked out with touches of black paint (visible in infra-red; Pl. 70), but the appearance of the similarly painted draperies in the Vienna tondo (Pl. 24), and in Granacci's *Rest on the Flight into Egypt* (Pl. 35), suggests that the *Manchester Madonna* may lack a final thin application of colour over the highlights. The lake is unlikely to have faded so completely that it has left no trace of this final layer; and the thinner mid-tones do not have the characteristic brownish tinge which indicates that some loss of colour has almost certainly occurred, as is the case with the Vienna picture. While the optical properties of the tempera medium mean that the lake can never be as transparent as when in oil, the method of application on these panels was evidently intended to come closer to the richness of oil painting, avoiding the colder, chalkier effects produced by modelling through an admixture of lead white as in Domenico's *Virgin and Child* (Pl. 61). However, Domenico also painted red lake draperies by modulation of the pure pigment, for example in the Virgin's dress in the Santa Maria Novella altarpiece (Pl. 101), presumably to imitate the depth and intensity of Netherlandish paintings, which he clearly admired.

Michelangelo's frequent use of brilliant golden yellows must also come from Ghirlandaio: indeed the modelling of the yellow robe of Saint Elizabeth in the Louvre *Visitation* (Pl. 60) exhibits the variety of hatched and stippled brushwork to be seen in Michelangelo's own tempera painting. In the angel's tunic in the *Manchester Madonna* (Pl. 2) the pale yellow pigment, lead-tin yellow, is applied over an underlayer of an exceptionally intense yellow earth,[34] and then shaded with more yellow earth, and in the shadows, with the opaque red pigment vermilion to obtain a *cangiante* (literally 'changing') effect in imitation of a shot-silk fabric. Unfortunately much of the original colour contrast is lost through the surface blackening of the vermilion. In Florence the *cangiante* textiles popular in the later fourteenth century, and described by Cennino, never quite died out; they occasionally occur in paintings from the Ghirlandaio workshop, including the same yellow and red or pink combi-nation – also favoured by Perugino and later by Raphael – but they seem relatively timid when compared with Michelangelo's originally vivid hues and contrasts. These anticipate both the brilliant yellow mantle of Joseph in the *Doni Tondo* (Pl. 125) and some of the draperies in the Sistine lunettes. Bolder still and even more prophetic of his later frescoes (for example the Aminadab lunette) is the sash of the angel on the right, where the vermilion is highlighted with a pale green, composed of malachite and lead white (Pl. 86). Again much of the intended effect is lost by the discoloration of the vermilion to a dull purple grey that can easily be misinterpreted as some form of underpainting.

Since the palette of the *Manchester Madonna* both reflects that of Ghirlandaio and looks forward to Michelangelo's later works, it is tempting to suggest possible colour combinations for the unpainted angels on the left. More of the cool blue-green hue

of malachite might have been intended, while another typical colour notable by its absence is the soft lilac purple, in fresco known as *morellone*, when it is based on a form of iron oxide, but in easel painting more likely to consist of a combination of lead white, red lake and a blue pigment – either ultramarine for a reasonably true purple or the greener blue pigment azurite to make a duller more maroon colour. If this were the case, the difficulties in obtaining blue pigment suggested by the unfinished state of the sky and the Virgin's robe may partly account for the decision to reserve these figures. To balance the angels on the right, touches of red and perhaps also yellow might be expected, perhaps as a sash or ribbon, or as further *cangiante* effects. The possibility of some gilded decoration cannot be excluded, either in discreet touches of shell gold, as on the ribbons in the hair of Christ and round the shoulder of the Virgin in the *Doni Tondo*, or more prominently in the form of the mordant gilding to be seen on the works by Domenico and David Ghirlandaio, Granacci and the painter of the Vienna tondo.[35] A decorated hem or border like that to be seen on the Bologna *Saint Proculus* (Pl. 9) would relieve the dark tones of the Virgin's mantle and some gold embellishment of the ornament at her forehead might have been intended. Gilded haloes, however, are unlikely, especially as they would probably have been indicated in the underdrawing as they are in the Madonnas by both Domenico and David Ghirlandaio (for example, the Baptist's halo in Pl. 75).

Even if the order of painting was to some extent dictated by pigment supplies, it is surprising to find a painter known to be right-handed apparently choosing to begin on the right. Nevertheless, the *giornate* of the *Last Judgement* show that Michelangelo, having first painted the left and right lunettes, then proceeded to work back across the upper section of the main wall from right to left. Examination of the surface of the *Manchester Madonna* in raking light reveals the order of application of the colours, and the scraping out of some of the outlines and pentimenti, an unusual feature noted in the previous publication on the technique of this painting.[36] The alterations are slight and generally concern the reduction of a form or outline. In the case of the Virgin's right hand where an over-large area of green earth was applied, the correction is made with a thin layer of lead white paint. Similarly an earlier outline of Christ's profile (Pl. 57) has been eliminated by covering it with the lead white used as an underpaint for the red lake of the Virgin's dress. The rather approximate nature of this first profile and the fact that its density in the X-radiographs (Pl. 64) is about equivalent to that of the green earth underpainting of the unfinished angels suggest that this correction was again no more than the covering of excess green earth. On Christ's left hand, however, where the index finger was originally extended, the green earth, already covered with a thin application of flesh paint, was scratched and scraped away (Pl. 57). The bunched drapery above his hand is an afterthought, appearing over the undermodelled folds of the Virgin's mantle and, of course, his entire grey tunic is painted over the fully modelled form of his naked body, beautifully exploiting the translucency of the tempera technique. The intimate and more

or less simultaneous working up of the figure of Christ and the draped folds over the Virgin's legs is confirmed by a slight adjustment at the back of his thigh where the green earth is covered with at least the first application of flesh tint, but is then in turn covered with the thin grey paint of the undermodelling of her mantle.

To ensure a crisp outline to the Virgin's mantle, lines were scored into the paint and ground, pushing back and scraping off excess paint where it meets her neckline (the flesh, as seems to have been the general rule, was already completed; Pl. 87), and, more evidently, down the entire length of the right edge of her drapery (Pl. 88). Here the deep depression with multiple incisions and occasional short nicks and grooves at right angles to the general direction of the contour indicate that a small knife was used to carve out the profile, paring off any paint that had encroached from the right-hand group and digging deep into the gesso. The black of the under-painting was then applied up to this carved edge, producing the rhythmical line and strong contrast of dark profile set against lighter forms to be seen in Michelangelo's later paintings.

The need to scrape out the contours of the mantle implies that much, if not all, of the figure of the Baptist had been painted, and with him probably most of the two angels. The exception is the red lake of the angel's tunic, which in places clearly overlaps areas of flesh and the green of the landscape (Pl. 85). The colour has been stippled carefully around the curls of Saint John's pelt and a small touch added to the right of his eye. The tunic was probably painted at the same time as the Virgin's

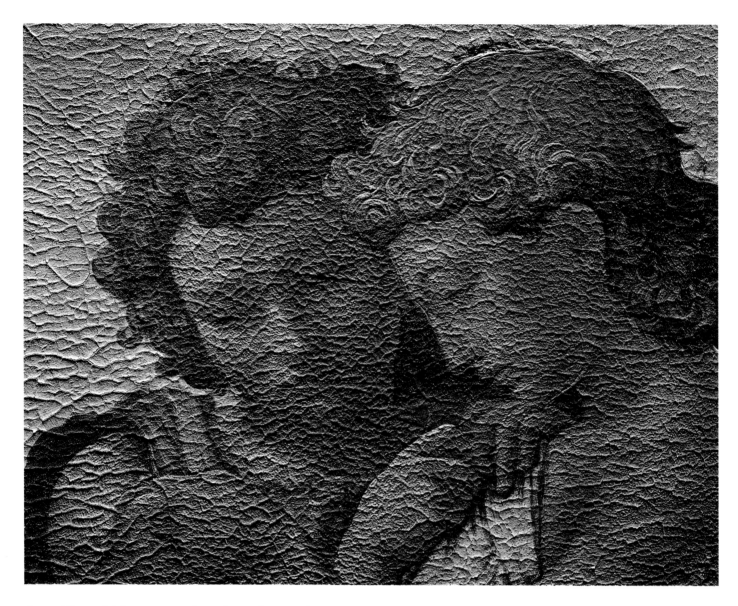

dress. The red lake seems to have been the penultimate colour to be applied to the draperies, the last being the dark malachite green lining of the mantle. The lac pigment identified was expensive and may not have been easily obtained.[37]

 Around the heads of the angels more incisions were made to scrape back the azurite of the sky (Pl. 89). The poor quality of the pigment (now so discoloured that it is almost indistinguishable from the green earth) and its broad and streaky application suggest that it can only have been intended as an underpainting, either for more azurite or for ultramarine, depending most probably on the pigment chosen for the Virgin's mantle. It is therefore curious that the wisps and curls of the angels' hair are so carefully and fully painted. In their sculptural quality these curls, and those of the children, are remarkably like the ringlets of the Christ Child in the *Doni Tondo* (Pl. 90), particularly when seen in raking light, which reveals a slight three-dimensional relief in the build-up of the paint, so structured and consistent is the modelling.

Pl. 89 Detail photographed in raking light of the angels on the right, showing the scraping and incisions around their heads, and along the profile, eyelids and brow of the angel on the right. The painting of the hair can be compared with that in Pl. 90.

Pl. 90 Michelangelo, *Doni Tondo* (Pl. 125), detail of the Christ Child photographed in raking light, showing the precise outlines and crisp painting of the curls of his hair.

Pl. 91 Michelangelo, detail photographed in raking light of the putto lighting the lamp of the *Erythrean Sibyl* on the Sistine Chapel ceiling, showing reinforcement by incision of outlines previously transferred by pouncing.

The fine incisions delineating the eyelids and brow of the angel in profile appear white in the X-radiographs, indicating that they were made at an early stage and then partially filled with paint opaque to X-rays. They have been lightly indented, either into the green earth or, more probably, into the gesso to reinforce the underdrawing, so as not to lose the features under the green earth as has happened with the two angels on the left. The absence of similar lines on the unfinished angels, and indeed elsewhere on the painting, means that they are unlikely to be associated with the transfer of a cartoon. On some of the heads on the Sistine ceiling outlines and features already transferred by means of pouncing are similarly reinforced with lines scored into the wet plaster (Pl. 91).

Even the profile of the angel was sharpened by incision and by scraping off excess paint before the space between him and his companion was filled with a purple-grey colour, and some more curls added over the grey. The components of this grey, a mixture of lead white, black and red lake, are exactly those of the feathered wing at the right edge of the painting and the area presumably should be read as the other wing. However, its illogical position and the fact that it seems to have been painted at a late stage suggest that it was coloured in this way as much to set off the remarkable profile, providing a more effective contrast than a light-toned sky.[38] Details such as this and the apparent indecision concerning the junction between the grass and the sky indicate Michelangelo's problems in reconciling a figure group conceived as if it were a sculpted relief with a natural, if non-specific, landscape setting. Whatever the reason for the abandonment of the painting, for him it may have been something of a release.

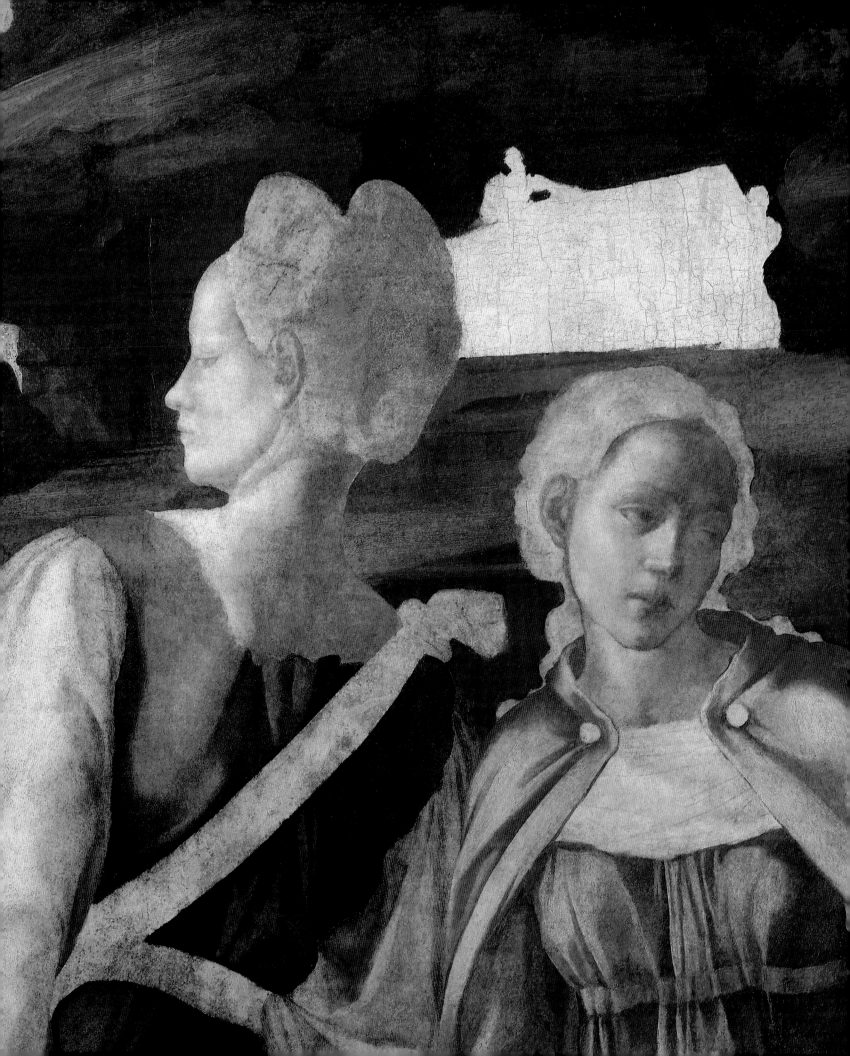

The Painting Technique
of the *Entombment*

Whether the *Manchester Madonna* is the panel paid for in 1497 and there-fore separated from the *Entombment* (Pl. 42) by only three years, or whether it dates from slightly earlier in Michelangelo's career, the differ-ence in technique and handling between the two paintings appears at first sight to be radical, and not merely because the *Entombment* is painted in oil. Indeed, it can be shown that in his wall paintings Michelangelo's technique changed and evolved both within the span of the Sistine ceiling and also from the ceiling to the *Last Judgement*.[1] Yet on closer inspection the *Entombment* reveals its links with the *Manchester Madonna* and, in some perhaps unexpected ways, with the paintings of Ghirlandaio. At the same time it anticipates many features of the *Doni Tondo*.

The Panel and Ground

Like the panels for Michelangelo's other two paintings the support for the *Entombment* (Pl. 93) was constructed with care.[2] It consists of three vertical planks of poplar, 3.4 cm thick and of varying widths, the widest extending from the left edge to the join, now opened up, which runs through the central group of Christ and Joseph of Arimathea. The second join falls beneath the figure of the Mary who supports Christ. Although the upper part of this join has opened and was conse-quently secured with butterfly keys the remainder can be detected on the surface only when viewed in raking light, or in the X-radiographs by the lack of continuity in the grain of the wood (Pl. 94).[3] The panel was reinforced with two battens inserted into horizontal dove-tailed channels, the channels tapering slightly so that they are narrower at the right edge (as seen from behind). The battens remained until about forty years ago when they were removed to treat the open join.

Given that battens are usually symmetrically placed, measurements between the battens and the upper and lower edges indicate that the lower edge has probably been cut by some 5–6 cm. The other edges are definitely uncut, exhibiting the same overhanging lips and dribbles of gesso to be seen on the *Manchester Madonna*.[4] This accords with the drawing in Siena made after the altarpiece (Pl. 50), which shows the hem of the kneeling Mary clear of the lower edge and indicates with a faint line indented with a stylus the upper edge of the composition as it appears in the painting.[5]

Planks as large as those used for the *Entombment* do not come without flaws. Some knots seem to have been filled with a putty (not to be confused in the X-radiograph with the Borghese inventory number and the vermilion-containing

OPPOSITE Pl. 92 *Entombment*, detail of the two Maries on the right.

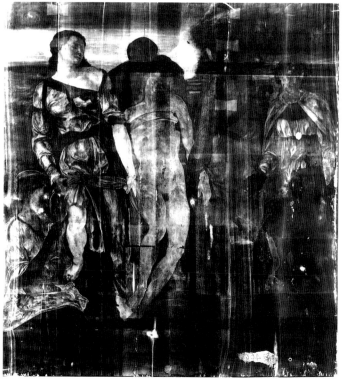

seals on the back of the panel), and one at the lower edge of the right-hand plank was cut out by the panel-maker and plugged with a block of wood on the front face of the panel. Running up from the lower edge of the largest plank on the left is a long wedge-shaped insert, so skilfully fitted that it is difficult to distinguish on the back of the panel, but it can be detected in the X-radiograph, its apex level with the kneeling Mary's elbow.

Also towards the lower edge and positioned almost exactly in the centre of the panel are two cylindrical wooden plugs, one above the other. They appear as shallow depressions on the surface of the painting and their opacity in the X-radiographs indicates that they were always slightly recessed, needing an extra thickness of gesso to fill them. While their function is not immediately evident their central position is unlikely to be a coincidence. Possibly the plugs originally projected out from the back of the panel and were intended to be dowelled into some form of vertical support behind the altar.[6]

The ground, like that of the *Manchester Madonna*, contains a mixture of the roasted anhydrite and dihydrate forms of calcium sulphate, but cross-sections (Pl. 95) show that this time it has been sealed with a coat of glue to prevent the absorption of oil from the subsequent paint layers. Furthermore, most, but not all, colour areas were thinly primed with lead white in egg tempera: the medium has been identified by analysis,[7] but is also recognisable under magnification by characteristic air bubbles from the foaming paint. A lead white *imprimitura* intended to seal the ground and to increase its reflective brilliance is reported on the *Doni Tondo*,[8] but similar layers,

Pl. 93 *Entombment*, back of the panel, photographed in 1952 before the removal of the battens. The butterfly keys have been added by restorers to reinforce the splits and joins.

Pl. 94 Composite X-radiograph.

Pl. 95 Cross-section from the mantle of the Mary kneeling in the lower left corner, showing the gesso ground, sealed with an application of glue size (there may also be a few particles of carbon black underdrawing), and the lead white *imprimitura*. Over this is the paint layer, discussed on p. 121. Magnification 160×.

often applied selectively to certain colour areas, are present on many Italian oil paintings of this period, both from Florence and central Italy, and from Venice.

The voids and craters in the ground caused by air bubbles in the liquid gesso (Pl. 97) may be partly responsible for the problems of condition which later affected the painting. The open structure was ideal for the spread of mould: a microphotograph of the ground (Pl. 98) shows the voids criss-crossed with the branching filaments and fruiting bodies of the long-dead mycelium. The *Entombment*, as an unfinished and therefore probably unvarnished painting, must have been particularly vulnerable to mould attack in its early years, especially as it may initially have been stored in damp dark conditions. The thousands of dark brown spots which disfigure the paint surface are not fly excreta as originally proposed, but the residues of a mould which seems to have fed on the wood of the panel as well as the glue in the ground.[9] To make matters worse, an early restorer seems to have tried to scrape off the spots, sometimes just removing the upper layers of paint, but more often digging small holes and pits into the gesso (Pl. 96).

The entire paint surface is abraded with scratch marks indicative of some form of mechanical cleaning, for example with pumice, powdered brick, or one of the other alarming materials recorded in early manuals on picture cleaning.[10] This was probably an attempt to remove or reduce the layers of unpigmented oil which have been brushed over the paint surface, intended, perhaps, as a treatment to contain the outbreak of mould. Unpigmented oil films dry very slowly and therefore dust and soot are attracted to the tacky surface, building up into the patchy brown-grey deposit to be seen over much of the *Entombment* and present as a distinct layer in many of the paint samples.[11] These deposits, their unevenness exaggerated by past efforts at their removal, and the extreme deterioration and discoloration of some of the pigments (discussed below, pages 119–23) can give a misleading impression of both the technique and the palette employed for this painting.

The layers of oil and embedded dirt are most easily misinterpreted in those areas where no colour has been applied. It has been claimed that a thin monochrome undermodelling is present, either over, or incorporated into the *imprimitura* layer. In fact the *imprimitura* is pure white (Pl. 95), and the impression of modelling is entirely caused by the accidental distribution of dirt, even when the 'modelling' appears as convincing as it does on the shoulders of Joseph of Arimathea. The presence of this sooty deposit over almost the whole surface of the painting, with its widely varying degrees of finish, confirms that it is a later accretion and cannot be part of the original layer structure.[12]

The Underdrawing

The confusing condition of the painting also affects the identification and interpretation of the underdrawing: for example, it is difficult to determine whether the broken black lines in the head-dress of the Mary supporting Christ (Pl. 92) are part of a sketchy underdrawing made with charcoal or black chalk or whether they are

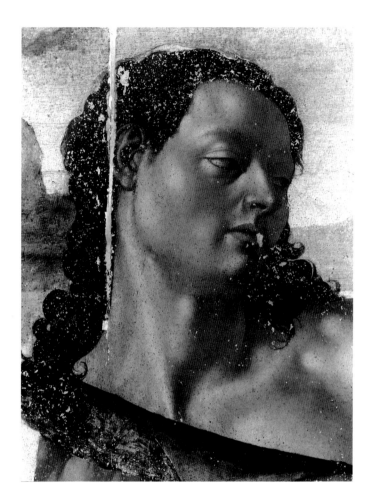

simply accidental marks. There are hints of a horizontal band across the back of her head, which might suggest that this detail in the drawing in Siena (not, as we shall see, always to be relied upon; Pl. 50) is reasonably accurate, but it may have been drawn with a knowledge of the similar head-dress with crossed bands which later appears on the figure of Judith on the Sistine ceiling and then on a female figure in the *Last Judgement*. Definite lines of underdrawing, faithfully recorded but probably augmented and embellished in the drawn copy, can be seen in the unpainted areas of the scarf across the chest of the Mary on the right, presumed to be the Magdalen (Pl. 92), on the robe or cape of Joseph of Arimathea (Pl. 49), and faintly in the rolled fabric around the waist of Saint John. Infra-red examination reveals a few more lines in the pink sleeves and skirt of the Mary supporting Christ (Pl. 99), and outlining her feet, but everywhere else the paint layers proved impenetrable to infra-red. Even where the drawn lines are covered only by the white *imprimitura* they appear faint because of the dilution of the drawing material, which, like that of the *Manchester Madonna*, appears to be a watery black paint pigmented with a vegetable black. On the evidence of the drawing that can be detected the general approach is similar to that of the *Manchester Madonna*, the principal contours defined and the main drapery folds established with long fluid strokes of the brush. Just as we must assume that all

Pl. 96 Detail of Saint John the Evangelist, photographed in 1968, after cleaning and before restoration, showing dark spots where the paint has been stained and corroded, almost certainly by the mould attack, and white spots of exposed gesso, probably the result of past attempts to scrape off the stains. This area is fairly typical of the general condition of the paint surface.

Pl. 97 Scanning electron micrograph of a sample of ground showing the pits and craters in the aerated gesso. Magnification 65×.

Pl. 98 Scanning electron micrograph of a sample of ground showing the filaments and fruiting bodies of the mycelium of an old mould growth. Magnification 2,400×.

Pl. 99 Infra-red photograph of the sleeve of the Mary who supports Christ, showing a few faint lines of underdrawing to delineate the folds.

the figures in the *Entombment* were outlined on the gesso, so it is hard to imagine that the *Doni Tondo* was painted without a careful underdrawing: the failure so far to detect any such underdrawing in the *Doni Tondo* is perhaps explained by the difficulties in recording the drawing in the *Entombment*.[13]

Michelangelo and Oil Painting Techniques

Conversely, to understand the method of paint application of the *Entombment* and to estimate the extent to which each area is finished and the final effect probably intended it is necessary to make frequent reference to the *Doni Tondo*. Paint samples from several different colours in the *Entombment* were all found by analysis to be bound in linseed oil,[14] and the *Doni Tondo*, although so impeccably preserved as to make sampling impossible, is also believed to be predominantly, if not entirely, in oil.[15] However the way in which Michelangelo employed the oil medium is very different from the essentially Netherlandish techniques adopted by many of the first and second generations of Italian painters to use oil (in particular the Venetians, but also Perugino, especially in paintings of the 1490s such as his panels for the Certosa di Pavia, now in the National Gallery, London, NG 288).[16] Instead of achieving relief by building up transparent glazes of varying thickness over a lighter and more opaque underlayer generally related in hue to the glaze, allowing each layer to dry before applying the next, Michelangelo modelled his forms by blending his shades into one another while they were still wet (or, strictly speaking, before the paint had set). As in tempera painting, tonal variation is obtained by the admixture of white or other light-coloured pigments. Glazes are reserved for the deepest shadows or for specific colour effects. This more opaque use of oil paint, which produces noticeably denser X-ray images, particularly in areas of flesh painting, first appears, in Florence at least, with Antonio and Piero del Pollaiuolo.[17] Similar effects can be seen in the oil paintings of Signorelli and in the earliest works of Raphael, before his technique became influenced by that of Perugino, but there is no reason to believe that in the possibly very short interval between the *Manchester Madonna* and the *Entombment* Michelangelo had much contact of a practical nature with other painters, occupied as he was with obtaining the marble for the *Pietà* and then carving it.

However, it is probably not necessary to suppose any current association with other painters working in oil to explain this difference in technique. Judging by a surface examination of those panels of Ghirlandaio's altarpiece for the Tornabuoni Chapel now in Munich (Pls 100 and 101), one of the painters who assisted in its execution used oil paint in a manner remarkably similar to that seen on the *Entombment* and the *Doni Tondo*. Smoothly blended tones very different from the hatched tempera technique of most of the altarpiece can be seen on the foot of the Baptist and on the whole of the figure of Saint John the Evangelist (Pl. 102), with the exception of the magnificent head, which is surely by Domenico himself (Pl. 103). The same metallic folds and fused technique, albeit less carefully executed, especially in the wet-in-wet painting of the marbled architecture, appear on the *Saint*

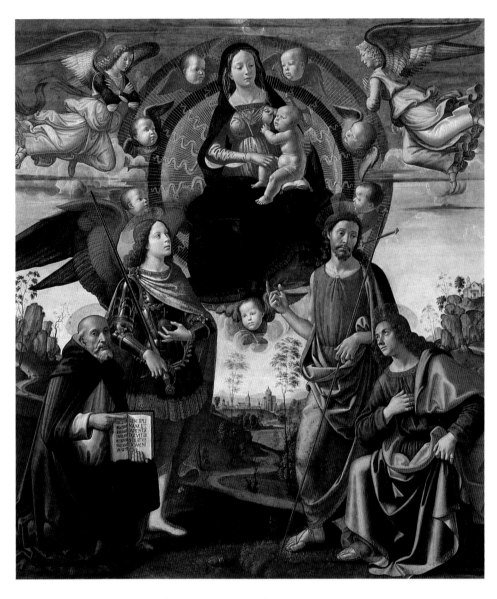

Pls 100 and 101 Domenico
Ghirlandaio and Workshop, *Saint
Catherine of Siena* (left) and the *Virgin
and Child in Glory with Saints* (right),
from the high altarpiece of S. Maria
Novella, completed by 1496. Panel,
211.5 × 56.8 cm and 221 × 198.2 cm.
Munich, Alte Pinakothek.

Catherine of Siena, one of the panels probably on the side piers of the altarpiece (Pl.
100).[18] In turn there are similarities between this figure and a panel showing *Saint
Lucy and a Donor* still in Santa Maria Novella and attributed by Vasari to Benedetto,
the third Ghirlandaio brother.[19] Vasari was well informed on the Ghirlandaio family
and there is no reason not to believe his statement that Domenico's principal collab-
orators on the high altarpiece were his brothers David (whose contributions to the
Munich panels can also be recognised)[20] and Benedetto. The latter is thought to
have returned from France in 1493, his experiences there perhaps leading him to
favour the oil technique. If, as seems likely, Michelangelo maintained contact with
the Ghirlandaio workshop while frequenting the sculpture garden at San Marco (see
page 14), he may have acquired some familiarity with the oil medium at this early stage
in his career, and, on receiving the commission for the *Entombment*, took it up in the
hope of achieving in paint something of the perfection of finish of the marble *Pietà*.

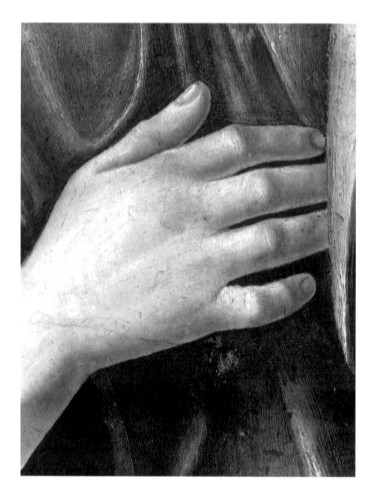

Pls 102 and 103 Details of the hand and head of Saint John the Evangelist from Pl. 101, showing blended tones which suggest the use of oil paint on the hands, and the hatched strokes characteristic of egg tempera on the head.

An oil painting technique developed in this tempera-based context would also account for the fragmentary execution of the *Entombment*. Like the *Manchester Madonna,* some colour areas were left untouched while others are on their way to completion, yet compared with that work the painting order of the *Entombment* often seems inexplicably random. The opposite approach, and one perhaps more typical of oil painting in late fifteenth- and early sixteenth-century Italy, is that exemplified by the paintings left unfinished by Raphael when he left Florence for Rome in 1508, the *Madonna del Baldacchino* (Florence, Palazzo Pitti) and the little *Esterházy Madonna* (Pl. 104). In these the whole composition was worked up gradually and evenly, each colour area having been left in a more or less similar state of incompleteness, the flesh painting if anything less fully modelled than the draperies.[21]

The Flesh Painting

In the case of the *Entombment*, as with the *Manchester Madonna*, Michelangelo seems to have given areas of flesh precedence over the draperies and much of the landscape detail. Yet a comparison between the most highly finished heads and limbs, and especially the figure of Saint John the Evangelist, and the principal group in the *Doni Tondo* (Pls 105–8), indicates that, even allowing for the inequality of condition and

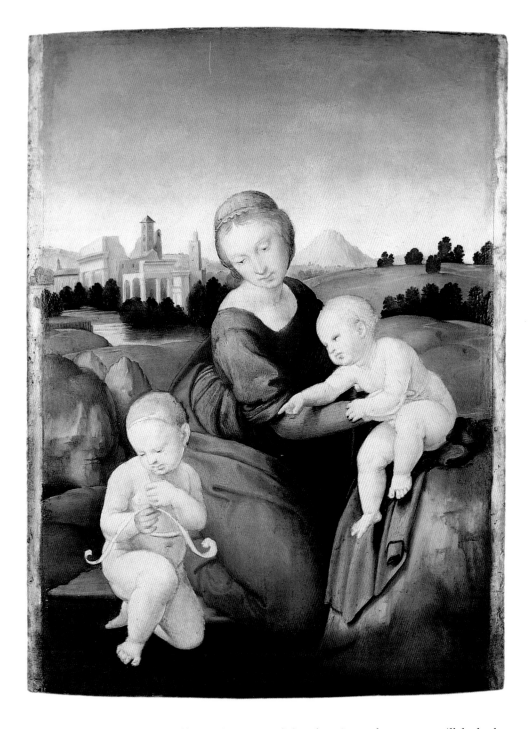

Pl. 104 Raphael, *Esterházy Madonna*, 1508. Panel, 28.5 × 21.5 cm. Budapest, Szépmüvészeti Múzeum. Unlike the piecemeal execution of Michelangelo's panel paintings, the whole composition was worked up gradually and uniformly before it was abandoned.

for the greater size and different location of the altarpiece, these areas still lack the final touches which would have refined and sharpened the detail and also increased the sense of volume by intensifying the depth of tone in the shadowed areas. A paint sample from the edge of Saint John's shoulder shows what appears to be a single layer of lead white with ochre and a little vermilion, but the opacity of this figure in the X-radiographs (Pl. 94) indicates that a considerable density of lead-containing paint was built up. The sequence of pre-mixed shades was probably applied in a rapid and

Pl. 105 *Entombment*, detail of Saint
John the Evangelist.

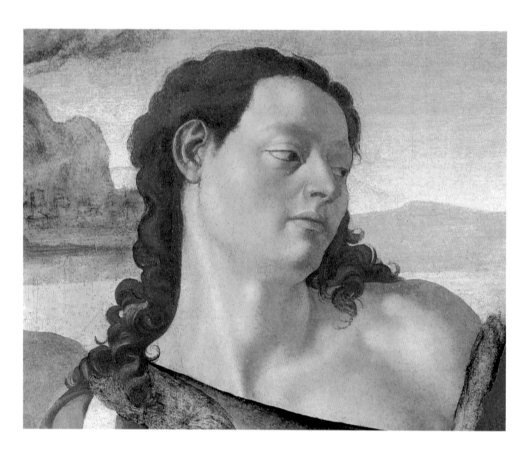

Pl. 106 Michelangelo, *Doni Tondo*
(Pl. 125), detail of the Virgin.

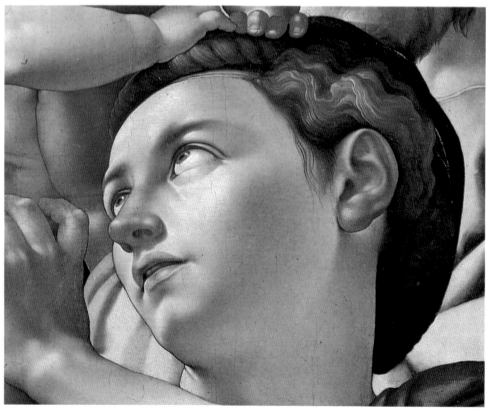

Pls 107 and 108 Details of the feet in the *Entombment* (left) and the *Doni Tondo* (right).

concentrated manner so that there is fusion not only as tone blends into tone, but also between the first application and any subsequent layers laid over it, making them appear as one in a cross-section. The flesh painting of this figure shows few signs of brushmarks, and in that of the *Doni Tondo* there is even less indication as to how the tones were so perfectly united. Perhaps a soft dry blending brush was employed: such brushes are known to have been in use by the seventeenth century.[22] That the essential modelling of the saint's head and shoulders is complete is suggested by the superimposition of the locks of hair over the already dry paint of his shoulder. Other curls are roughed in over the flat red-brown base colour but again lack the definition of those in the *Doni Tondo*.[23]

The head of the kneeling Mary (Pl. 119) is much damaged but seems to have been left only slightly less finished than the Saint John. This makes Michelangelo's failure even to begin the arm all the more puzzling given that we know that a figure study had been made (Pl. 52). Her features, with the characteristic positioning of the eyelashes (Pls 81–3), and details such as her earring with its cast shadow, are established, but this is also the case for the heads of Joseph of Arimathea (Pl. 49) and the other two Maries (Pl. 92), which have received no more than a first lay-in of colour. They appear pale and insubstantial in infra-red photographs, which accentuate the different levels of finish in the flesh painting (Pl. 109), and are almost transparent in the X-radiographs (although with Joseph it should be pointed out that the flesh of

older men is often painted with less lead white and therefore registers less strongly). In addition the paint surface does not yet have the smooth finish of Saint John. Brushmarks and, in the foot of the Mary supporting Christ, fingerprints (Pl. 110) are clearly visible.[24] With his training as a tempera and fresco painter, Michelangelo evidently thought about form, modelling and even expression right from the first brushstrokes.

The cold, apparently greenish flesh of Christ looks very unlike the vermilion, ochre and lead white combination used for the living figures. The distinction is achieved not by underpainting with green earth nor by adding green or blue pigments such as azurite or malachite, as in some Italian paintings of this period, but by optical means reminiscent of certain effects in the *Manchester Madonna*. In samples the flesh colour can be seen to consist of lead white lightly tinted with the same pigments as the other figures but applied over a much darker undermodelling of red ochre and lead white (Pl. 112), often visible where only the upper paint layer was damaged by the mould attack and in particular around the contours of the limbs. Here Michelangelo very carefully and deliberately painted the upper colour not quite up to the edges of the undermodelling – which he had previously sharpened by incision – so that the contours vibrate with a distinct red-brown aura (Pls 111 and 107).[25] In several areas it is evident that the upper paint layer was worked into the lower while the latter was still soft, melding the colours and introducing some of the warmth of the undercolour to the paint mixture. Towards the highlights, where the

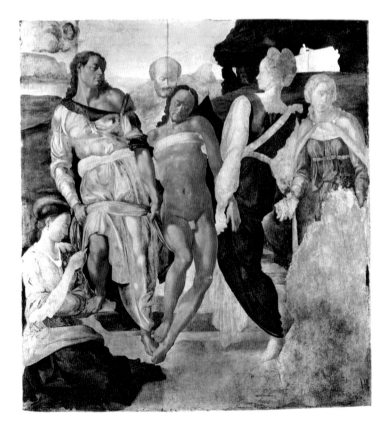

LEFT Pl. 109 Infra-red photograph of the *Entombment*.

ABOVE Pl. 110 *Entombment*, detail of the foot of the Mary who supports Christ, showing fingerprints and brushmarks.

Pl. 111 Detail of Christ's legs photographed in raking light, showing the scraping and incising of the outlines.

paler upper colour is allowed to lie over the undisturbed darker underpaint, a cool pallor results.[26]

For all the superb illusion of relief, Christ's body is still relatively limited in its tonal range and more work was surely intended. The hair is only blocked in and the junction with Joseph's hands left unresolved. Joseph's hands may have been reserved in this indistinct way, looking like mittens, because they were to be depicted wrapped in fabric – possibly the same pale pink as the band across Christ's chest – so as not to touch the body.[27] Christ's wounds and blood could also have been superimposed at a later stage, although Michelangelo might perhaps have been expected to indicate the wounds by some disruption to the smooth modelling of the flesh. In addition, the painting of his genitals was abandoned half-finished, the brushstrokes of the upper layer petering out over the thin red-brown undermodelling (Pl. 115), leaving a clotted and frayed edge that can also be seen at the ends of brushstrokes on the *Doni Tondo* (Pls 113 and 114). However, the enamelled surface of the *Doni Tondo* shows no sign of the comb-like marks occasionally visible in raking light on the *Entombment*, for example in the unpainted part of Christ's genitals and along his groin and particularly in the distant mountains (Pl. 121). The grooves appear too regular and widely spaced for a stiff dry brush and suggest that Michelangelo may have employed a carving or modelling tool with some form of serrated edge to work the soft paint.[28]

Pl. 112 Cross-section of Christ's flesh from a shadowed area below the area reserved for Joseph of Arimathea's left hand, showing the gesso ground sealed with a layer of glue, the lead white *imprimitura* and two layers of flesh paint. The first darker layer contains red ochre and lead white. The upper layer consists of lead white, ochre and a little vermilion. Magnification 405×.

Pl. 113 Macro detail showing the termination of the brushstrokes at the edge of the unpainted area of Christ's genitals.

Pl. 114 *Doni Tondo*, macro detail showing the termination of the brushstrokes at the junction of the sky with the edge of Saint Joseph's left shoulder and the hair of the nude figure in the background.

Pl. 115 Detail of Christ showing the unfinished painting of the genitals. The red-brown underpaint is therefore visible.

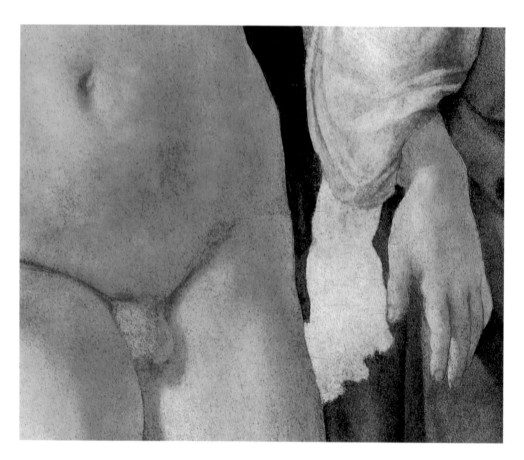

The Draperies and Landscape

Like the areas of flesh, the draperies also show a variety of paint textures and degrees of finish, although in interpreting what we now see it is important to take into account the very damaged condition of the painting. Moreover most of the colours have altered to such an extent that we are left with an entirely false view of the appearance of the painting when it was abandoned, let alone of what it might have looked like had it ever been finished. Saint John's orange-red robe now seems obtrusively bright, the vermilion made yet more brilliant by the addition of the orange pigment, red lead.[29] The tonal range remains limited, the red carefully gradated through to the highlights by the addition of lead white, but still wanting depth in the shadows. Some glazing with red lake was almost certainly planned but later Florentine paintings often show a surprisingly limited tonal range in vermilion-based draperies. In imagining the possible intended appearance of Saint John's robe we are not helped by the fact that where the vermilion is at its purest, in the mid-tones and shadows, it has often blackened, producing a misplaced depth of tone with sometimes unfortunate results.

Discoloration has also disrupted the tonal balance of the green lining of the robe, the final 'copper resinate' glaze having darkened to a dense blackish brown. It therefore presents too strong a contrast both with the red and with the much paler green of the section of lining at the front of the hem, which may have lost, or have

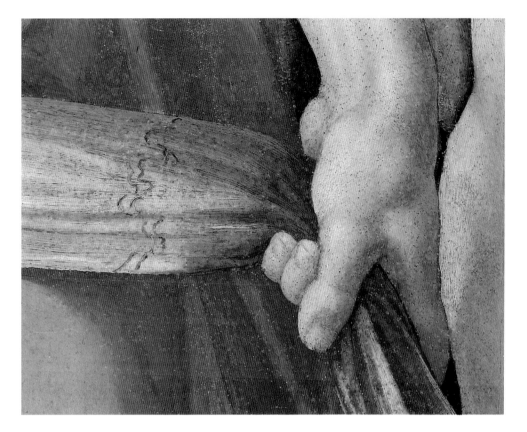

Pl. 116 Detail of the band of fabric held by Saint John showing the wet-in-wet painting of the dark green stripes.

Pl. 117 Cross-section from a shadowed area of the dark green dress of the Mary who supports Christ, showing the gesso ground, the lead white *imprimitura*, an opaque green layer consisting of verdigris with a little lead white and then (at the right end of the section only) traces of a thin and very discoloured 'copper resinate' glaze. Over this are old varnish residues and oil layers with embedded particles of dirt. Magnification 370×.

Pl. 118 Macro detail of the right edge of the green dress of the Mary who supports Christ, showing the blotting of the opaque green paint.

never received, a final thin glaze. With a small brush dipped in what must be the same dark green, two wiggling stripes were painted across the still soft paint of the biscuit-coloured band used to support the weight of Christ: a perfect illustration of the wet-in-wet technique (Pl. 116).

The once brilliant green dress of the Mary supporting Christ shows Michelangelo exploring the textural properties of oil paint in another way. The drapery was first undermodelled in the highlights with a pale green consisting of lead white and a little verdigris, and in the shadows with a bright emerald green, containing the same combination of pigments but with verdigris predominating (Pl. 117). The paint appears to have been dabbed on and blotted, either to blend the tones or perhaps to suggest a heavy textured fabric.[30] Viewed under low magnification this technique produces a peculiar filigree effect, with the white *imprimitura* clearly visible through the gaps in the green (Pl. 118). Over this is the 'copper resinate' glaze, now so sadly discoloured. To appreciate how much these areas have altered we need only to compare them with the exceptionally well-preserved green lining of the Virgin's mantle in the *Doni Tondo* (Pl. 125).

Equally changed, but in a very different way, are the cloak of the kneeling Mary (Pl. 119) and the robe of Joseph of Arimathea (Pl. 49), which now appear so similar in tone and colour to the areas of discoloured green. Cross-sections reveal that the paint of the shadows actually contains mainly red lake and azurite with some red ochre and lead white, forming what must originally have been a deep purple or

maroon colour (Pl. 120). The highlights were once a pale, slightly mauve blue made up of azurite with a little red lake and ochre in a matrix of lead white. A hint of this colour is still visible in the fanned drapery folds of the kneeling Mary. Apart from the red ochre, added probably to improve the covering power of the mixture – necessary in a direct *alla prima* technique – all the components have altered, the azurite darkening and turning a murky blackish green, as it can when used in an oil-rich paint such as this, and the lake discolouring to a dull transparent brown. There is also considerable surface discoloration from the excess oil medium and from the old varnish and applied oil layers.[31] A darker colour may always have been intended in the deepest folds of Joseph's robes, to ensure that his figure provided a foil for Christ's body and remained visually in his place at the back of the group, as does the Joseph of the *Doni Tondo* with his subdued slate-blue robe.

The combination of plum or purple shadows and pale blue highlights in a *cangiante* drapery later features on the Sistine ceiling, for example on a woman with outstretched arms in the group on the right of the *Deluge*, but again it is part of a Quattrocento tradition and was previously used by Domenico Ghirlandaio for one of the sumptuously dressed retinue on the right of the altarpiece for the Innocenti (Pl. 3). On the kneeling Mary in the *Entombment* the original richness of effect of her cloak would have better balanced the vivid lead-tin yellow and vermilion *cangiante* lining, the vermilion brightened by the addition of red lead, but now muted by the grime-encrusted oil layer and by some surface blackening of the vermilion. The paint is strongly brushmarked and, where they meet, the red and yellow colours have clearly been blended into one another while still wet. The discoloured surface is partly responsible for the subdued pink of her dress, no longer able to assert itself against the vermilion of the Evangelist, but its dull grey tinge is also typical of red lake and lead white mixtures where the red lake has faded.[32] Some additional glazing may have been intended in the shadows.

Cross-sections (and flake losses visible in photographs taken before the last restoration) reveal that the pink of the kneeling Mary's dress is painted over an undermodelling identical in colour and composition to that of the sleeves and under-skirt of the Mary who supports Christ. Here the paint, also red lake and white but with a little vermilion as well, seems thin and lacking in body when compared with the other draperies and was probably going to be worked up further. The cloak of the figure on the extreme right, assumed to be the Magdalen (Pl. 92), now appears very close in colour to the pink of the figure next to her, but this is yet another acci-dent of time, for underneath the dirt and a thin skin of deteriorated pigment is a bright vermilion modelled up to very pale, almost white highlights – a startling colour scale later to be seen in paintings by Pontormo, for example in the Magdalen in his own version of this episode in Santa Felicità, Florence. The now greenish-grey dress of Michelangelo's Magdalen contains yet more degraded azurite mixed with lead white, presumably to make a light turquoise blue.

Unfortunately the junction between this figure and the unpainted Virgin is the

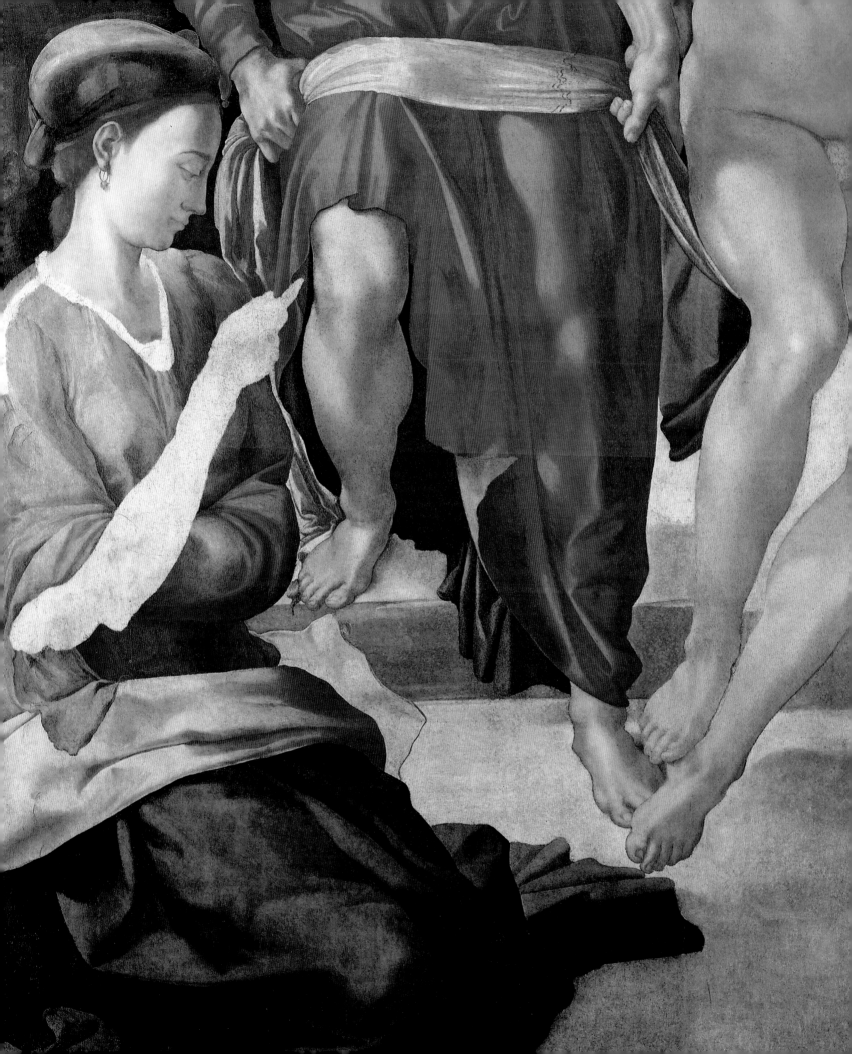

Pl. 120 Cross-section from a mid-tone area of the mantle (now brown) of the kneeling Mary on the left, showing the lead white *imprimitura* (no gesso is present in the sample), followed by a layer of lead white, with azurite, red lake and a little red ochre. The ochre tends to stain the lead white matrix giving the impression that it is present in greater amounts than is actually the case. Both the lake and the azurite have lost much of their colour but some blue particles remain. (In the sample from the shadowed area illustrated in Pl. 95 the same mixture is present but with less lead white and the blue particles can no longer be distinguished.) In the sample illustrated here varnish and a thin layer of blackish green retouching are also present. Magnification 370×.

OPPOSITE Pl. 119 Detail of the kneeling Mary.

part of the picture worst affected by flaking. The drawn copy (Pl. 50) appears to be fairly reliable as far as the left contour of the Virgin is concerned, but the spatially illogical left hand of the Magdalen placed on the Virgin's shoulder must be an invention, as was perhaps realised by the copyist since the fingers are partially abraded as if to erase them. Along the right edge of the painting a small fragment of green-brown paint survives, almost certainly the discoloured skirt of the Magdalen, and in the lower right corner there is an area of light grey-brown paint, the same as that in the foreground, together with traces of an underdrawn outline.[33] This confirms that the Virgin was posed turning towards Christ, the folds of her robe gathered closely about her.

It has been suggested that the reason Michelangelo left the figure of the Virgin untouched is that, as may also have been the case with the *Manchester Madonna*, he was awaiting supplies of the lapis lazuli appropriate for the rich blue of her mantle.[34] At this date Rome did not yet have an organised community of resident painters and so apothecaries are unlikely to have carried large stocks of the more expensive materials such as ultramarine (made from lapis lazuli). Perhaps significantly, Signorelli, while working on his *Last Judgement* at Orvieto in 1501, was able to obtain the cheaper blue pigments, azurite and smalt, from Rome, but had to send to Florence, nearly twice the distance, for ultramarine.[35] Michelangelo is well known to have been particular about his materials and in 1508, when about to start work on the Sistine ceiling, he wrote to the Gesuati friars, the principal suppliers of high-quality pigments in Florence, to ask them to send 'azzurri begli' (fine blues).[36] His contacts with the Gesuati almost certainly go back to his time with Domenico Ghirlandaio: the Gesuati were involved in the commission for the Innocenti altarpiece (Pl. 3) and Domenico also painted the altarpiece for their church of San Giusto alle Mura, now in the Uffizi, Florence.

To balance and integrate such a large area of ultramarine as would have appeared on the Virgin in the *Entombment*, local touches of the pigment may well have been planned for some of the other unpainted parts: for instance the neckline of the kneeling Mary and perhaps even the sashes around the waists of Saint John and the Mary who supports Christ (although not the band across her back, which should probably be read as an extension of the cloth used to support Christ, knotted at her shoulder to form a sort of sling). In fact, Michelangelo was able to obtain at least a small amount of ultramarine of reasonable quality for what appears to have been the first part of the picture to be painted. The sky was freely brushed in with lead white and ultramarine, the X-radiographs (Pl. 94) showing that the paint extends well under the present edge of the rocks around the tomb. The mountains and the sketchy little town on the left were then superimposed with more ultramarine and white. As so often in this work, the paint of the upper layer is rich in oil and has therefore discoloured to a certain extent, but the appearance of the infra-red image (Pl. 109) indicates that some azurite, and perhaps even some black pigment, were also used, particularly in the clouds. In the sky the uninterrupted horizontal brushstrokes and the sharp edges around the heads of Saint John the Evangelist and Joseph

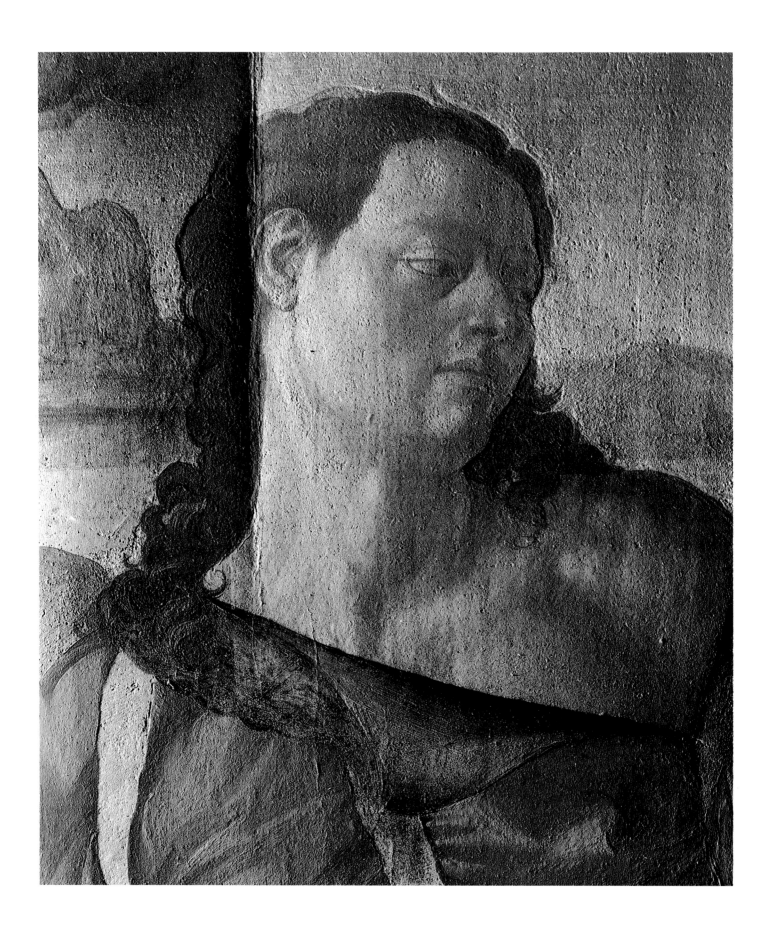

124 *Michelangelo as a Painter on Panel*

Pl. 122 Detail photographed in raking light of Christ and Joseph of Arimathea, showing the scraping of the sky around the contours and, to the right, comb-like marks in the paint of the mountains.

Pl. 123 *Doni Tondo*, detail photographed in raking light of the head of Saint Joseph, showing the paint of the sky worked carefully around his head.

OPPOSITE Pl. 121 Detail photographed in raking light of Saint John the Evangelist, showing the scraping away of the paint of the sky around the head and an indented line along the bridge of the nose.

of Arimathea (Pls 121 and 122) suggest that the outlines of the reserved areas were cleaned up by scraping. Certainly there is a lightly indented line to reinforce the bridge of Saint John's nose, while the erosion of the gesso along the right edge of Joseph's unpainted shoulders may have occurred in a later cleaning precisely because it had been scraped back, damaging the protective tempera *imprimitura*. By contrast a photograph of Saint Joseph in the *Doni Tondo* taken in raking light (Pl. 123) shows the paint of the sky worked carefully around the contour of his head,[37] in other respects so very like that of Joseph of Arimathea in the *Entombment*. On the mountains to the right of Joseph and Christ in the *Entombment* several of the comb-like marks referred to earlier can be seen. They look altogether different from the more conventional brushmarks in Christ's hair.

The light green section of the landscape on the left – a mixture of lead-tin yellow and azurite which has retained more of its colour than elsewhere on the painting, except when glazed with browned 'copper resinate' in the lower part – is slightly overlapped by the left-hand figures, most evidently by the sleeve of Saint John and the hat of the kneeling Mary. This is about as close as the painting ever comes to a pentimento. The sandy foreground colour was laid in before the three most finished figures were painted, the careful undulation of the brush providing the only clue as to the position of Joseph of Arimathea's toes. In the section of landscape

on the right, the first red-brown layer, a mixture of earth pigments with black, vermilion and lead white, may have been applied before the figures; but the boldly brushmarked streaks of lighter greenish brown (mainly lead white, yellow ochre and black, but with a few fine particles of azurite), including the steps to the tomb, were clearly painted after, the paint straying over the edges of the apparently completed maroon of Joseph and the green of the female bearer. Moreover, as is also evident from the area reserved for the tomb, this is the only part of the painting that seems not to have been prepared with the lead white *imprimitura*. The direction of the brushstrokes confirms that the tomb and the two figures lifting the lid were always reserved (Pl. 124), but even for this little detail the outlines were scraped back, the edges slightly ragged because the oil paint evidently did not come away as cleanly as the tempera of the *Manchester Madonna*.

Neither half of the landscape is finished – on the left there is an expanse of unpainted *imprimitura*, perhaps destined to be water – but from the handling of the paint it seems likely that Michelangelo would have preserved the distinction between loosely painted unfocused background and hard-edged perfectly finished principal figures which was to become a feature of the *Doni Tondo* (Pl. 125). When the landscapes of the *Doni Tondo* and the *Entombment* are compared with the minutely detailed, gold-highlighted landscapes of Domenico Ghirlandaio we are reminded that, however much Michelangelo owed to his master, and the National Gallery panels show that this was a great deal, the *Entombment* remains as innovative and experimental in its technique as it is in its design and representation of the human form.

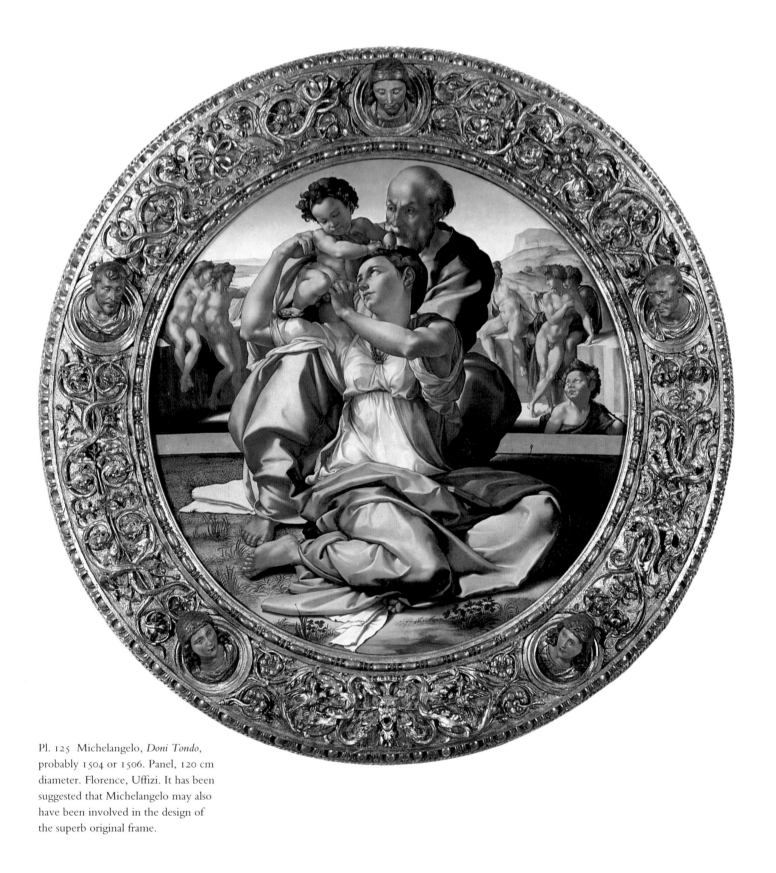

Pl. 125 Michelangelo, *Doni Tondo*,
probably 1504 or 1506. Panel, 120 cm
diameter. Florence, Uffizi. It has been
suggested that Michelangelo may also
have been involved in the design of
the superb original frame.

Chapter VI: The Painting Technique of the *Manchester Madonna*

1. For publications following the cleaning and examination of the *Manchester Madonna,* see Ruhemann and Plesters 1964, pp. 546–54, and for the *Entombment* see *Michelangelo's 'Entombment of Christ'*, [1970], esp. Plesters, pp. 21–8.

2. See *Il Tondo Doni di Michelangelo e il suo restauro*, 1985, esp. Bonsanti, pp. 17–20, and Buzzegoli, pp. 57–70. The many observations made in this and the next chapter about the technical relationship between the *Doni Tondo* and the National Gallery panels are based on this publication and on invaluable discussions with Ezio Buzzegoli.

3. For Ghirlandaio's palette at Santa Maria Novella, see Bandini et al. 1986, p. 186, and for that of the Sistine Chapel ceiling, see Gabrielli 1987, pp. 155–6, Mancinelli in Chastel et al. 1986, p. 242 (the lunettes only).

4. There would have been less emphasis, for example, on the application of perfect gesso grounds needed for gilding and indeed on the techniques for gilding and its decoration. An evidently talented apprentice like Michelangelo might also have been excused chores such as the grinding of pigments, since a workshop as large as that of the Ghirlandaio brothers may well have employed a specialist to prepare colours.

5. The essential truth of this story is confirmed by the survival of a work fitting their descriptions (sold at Sotheby's, 7 December 1960, Lot 17), which, although it would be disappointing as a very early Michelangelo, is almost certainly a product of the Ghirlandaio workshop. Judging from photographs, the landscape – not part of the original Schongauer design – is particularly Ghirlandesque.

6. For a recent account of the Ghirlandaio workshop, and examples of the multiple repetition of popular compositions see *Maestri e botteghe*, 1992, especially the contributions by Venturini, pp. 109–13 and pp. 149–51.

7. For discussion of the functions of Ghirlandaio's drawings, see Cadogan 1983, pp. 274–90.

8. Much of David's output had previously been assigned to their brother-in-law, Sebastiano Mainardi. A group of paintings assigned to a painter provisionally named the 'Master of the St Louis Madonna' is discussed in Fahy 1967, pp. 134–7; for evidence to support Fahy's suggestion that this painter is likely to be David Ghirlandaio, see Venturini 1990, pp. 70–1, and also Venturini in *Maestri e botteghe*, 1992, p. 111.

9. The *Virgin and Child* (NG 3937) is catalogued in Davies 1961, pp. 220–1, as 'Studio of Domenico Ghirlandaio', but in the recent literature (for example *Maestri e botteghe*, 1992, p. 149) has tended to appear, even before it was cleaned in 1992–3, as by Domenico himself. The cleaning revealed the high quality of the painting and also that some areas had been repainted, probably when it was acquired by Sir Charles Eastlake for his own collection at some time before 1855. The repainting included the admittedly much damaged mantle of the Virgin, while the haloes of the Virgin and the Christ Child were obliterated. In addition, the panel had been adapted from its original arched top to a rectangle, cutting segments from the wood in the process. It has now been restored to its correct shape, with the modelling of the architecture reconstructed but with the replacement segments indicated by slight gaps or grooves between them and the original panel.

10. The attribution was proposed in 1983 by E. Fahy, amending his previous listing under Mainardi (see Fahy 1976, p. 217). It was catalogued in Davies 1961, pp. 222–3, as Follower of Ghirlandaio, and before that as Mainardi. The tendency, usually indicative of a left-handed artist, for the diagonal hatched strokes of the tempera to run from top left to lower right, has also been noted on those other paintings in the group now assigned to David Ghirlandaio seen to date by the present writer.

11. There is no evidence for a second hand in the painting of the *Manchester Madonna* – and certainly not if Piero d'Argenta is indeed the painter of the Vienna tondo and other associated works. In the case of the larger *Entombment*, it might be thought that the use of workshop assistants could explain the differences between the figures but an alternative explanation is presented in the next chapter. There has never been any suggestion of workshop participation in the *Doni Tondo*. To some extent Michelangelo may have been reacting against the commercial practices so efficiently exercised in the Ghirlandaio workshop.

12. These faults are probably symptomatic of a more general relaxation of standards as the practice of gilding large areas of the picture surface fell into disuse: similar craters can be seen in the grounds of paintings by, among others, Botticelli, Raphael and Pontormo.

13. In the case of some 14th-century Italian panels X-ray diffraction and scanning electron microscopy have shown that the presence of both the anhydrite and the dihydrate forms of calcium sulphate is related to the use first of *gesso grosso* and then of *gesso sottile* as prescribed by Cennino Cennini (see Bomford et al. 1989, pp. 17–18). However, the results of X-ray diffraction analysis of samples of gesso from 15th- and 16th-century paintings in the National Gallery generally bear out the geographical difference whereby paintings from centres south of the Apennines, such as Florence, Siena and Rome, have grounds either of the burnt anhydrite alone or (like the Michelangelo panels) contain both anhydrite and dihydrate forms, while paintings from north of the Apennines, including Venice, Ferrara and therefore most probably Bologna, contain only the dihydrate form, either because the gypsum was used raw or because it had been slaked. Therefore this distinction, which was first noted by Gettens and Mrose 1954, pp. 182–3, provides some evidence in support of a Roman (or Florentine) rather than Bolognese origin for the *Manchester Madonna*.

14. See Cennino, trans. Thompson, 1954 edn, pp. 69–74, and Vasari, trans. Maclehose, 1960 edn, p. 223; the latter refers to the smoothing of gesso without mention of the means. Of early sources only a 14th-century Icelandic MS refers to the use of a fish skin, and specifically that of a dogfish (only the skin of members of the subclass Elasmobranchii, which includes sharks, rays and dogfish, has the tooth-like denticles or placoid scales that make it suitable as an abrasive), for the rubbing down of chalk grounds in

painted and gilded sculpture. See Plahter 1992, pp. 168–9. I am grateful to Jo Kirby for drawing my attention to this reference. Pumice is mentioned by Vasari for the finishing of bronzes and marble, followed, if desired, by polishing with a slightly abrasive earth and bunches of straw. A piece of dogfish or shark skin might have served equally well.

15. The particles do not have the long splintered shapes characteristic of charcoal, but are more rounded. They may derive from some other vegetable source such as charred peach stones.

16. See Cadogan 1984.

17. It was partly the existence of this altarpiece, also recently cleaned (see Burresi, ed., 1992, pp. 162–7), that led Davies (1961, pp. 120–1) to consider the National Gallery *Virgin and Child* as a workshop piece derived from the altarpiece. However the Pisa painting is of inferior quality and the pose of the Child makes much more sense in the National Gallery design, originating as it must from terracotta and marble reliefs produced in the workshop of Verrocchio (see also *Maestri e botteghe*, 1992, pp. 147–9).

18. A full account of the technical examination made during the recent cleaning of the Vienna tondo will be published shortly. However Martina Fleischer and Franz Mairinger of the Akademie der bildenden Künste have generously made this information – including infra-red reflectograms, X-radiographs and cross-sections – available to us and we have benefited greatly from our discussions of this painting with them.

19. A substantial glue layer to seal the ground has been noted on several North Italian, and especially Ferrarese paintings at the National Gallery and elsewhere. Among paintings of the period to have been examined at the National Gallery, there are no examples with an apparently deliberately pigmented gesso as in the Vienna tondo, but for a painting by Tura with a glue-rich ground and a yellow-brown undermodelling – also based on ochre, but with a little black – see Dunkerton 1994, pp. 46–7.

20. Ruhemann, in Ruhemann and Plesters 1964, p. 550, implies that 'a semi-transparent grey wash was applied' over the gesso. However no discrete pigmented layer appears in the cross-sections, nor is it visible on the top surface of a sample of the unpainted gesso. Analysis by GC–MS (gas chromatography–mass spectrometry) of a scraping from the upper surface found no trace of any medium, but only fats resembling those that result from the touching and handling of the surface of a painting.

21. For fuller accounts of the properties of the egg tempera medium, see Dunkerton et al. 1991, pp. 188–92, and Bomford et al. 1989, pp. 27–9.

22. Curiously it does not appear on the earliest group of panel paintings attributed to Domenico, those linked with his presumed association with the Verrocchio workshop. He may have revived its use as a result of his experience as a fresco painter. Although the use of a green earth underpainting is by no means exclusive to the Ghirlandaio workshop, it was becoming less common.

23. When the painting was cleaned in 1943 and the damaged condition of the flesh painting revealed, it was decided 'to leave the picture without any restoration for students' (entry in National Gallery Conservation Record) and it was displayed in the condition shown in Pl. 79. However, in 1992–3 some retouching was carried out to modify the disturbing transitions between abraded areas and surviving patches of paint and also to reduce the contrast between the relatively well-preserved parts such as the Virgin's head, which retains much of its volume and detailed modelling, and the very badly damaged and consequently flat face of the Baptist.

24. Ruhemann in Ruhemann and Plesters 1964, p. 548, suggests that the green earth was modelled intentionally to indicate relief. To the present writer the variation in thickness seems more to do with the application of the paint, but it says much for the way in which the contours of the limbs imply volume that such a suggestion could have been made.

25. The painter who comes closest in density and evenness of transition when painting flesh in tempera is perhaps Botticelli, at least in his more highly finished works, although in his case there is no green earth underpainting. See Ciatti, ed., 1990, esp. pp. 99–100 and 117–18.

26. This observation was made by Ezio Buzzegoli.

27. It has long been recognised that this can only be an underpainting: for example, in 1908, Thode wrote: 'ihr Mantel, tiefschwarz, wie mit Tusche untermelt, sollte wohl blau übergangen werden' (Thode 1908, I, pp. 71–5, esp. p. 73). Ruhemann in Ruhemann and Plesters 1964, p. 548, observes that along the lightest part of the taut fold on which the Child places his foot the separated strokes characteristic of tempera are replaced by marks more like those made by a bristle brush. Such marks could also perhaps have been made by the wiping or sponging on of the tempera paint.

28. The black pigment appears to be the same carbon black of vegetable origin used for the underdrawing. Analysis by GC–MS showed the medium to be an egg tempera, rich in egg fats, but with no indication of any oil. In 1964 – several years before the application of gas chromatography to the analysis of paint media – the black paint was reported as having an oil medium (Ruhemann and Plesters 1964, p. 553).

29. Oil may sometimes have been chosen for use with azurite because of its greater optical richness, but painters may also have become more aware of the tendency of copper-based pigments like azurite to react with the egg, particularly when used with little or no lead white, causing the paint film to darken and discolour. Despite the use of walnut oil (identified by GC–MS), the blue robe of Ghirlandaio's Virgin has evidently still discoloured and darkened. In both oil and egg tempera the discoloration appears to be mainly in the medium rather than the pigment particles (see Roy, ed., 1993, p. 27). For a particularly extreme case of the discoloration of a paint film containing azurite, see the following chapter.

30. Malachite in its various natural and artificial forms seems to have been used in this way for the lining of the Virgin's robe in several Florentine paintings of the later 15th century, including those by the Ghirlandaio brothers in the National Gallery.

31. Analysis by GC–MS of a sample from the brownish-green grass in the foreground showed the paint to be bound in egg tempera.

However, there were possible traces of a drying oil, perhaps from a thin superimposed glaze rather than from the addition of some oil to the tempera (see note 32). There was no indication of the diterpenoid or triterpenoid resin which would confirm the presence of a true 'copper resinate' glaze. A dark green glaze of the 'copper resinate' type is reported in a sample from the foreground of the *Doni Tondo*. See Matteini and Moles in *Il Tondo Doni*, 1985, pp. 77–9.

32. Analysis by GC–MS. For other examples of enriched tempera or *tempera grassa* in paintings at the National Gallery see Dunkerton et al. 1991, p. 201. The appearance, both on the paint surface and in cross-section, of the red lake glazes over the striped textile in the foreground of the Domenico Ghirlandaio *Virgin and Child*, suggests that they may contain some oil. The robe, on the other hand, is less saturated and has the characteristics of pure egg tempera.

33. The identification of the lac dyestuff (from *Kerria lacca* Kerr, or a similar species) was by HPLC (high performance liquid chromatography), confirmed by mass-spectrometry.

34. Analysis by EDX (energy dispersive X-ray microanalysis) of this bright orange yellow paint showed that it contains only yellow ochre. It was reported previously as the arsenic sulphide pigment, realgar (see Ruhemann and Plesters 1964, p. 553), but no arsenic could be detected by analysis.

35. Buzzegoli in *Il Tondo Doni*, 1985, p. 63, reproduces a macrophotograph (fig. 17) in which a broken line of shell gold on the ribbons of the Christ Child in the *Doni Tondo* can be seen. For the mordant gilding on the Granacci and the Madonnas by Domenico and David Ghirlandaio an oil-based mordant, lightly pigmented with ochres seems to have been used. There is no reason to believe that the gilded decoration on the David Ghirlandaio is 'new' as suggested in Davies 1961, p. 222.

36. Ruhemann and Plesters 1964, pp. 549–50.

37. In August 1508 in a letter sent from Rome to his father, Michelangelo asked for his brother to buy from Francesco Granacci or another painter 'un'oncia di lacha, o tanta quanta è può avere pe' decti denari, che sia la più bella che si trova in Firenze' (cited by Mancinelli in Hirst et al. 1994, p. 267, note 34). Lac is not commonly used in fresco and has not been identified on the Sistine ceiling, so the purpose for which the pigment was needed is not known.

38. The identical pigment mixture was employed by Ghirlandaio for the purple-grey stone of the window-opening of his *Virgin and Child* (Pl. 61). It is tempting to speculate whether Michelangelo had the colour of stone in mind when he filled in this area. The simulated architecture of the Sistine lunettes also has a purple-pink cast, in this case from the use of *morellone*.

Chapter VII: The Painting Technique of the *Entombment*

1. Mancinelli, Colalucci and Gabrielli in Hirst et al. 1994, esp. pp. 246–51.

2. For the construction of the panel of the *Doni Tondo*, see Buzzegoli in *Il Tondo Doni*, 1985, pp. 57–8. Ezio Buzzegoli has also pointed out that, in the case of the tondo, Michelangelo has shown such concern – unusual among Italian painters – for the neatness of the carpentry on the reverse that on the front face of the panel he has accepted a slight step in the join which runs beneath the Virgin's right arm and the draped knee of Joseph. To fill the depression extra gesso and a strip of canvas were applied, resulting in the cracking now visible on the surface.

3. The panel was previously reported as being on a single massive plank of poplar (see Plesters in *Michelangelo's 'Entombment'*, [1970], p. 21). The joins are particularly difficult to detect in X-radiographs because, unlike most Italian panels of the period (including the *Doni Tondo* and the *Manchester Madonna*), they do not register as a fine white, or grey, line. Joins probably register when X-ray opaque materials, such as calcium sulphate (which will register strongly if sufficiently thick) have been added to the glue to give it some bulk. For an example of a glue to which lead white was added, see Bomford et al. 1989, pp. 159–60.

4. Along the right edge (as seen from the front), a narrow strip of wood has been pinned to the panel (probably in the 19th-century restoration – see note 11) and covered with gesso. It was presumably applied to reinforce the crumbling wood (much affected by woodworm) and to square up the sloping original edge. At the back edge gesso dribbles can be seen, confirming that this is the original edge.

5. When publishing the drawing, Gould (1951, p. 281) suggested that its proportions indicated that the panel might have been cut at the top as well as the bottom edge.

6. They might also have been designed for securing the heavy panel to some form of easel during the process of painting. Nothing like these plugs has been observed on panels in the National Gallery and Ezio Buzzegoli, who was present when they were discovered, has not encountered them on paintings that he has examined in Florence.

7. The use of egg tempera in the *imprimitura* was first reported by Plesters in *Michelangelo's 'Entombment'*, [1970], p. 23. As this was a very early application of the technique of gas chromatography, further tests were run during the examination of the painting for the present study and the results were confirmed. In addition, cross-section staining tests have been carried out, showing the presence of egg in the *imprimitura* layer only. Staining also confirmed the use of an animal-skin glue as the binder for the gesso ground.

8. Buzzegoli in *Il Tondo Doni*, 1985, p. 57, and also Matteini and Moles in ibid pp. 77–9. In the case of the *Doni Tondo* the medium of the *imprimitura* is believed to be oil and the lead white includes granular agglomerations of pigment which appear as raised lumps on the surface of the painting when viewed in raking light. If any such lumps existed in the *imprimitura* of the *Entombment* they are likely to have been scraped off in one of the past cleanings of the painting (see note 11).

9. For the proposal that the spots are from fly excreta, see Ruhemann in *Michelangelo's 'Entombment'*, [1970], p. 30. For the present study, a sample from one of these spots was examined by FTIR–IR

microscopy and by mass spectroscopy which indicated the presence of chlorogenic acid, associated with fungi that have metabolised wood. The possibility that paintings with aerated gesso grounds are particularly prone to fungal attack is also suggested by samples from the ground of the Domenico Ghirlandaio *Virgin and Child*. Although nothing like as extensive as in the *Entombment*, filaments of mould are visible across the voids, even at the lower magnification used to examine cross-sections.

10. For examples, see the bibliography by Plesters in Ruhemann 1968, pp. 377–84.

11. Since the results of the analysis of the paint medium were unambiguously linseed oil (see note 14), it is likely that the later applications of oil were also of linseed. Removal of old cross-linked layers of linseed oil from a paint film based on the same medium would be difficult and dangerous, especially on an unfinished painting such as this. The cleaning of 1968–9 comprised solely the removal of a discoloured soft-resin varnish, soluble in acetone, and of the darkened old retouchings (see Ruhemann in *Michelangelo's 'Entombment'*, [1970], p. 31). When the painting was acquired by the National Gallery in 1868 it was examined by the Italian restorer and picture dealer Rafaelle Pinti (who worked in London for the Gallery). He made some remarkable observations on the technique (see note 26), but, according to the Conservation Record, the painting seems to have undergone only minor repairs and blister treatment, repeated on many occasions until the introduction of air-conditioning to the galleries. Therefore the varnish removed in the 1960s probably dates from a cleaning made after the discovery of the painting in Rome by the painter and photographer Robert Macpherson in 1845/6. More information about this extraordinary episode in the history of the *Entombment* is supplied in an article by Martin Bailey in the October 1994 issue of *Apollo*. He has generously allowed us to make use of his material. As far as the cleaning of the painting is concerned there are two contradictory accounts. In a privately published autobiography the painter Clement Burlison (cited but not quoted in Gould 1975, p. 148), writing some 50 years after the event, claimed to have visited Macpherson with a friend and to have been shown the *Entombment*. He recollected that it was 'in a very dirty, bad condition' and so 'we three set to work with brushes, warm water, soap etc., making it tolerably clean'. If his account is to be believed, the use of these materials, let alone the 'etc.', provides some explanation for the condition of the painting. However, Burlison was also responsible for the implausible story of Macpherson discovering the panel in use as 'a stall or table, used sometimes for fish, frogs, etc., but usually old pans, grid-irons, locks, horseshoes, etc. etc.'. The painting has not suffered the quantity of scratches and dents (for the dents in the lower corners see note 33) likely to have been inflicted by the second part of this list of merchandise, while the theory that the surface is marked by the excreta of flies attracted by the fish is disproved by the recent scientific examination. A more convincing account, cited by Bailey for the first time in connection with the history of the *Entombment*, appears in the autobiography of another artist, the Canadian James Freeman. According to him, Macpherson first noticed the *Entombment*, 'a large panel, over which dust, smoke and varnish had accumulated to such a degree as to make it difficult to distinguish what it represented', when it was part of a job lot at the auction of the Fesch Collection. He later bought it from the dealer who had acquired the lot. A rather less credible detail is that the dealer was planning to sell the panel to a cabinet-maker to make a table; it could hardly have been suitable for furniture since the wood is already likely to have been worm-eaten and poplar lacks sufficient structural strength for this purpose. Nevertheless, according to Freeman's story, Macpherson brought in 'the experienced and well-known picture cleaner, old Colombo [probably the painter Giovanni Colombo], who removed from one of the heads and from a part of one of the figures of the composition, the numerous strata of dirt and smoke with which it was overlaid.' As Bailey suggests, it is possible that both stories are at least partly true and that Macpherson and his friends began to clean the painting, but discovering its value, and perhaps their inability to remove the dirt and varnish without damaging it (soap and water, while potentially very injurious to the original paint film and to the gesso ground, would not necessarily remove an old oil-based varnish), called in the expert, Colombo. Martin Wyld, who assisted in the 1968–9 restoration of the *Entombment*, has pointed out that the old retouchings, although much discoloured, had been carefully executed, particularly by the standards of the day. Although with a painting of this age it is most unlikely to have been the first ever cleaning, the combination of neglect (and the problems with mould may have been exacerbated at this period), and the possibly amateur attempts to clean it, may account for much of the damage. Certainly an early cleaning was sufficiently vigorous to rub off particles of vermilion – a pigment particularly vulnerable to damage by over-cleaning – from Saint John's robe, redistributing the pigment into cracks and air bubbles in the ground and *imprimitura* of the unpainted band of fabric around his waist.

12. For the suggestion that there is a monochrome undermodelling over the *imprimitura*, see Ruhemann in *Michelangelo's 'Entombment'*, [1970], p. 29ff. Ruhemann's account of the technique – based on notes dictated during the examination of the paint surface with a stereo binocular microscope, and published apparently without editing (the original notes still exist) and without reference to the work of Plesters – includes many valuable observations on Michelangelo's painting method. However, his notes are also confusing and ambiguous, particularly regarding the status of what he presumably believed to be the final layer. He usually describes this as the 'grey layer', but it is not clear whether he considered this to be part of the original paint layer structure or whether he recognised it as a later accretion. In his other writings he generally used the term 'grey layer' to mean accumulations of dirt and blanched varnish residues. Furthermore, his interpretation of the technique – and, to a lesser extent, that of Plesters – is coloured by the hypothesis put forward in the same publication by Levey and Gould that the differences between the figures can be explained by

the painting having been worked on in two separate campaigns, in 1506 and 1515–16. The subsequent discovery of the documents supporting the identification of the *Entombment* with the unfinished commission for Sant'Agostino means that this explanation is no longer tenable. In addition, comparison with the *Doni Tondo* following its cleaning makes the overall relative lack of finish of the *Entombment* more evident.

13. Further evidence for the existence of underdrawing on the *Entombment* is the presence in more than one cross-section of a thin line of carbon black pigment between the gesso and the *imprimitura*. For the infra-red examination of the *Doni Tondo* see Buzzegoli in *Il Tondo Doni*, 1985, pp. 57 and 60. Only slight pentimenti could be detected on the *Doni Tondo*, but it is possible that with the better penetration of more up-to-date infra-red equipment some traces of drawing will eventually be found.

14. In the earlier analysis by gas chromatography published by Plesters in *Michelangelo's 'Entombment'*, [1970], the samples were from the flesh and the robe of Saint John. The recent set of samples analysed by GC–MS were from the flesh of Saint John (to confirm the previous result) and of Christ, the cloak of Joseph of Arimathea and the blue of the sky. No resin was found and there was no evidence for any prepolymerisation of the linseed oil by heating or exposure to the sun.

15. For discussion of the medium of the *Doni Tondo* see Buzzegoli in *Il Tondo Doni*, 1985, pp. 57–8. He finds it difficult to believe that such precision and such a perfectly blended finish could be achieved with a pure oil medium, and that some form of emulsion was therefore used. However, in our analyses of many Italian paintings from this so-called transitional period from tempera to oil, the only emulsions we have found are the simple oil-enriched temperas like that used for the red lake drapery in the *Manchester Madonna* (see p. 100). In addition, in refined and highly finished Netherlandish paintings (at present being examined for the revision of the *National Gallery Catalogues*) the upper layers, at least, are all turning out to be in oil.

16. See Bomford, Brough and Roy 1980, p. 25ff., and p. 21 for illustrations of cross-sections showing a technique based on glazes.

17. See Dunkerton et al. 1991, pp. 201–3.

18. For a reconstruction of the altarpiece, see von Holst 1969, p. 36ff.

19. For Benedetto Ghirlandaio, see Venturini in *Maestri e botteghe*, 1985, pp. 110–11, and p. 146 for the catalogue entry on the *Saint Lucy and a Donor*. The version from the Museo di Capodimente, Naples, of the much repeated tondo composition of the *Virgin and Child with Saint John and Three Angels*, which was in the exhibition (cat. no. 5.6, pp. 162–3) has a notably smooth and blended finish suggesting the use of oil.

20. The same delicate and carefully separated 'left-handed' hatching that can be seen on the National Gallery *Virgin and Child with Saint John* appears both on the main panel, particularly in the Saint Michael, and in the side panel of *Saint Lawrence*, which seems to be entirely by this painter. He perhaps tended to specialise in the sort of decorative detail seen on these figures. In identifying the various members of the workshop involved in the Santa Maria Novella

altarpiece it should be remembered that Sir Charles Eastlake, observant as always, recorded that of the two side panels that were in Berlin (destroyed in 1945), the *Saint Vincent Ferrer* had the characteristics of a tempera painting, whereas in the case of the *Saint Anthony* he noted that 'the saint is painted in oil and the background in tempera'. See Eastlake 1960 edn, II, p. 20.

21. For a discussion of the technique of the Florence panel, see *Raffaello a Pitti*, 1991, pp. 55–64 and 79–82, and for the *Esterházy Madonna*, see von Sonnenburg 1983, p. 70.

22. References to the type of flat or square-headed blending brushes still used today appear in 17th-century sources (see Beal 1984, p. 77), but in the previous century Armenini, for example, describes the blending of colours in fresco with a brush dipped in water and then squeezed out (Armenini 1587, p. 117). A much later, but very clear, description of the practice of blending or uniting tones in oil painting with a clean brush is given in a treatise by Francesco Lana published in Brescia in 1670: according to him the most common method of handling the brush is 'unendo; il che si fa con mettere ciascuri colori a suo luogo, a poi con un altro pennello, che sia netto, e senza tinta, congiongendo le parti estreme delli due colori vicini, acciò unendosi' (Lana 1670, p. 167). (All these references were supplied by Jo Kirby.)

23. In the *Doni Tondo* the curls of the Christ Child, for example, are reinforced in the shadows with a rich transparent brown glaze (see Buzzegoli in *Il Tondo Doni*, 1985, p. 57). This may be one of the organic brown pigments that can now sometimes be identified by GC–MS. For examples on paintings by Cima and the Pollaiuoli, see Dunkerton el al. 1991, p. 187.

24. If the modelling had been completed the fingerprints would probably have been covered. The only visible fingerprint on the *Doni Tondo*, illustrated in *Il Tondo Doni*, 1985, fig. 17 on p. 64, is in the brown glaze of a wisp of hair over the Christ Child's forehead, made either to lift surplus paint or perhaps to test whether the paint was dry.

25. Buzzegoli in *Il Tondo Doni*, 1985, p. 58, observes that the plasticity of the flesh in the main group in the *Doni Tondo* is achieved with 'due sfumature leggerissime ed un righino rosso'.

26. The description of the technique used for the painting of Christ's flesh by Raffaele Pinti, when he made notes on the technique of the *Entombment* on its arrival at the National Gallery (see note 11), is worth quoting: 'Il Cristo, una delle figure dipinte due volte, è tutt'olio, ove si legge mirabilmente che la prima volta che l'ha dipinto ha usato terra d'ombra bruciata con bianco, ed essendosi pentito l'ha ricoperto con terra d'ombra naturale e bianco, cosicchè in alcuni parti mostra chiaramente la pittura di sotto, e ciò si osserva nel piede sinistro più che altrove, nei contorni delle gambe, che non sono contorni, sotto la cartilagine...alla costa sinistra, sotto la clavicola destra, nei contorni del pube, e all'ombra del naso vicino all'occhio.' National Gallery Archive, Boxall files, 1869, filed with miscellaneous papers relating to Lord Winchelsea's attack on the acquisition of the painting.

27. This was suggested by Michael Hirst. In the Siena drawing (Pl. 50) fingers are shown but they have almost certainly been introduced

by the copyist. On the *Entombment* the shape of the areas reserved is not much altered by the damage to the paint surface: traces of underdrawing and a more precise indication of the contours of the fingers would surely be expected.

28. For example, a small claw chisel or a tool for modelling clay.

29. When used in a mixture with vermilion, red lead is not always easily identified in cross-sections but EDX analysis of a sample showed a higher proportion of lead present than would be expected from the admixture of the small amount of lead white added to model the highlights. Red lead used in conjunction with vermilion also appears in the mid-tones of Saint Joseph's *cangiante* mantle in the *Doni Tondo* (Buzzegoli in *Il Tondo Doni*, 1985, p. 57) and, rather unusually, in the earliest scenes on the Sistine ceiling (Gabrielli 1987, p. 156).

30. In the *Doni Tondo* there is a suggestion of a heavy woollen textile – perhaps unexpected given the smooth hard finish of the painting – in the tiny hatched strokes, almost a fringe, along the edges of some of the folds of Saint Joseph's mantle.

31. The surface of the painting when examined under ultra-violet light shows large areas of fluorescence which cannot be from the modern varnish. This suggests that some old varnish was left on the surface both following the most recent cleaning in 1968–9 and probably from that apparently made in Rome in 1846. The fluorescence is strongest over the darker colours, particularly the background on the right and the drapery of the kneeling Mary.

32. No samples were available for the identification of the dyestuff, but the appearance of the drapery and the discovery of lac on the *Manchester Madonna* suggest that it is most probably lac as well. Test panels painted with a mixture of lac and lead white and then faded by exposure to artificial daylight exhibit the same cold greyish tinge to be seen on the *Entombment*. Cleaning with alkalis (for example the soap and water that may have been employed in 1846 – see note 11) might also have contributed to the deterioration of the colour.

33. In the course of the recent examination some old varnish which had been left around the edges – in the last cleaning the painting was not taken out of its supporting panel tray – was removed, and in the lower right corner a little more original paint was recovered from underneath putty which was filling oval indentations in the paint surface like those to be seen in the opposite corner. (The panel seems to have been struck with a mallet or something similar, perhaps to dislodge it from a tightly fitting frame). The outline of the Virgin is therefore slightly clearer than it was after the last restoration.

34. This suggestion was first made by Hirst 1981, p. 589.

35. McClellan 1992, docs. 370d and 370p. I am grateful to Tom Henry for this reference. That this situation continued, with Roman suppliers not yet geared to the needs of painters, is suggested by the fact that in 1508, when Michelangelo was planning the decoration of the Sistine Chapel ceiling, he asked Francesco Granacci, who was then in Florence, to obtain what appear to have been samples of pigments, not necessarily just the expensive blues. The large quantities needed for the project and Michelangelo's particularity about materials may have made a Florentine source essential. See Mancinelli in Hirst et al. 1994, p. 49 and p. 267, note 34.

36. For Michelangelo's (and Ghirlandaio's) dealings with the Gesuati in Florence see Bensi 1980, esp. p. 38.

37. According to Ezio Buzzegoli a careful examination using a microscope did not find any evidence for the scraping and incising of the contours. Instead their clarity seems to be the result of the extraordinary precision of the paint application.

Bibliography

Full archival references for the Balducci bank ledgers and the accounts of the Augustinians of S. Agostino are given in Ch. I, note 24 (p. 72) and Ch. V, note 5 (p. 79) respectively.

G. Agosti and V. Farinella, eds, *Michelangelo e l'arte classica*, Florence 1987.

Leon Battista Alberti, *On Painting and On Sculpture*, trans. and ed. C. Grayson, London 1972.

G.B. Armenini, *De' Veri Precetti della Pittura*, Ravenna 1587.

F. Bandini, G. Botticelli, C. Danti, M. Matteini and M. Moles, 'The Restoration of Domenico Ghirlandaio's frescoes in the Cappella Maggiore of S. Maria Novella in Florence: problems, practical work, results', *Case Studies in the Conservation of Stone and Wall Paintings*, Preprints of the Contributions to the Bologna Congress of the International Institute for Conservation of Historic and Artistic Works, 21–26 September 1986, London 1986, pp. 186–9.

P. Barocchi, ed., *Scritti d'Arte del Cinquecento*, I, Milan and Naples 1971.

M. Beal, *A Study of Richard Symonds. His Italian Notebooks and Their Relevance to Seventeenth-Century Painting Techniques*, New York and London 1984.

H. Belting, *L'Arte e il suo Pubblico*, Bologna 1986 (Italian edition of *Das Bild und sein Publikum in Mittelalter*, Berlin 1981).

P. Bembo, *Prose e Rime*, ed. C. Dionisotti, Turin 1966.

P. Bensi, 'Gli arnesi dell'arte. I Gesuati di San Giusto alle Mura e la pittura del rinascimento a Firenze', *Studi di Storia delle arti*, III, 1980, pp. 33–47.

B. Berenson, *The Drawings of the Florentine Painters*, 3 vols, Chicago and London 1938.

B. Berenson, *Italian Pictures of the Renaissance, Florentine School*, 2 vols, London 1963.

R. Biering and H. von Hesberg, 'Zur Bau- und Kultgeschichte von St. Andreas apud S. Petrum ...', *Römischer Quartalschrift für christlich Altertumskunde und Kirchengeschichte*, LXXXII, 1987, pp. 145–82.

P.P. Bober and R. Rubinstein, *Renaissance Artists and Antique Sculpture*, Oxford 1986.

D. Bomford, J. Brough and A. Roy, 'Three Panels from Perugino's Certosa di Pavia Altarpiece', *National Gallery Technical Bulletin*, 4, 1980, pp. 3–31.

D. Bomford, J. Dunkerton, D. Gordon and A. Roy, *Art in the Making. Italian Painting before 1400* (exhibition catalogue), National Gallery, London 1989.

A. Brown, 'Pierfrancesco de' Medici 1430–1476: a radical alternative to elder Medicean supremacy?', *Journal of the Warburg and Courtauld Institutes*, XLII, 1979, pp. 81–103.

C.M. Brown, '"Lo Insaciabile Desiderio Nostro de Cose Antique": New Documents on Isabella d'Este's Collection of Antiques', *Cultural Aspects of the Italian Renaissance, Essays in Honour of P.O. Kristeller*, ed. C. Clough, Manchester 1976, pp. 324–53.

A. Bruschi, *Bramante architetto*, Bari 1969.

J. Burchard, *Liber Notarum*, ed. E. Celani, 2 vols, Città di Castello 1906.

M. Burresi, ed., *Nel secolo di Lorenzo. Restauri di opere d'arte del Quattrocento* (exhibition catalogue), Museo Nazionale di San Matteo, Pisa 1992.

A. Butterfield, 'A source for Michelangelo's National Gallery "Entombment"', *Mitteilungen des Kunsthistorischen Institutes in Florenz*, XXXIII, 1989, pp. 390–3.

J.K. Cadogan, 'Reconsidering Some Aspects of Ghirlandaio's Drawings', *The Art Bulletin*, LXV, 1983, pp. 274–90.

J.K. Cadogan, 'Observations on Ghirlandaio's Method of Composition', *Master Drawings*, XXII, 2, 1984, pp. 159–72.

J.K. Cadogan, 'Michelangelo in the workshop of Domenico Ghirlandaio', *The Burlington Magazine*, CXXXV, 1993, pp. 30–1.

Il Carteggio di Michelangelo, I, eds P. Barocchi and R. Ristori, Florence 1965.

Il Carteggio di Michelangelo, III, eds P. Barocchi and R. Ristori, Florence 1973.

Il Carteggio Indiretto di Michelangelo, I, eds P. Barocchi, K.L. Bramanti and R. Ristori, Florence 1988.

Il Carteggio Indiretto di Michelangelo, II, eds P. Barocchi and R. Ristori, Florence, forthcoming 1994.

G. Celio, *Memoria delli nomi dell'artefici delle pitture...*, ed. E. Zocca, Milan 1967 (first edition 1638).

Cennino d'Andrea Cennini, *The craftsman's handbook: the Italian 'Il libro dell'arte'*, trans. D.V. Thompson, Jr, Dover reprint, New

York and London 1954.

A. Chastel et al., *The Sistine Chapel. Michelangelo Rediscovered*, English edition, London 1986.

M. Ciatti, ed., *'L'incoronazione della Vergine' del Botticelli: restauro e ricerche* (exhibition catalogue), Uffizi, Florence 1990.

L. Cicognara, *Biografia di Antonio Canova scritta dal Cav. Leopoldo Cicognara*, Venice 1823.

G. Colalucci, 'The Frescoes of Michelangelo on the Vault of the Sistine Chapel: Original Technique and Conservation', in *The Conservation of Wall Paintings*, Proceedings of a symposium organized by the Courtauld Institute of Art and the Getty Conservation Institute, London, 13–16 July 1987, ed. S. Cather, Getty Conservation Institute, 1991, pp. 67–75.

A. Condivi, *Vita di Michelagnolo Buonarroti...*, ed. A.F. Gori, Florence 1746.

A. Conti, *Michelangelo e la pittura a fresco: Tecnica e conservazione della Volta Sistina*, Florence 1986.

M. Daly Davis, '"Opus isodomum" at the Palazzo della Cancelleria: Vitruvian Studies and Archeological and Antiquarian Interests at the Court of Raffaele Riario', *Roma, centro ideale della cultura dell'antico nei secoli XV e XVI...*, ed. S. Danesi Squarzina, Milan 1989, pp. 442–57.

M. Davies, *The Earlier Italian Schools*, National Gallery Catalogues, London 1961, reprinted 1986.

M. Delacourt, *Hermaphrodite*, Paris 1958.

P. Della Pergola, 'La Madonna di Manchester nella Galleria Borghese', *Paragone*, V, 1954, pp. 47–8.

E.R. Dodds, ed., Euripides, *Bacchae*, second edition, Oxford 1960.

E.R. Dodds, *The Greeks and the Irrational*, Berkeley and Los Angeles 1973 (first published 1951).

J. Dunkerton, S. Foister, D. Gordon and N. Penny, *Giotto to Dürer. Early Renaissance Painting in The National Gallery*, New Haven and London 1991.

J. Dunkerton, 'Cosimo Tura as Painter and Draughtsman: The Cleaning and Examination of his "Saint Jerome"', *National Gallery Technical Bulletin*, 15, 1994, pp. 42–53.

C. L. Eastlake, *Methods and Materials of Painting of the Great Schools and Masters* (formerly titled *Materials for a History of Oil Painting* and first published in 1847), 2 vols, Dover edition, New York 1960.

C. Elam, 'Lorenzo de' Medici's Sculpture Garden', *Mitteilungen des Kunsthistorischen Institutes in Florenz*, XXXVI, 1992, Heft 1/2, pp. 41–83.

A. Esposito Aliano, 'La Parrocchia "Agostiniana" di S. Trifone nella Roma di Leone X', *Mélanges de l'école française de Rome*, XCIII, 1981, pp. 495–597.

E. Fahy, 'Some Early Italian Pictures in the Gambier-Parry Collection', *The Burlington Magazine*, CIX, 1967, pp. 128–39.

E. Fahy, *Some Followers of Domenico Ghirlandajo*, New York and London 1976 (originally presented as thesis, Harvard University, 1968).

L.R. Farnell, *The Cults of the Greek States*, 5 vols, Oxford 1909.

S. Ferino Pagden, ed., *La prima donna del mondo. Isabella d'Este. Fürsten und Mäzenatin der Renaissance* (exhibition catalogue), Kunsthistorisches Museum, Vienna 1994.

G. Fiocco, 'Sull'inizio di Michelangelo', *Le Arti*, IV, 1941, pp. 5–10.

W. Forsyth, *The Entombment of Christ: French Sculptures of the 15th and 16th Centuries*, Cambridge, Mass., 1970.

D. Franklin, 'New Documents for Rosso Fiorentino in Sansepolcro', *The Burlington Magazine*, CXXXI, 1989, pp. 817–27.

D. Franklin, *Rosso in Italy*, New Haven and London 1994.

K. Frey, *Le Vite di Michelangelo Buonarroti scritte da Giorgio Vasari e da Ascanio Condivi con aggiunte e note*, Berlin 1887.

K. Frey, *Il Codice Magliabechiano*, Berlin 1892.

K. Frey, *Michelagniolo Buonarroti; Sein Leben und seine Werk*, I, Berlin 1907. (Frey 1907a)

K. Frey, *Michelagniolo Buonarroti, Quellen und Forschungen zu seiner Geschichte und Kunst*, I, Berlin 1907. (Frey 1907b)

M.J. Friedländer, *Early Netherlandish Painting*, Vol. V, Leiden 1969.

C.L. Frommel, 'Il Cardinal Raffaele Riario ed il Palazzo della Cancelleria', in *Sisto IV e Giulio II, mecenati e promotori di cultura*, Atti del Convegno Internazionale di Studi, Savona 1985, pp. 73–85.

C.L. Frommel, 'Jacobo Gallo als Förderer der Künste: Das Grabmal seines Vaters in S. Lorenzo in Damaso und Michelangelos erste römische Jahre', in *Kotinos, Festschrift für Erika Simon*, Mainz 1992, pp. 450–60.

N. Gabrielli, 'Aspetti scientifici nel restauro degli affreschi di Michelangelo nella Cappella Sistina', *Monumenti Musei e Gallerie Pontificie Bollettino*, VII, 1987, pp. 151–62.

C. Gamba, *La Pittura di Michelangelo*, Novara 1948.

Giovanni Battista Gelli, *Vite d'Artisti*, ed. G. Mancini, *Archivio Storico Italiano*, 5th series, XVII, 1896, pp. 32–62.

R.J. Gettens and M.E. Mrose, 'Calcium sulphate minerals in the grounds of Italian paintings', *Studies in Conservation*, 1, 4, 1954, pp. 174–89.

Il Giardino di San Marco, Maestri e Compagni del Giovane Michelangelo (exhibition catalogue), ed. P. Barocchi, Casa Buonarroti, Florence 1992.

D. Gnoli, *La Roma di Leone X*, Milan 1938.

C. Gould, 'Some Addenda to Michelangelo Studies', *The Burlington Magazine*, XCIII, 1951, pp. 279–82.

C. Gould, *The Sixteenth Century Italian Schools*, National Gallery Catalogues, London 1975.

M. Hirst, 'Michelangelo in Rome: an altar-piece and the "Bacchus"', *The Burlington Magazine*, CXXIII, 1981, pp. 581–93.

M. Hirst, 'Michelangelo, Carrara and the marble for the Cardinal's Pietà', *The Burlington Magazine*, CXXVII, 1985, pp. 154–9.

M. Hirst, *Michelangelo and his Drawings*, New Haven and London 1988.

M. Hirst et al., *The Sistine Chapel. A Glorious Restoration*, New York 1994.

C.J. Holmes, 'Where did Michelangelo learn to paint?', *The Burlington Magazine*, XI, 1907, pp. 235ff.

C.J. Holmes, *The National Gallery, Italian Schools*, London 1923.

C. von Holst, 'Domenico Ghirlandaio: l'altare maggiore di Santa Maria Novella a Firenze Ricostruito', *Antichità Viva*, VIII, 3, 1969, pp. 36–41.

C. von Holst, *Francesco Granacci*, Munich 1974.

W. Hood, *Fra Angelico at San Marco*, New Haven and London, 1993.

P. Joannides, 'Michelangelo's lost Hercules', *The Burlington Magazine*, CXIX, 1977, pp. 550–4.

P. Joannides, 'A supplement to Michelangelo's lost Hercules', *The Burlington Magazine*, CXXIII, 1981, pp. 20–3.

V. Juřen, 'Fecit Faciebat', *Revue de l'Art*, XXVI, 1974, pp. 27–30.

W. Körte, 'Deutsche Vesperbilder in Italien', *Kunstgeschichtliches Jahrbuch der Bibliotheca Hertziana*, I, Leipzig 1937, pp. 1–138.

O. Kurz, *Falsi e Falsari*, ed. L. Ragghianti Collobi, Venice 1961.

O. Kurz, *Fakes*, New York 1967.

P.F. Lana, *Prodromo, overo saggio di alcune inventioni nuove premesso all'arte maestra*, Brescia 1670.

R. Lanciani, *Storia degli Scavi di Roma*, 4 vols, Rome 1902–12.

K. Lanckoronska, 'Antike Elemente im Bacchus Michelangelos und in seiner Darstellung des David', *Dawna Sztuka Rocznik*, I, 1938, pp. 183ff.

L. Landucci, *Diario Fiorentino dal 1450 al 1516*, ed. I. del Badia, Florence 1883.

L.O. Larrson, *Von allen Seiten gleich schön, Studien zum Begriff der Vielansichtigkeit in der europäischen Plastik von der Renaissance bis zum Klassizismus*, Stockholm 1974.

A. Luchs, 'Michelangelo's Bologna Angel: Counterfeiting the Tuscan Duecento', *The Burlington Magazine*, CXX, 1978, pp. 222–5.

A. Luzio, 'Isabella d'Este e Giulio II', *Rivista d'Italia*, XII, 1909, pp. 837–76.

A. Luzio, *La Galleria dei Gonzaga venduta all'Inghilterra nel 1627–28*, Milan 1913.

Maestri e botteghe. Pittura a Firenze alla fine del quattrocento (exhibition catalogue), Palazzo Strozzi, Florence 1992.

D. Maffei, *Il Giovane Machiavelli Banchiere con Berto Berti a Roma*, Florence 1973.

Raphael Maffeius (Volterrano), *Commentariorum liber primus…*, Rome 1506.

F. Mancinelli and R. Bellini, *Michelangiolo*, Florence 1992.

H.R. Mancusi-Ungaro, *Michelangelo, the Bruges Madonna and the Piccolomini Altar*, New Haven and London 1971.

P. Mantz, 'Michel-Ange peintre', *Gazette des Beaux-Arts*, 2ᵉ Période, XIII, 1876, pp.119–86.

V. Marucci, A. Marzo and A. Romano, *Pasquinate Romane del Cinquecento*, 2 vols, Rome 1983.

D.E. McClellan, *Luca Signorelli's Last Judgement Fresco Cycle at Orvieto: An Interpretation of the Fears and Hopes of the Comune and People of Orvieto at a Time of Reckoning*, unpublished doctoral thesis, Melbourne University, 1992.

Michelangelo's 'Entombment of Christ'. Some new hypotheses and some new facts, National Gallery, London n.d. (1970).

G. Milanesi, *Documenti per la Storia dell'Arte Senese*, 3 vols, Siena 1854–6.

G. Milanesi, *Le lettere di Michelangelo Buonarroti edite ed inedite coi ricordi ed i contratti artistici*, Florence 1875.

O. Millar, 'The Inventories and Valuations of the King's Goods, 1649–1651', *The Walpole Society*, XLIII, Glasgow 1972.

M.L. Morricone Matini, 'Giorgio Vasari e le "Anticaglie": Storia del "Putto in Pietra Nera che Dorme" alla Galleria degli Uffizi', *Atti della Accademia Nazionale dei Lincei*, Anno CCCLXXXVI, 1989, Rendiconti XLIV, Rome 1991, pp. 259–77.

A. Nagel, 'Michelangelo's London "Entombment" and the church of S. Agostino in Rome', *The Burlington Magazine*, CXXVI, 1994, pp.164–7.

P.F. Norton, 'The lost sleeping Cupid of Michelangelo', *The Art Bulletin*, XXXIX, 1957, pp. 251–7.

A. Parronchi, *Opere Giovanili di Michelangelo, III: Miscellanea Michelangiolesca*, Florence 1981.

C.C. Perkins, *Tuscan Sculptors: their Lives, Works and Times*, 2 vols, London 1864.

A. Perrig, *Michelangelo's Drawings: the Science of Attribution*, New Haven and London 1991.

G. Pieraccini, *La stirpe dei Medici di Cafaggiolo*, 3 vols, Florence 1924.

U. Plahter, 'Líkneskjusmíð: Fourteenth century instructions for painting from Iceland', *Zeitschrift für Kunsttechnologie und Konservierung*, 6, 1, 1992, pp. 167–73.

G. Poggi, 'Note michelangiolesche', *Il IVᵒ Centenario del Giudizio*, 1942, pp. 117ff.

A.E. Popham, *Catalogue of the Drawings of Parmigianino*, 3 vols, New Haven and London 1971.

T.C. Price Zimmermann, 'Paolo Giovio and the evolution of Renaissance art criticism', in *Cultural Aspects of the Italian Renaissance, Essays in Honour of P.O. Kristeller*, ed. C.H. Clough, Manchester and New York 1976, pp. 406–24.

Raffaello a Pitti 'La Madonna del baldacchino' storia e restauro (exhibition catalogue), Palazzo Pitti, Florence 1991.

I. Ragusa and R.B. Green, eds, *Meditations on the Life of Christ*, Princeton 1961.

M. Rohlmann, 'Ein flämisches Vorbild für Ghirlandaios "prime pitture"', *Mitteilungen des Kunsthistorischen Institutes in Florenz*, XXXVI, 1992, pp. 388–96.

A. Roy, ed., *Artists' Pigments. A Handbook of Their History and Characteristics*, Vol. 2, Washington 1993.

M. Rubin, *Corpus Christi, the Eucharist in Late Medieval Culture*, Cambridge 1991.

R. Rubinstein, 'Michelangelo's lost "Sleeping Cupid" and Fetti's "Vertumnus and Pomona"', *Journal of the Warburg and Courtauld Institutes*, XIL, 1986, pp. 257–9.

H. Ruhemann and J. Plesters, 'The Technique of Painting in a "Madonna" attributed to Michelangelo', *The Burlington Magazine*, CVI, 1964, pp. 546–54.

H. Ruhemann, *The Cleaning of Paintings*, London 1968.

K. von Rumohr, *Italienische Forschungen*, Berlin and Stettin 1827–31.

R. Sabbadini, *Le scoperte dei codici latini e greci ne' secoli XIV e XV*, 2 vols, Florence 1905.

C. Samaran, *Jean de Bilhères-Lagraulas Cardinal de Saint-Denis, un diplomate Français sous Louis XI et Charles XIII*, Paris 1921.

A. Schiavo, 'Profilo e Testamento di Raffaele Riario', *Studi Romani*, VIII, 1960, pp. 414–29.

A. Schiavo, *Il Palazzo della Cancelleria*, Rome 1964.

A. Scott-Elliot, 'The statues from Mantua in the collection of King Charles I', *The Burlington Magazine*, CI, 1959, pp. 218–27.

J. Shearman, 'The Collections of the Younger Branch of the Medici', *The Burlington Magazine*, CXVII, 1975, pp. 12–27.

J. Shearman, *Only Connect…, Art and the Spectator in the Italian Renaissance*, Princeton 1992.

A. Smart, 'Michelangelo: the Taddeo Taddei

"Madonna" and the National Gallery "Entombment", *Journal of the Royal Society of Arts*, 1967, pp. 835–62.

H. von Sonnenburg, *Raphael in der Alten Pinakothek*, Munich 1983.

M. Spallanzani and G.G. Bertelà, eds, *Libro d'Inventario dei Beni di Lorenzo il Magnifico*, Florence 1992.

G. Spini, 'Politicità di Michelangelo', in *Atti del Convegno di Studi Michelangioleschi*, Rome 1966, pp. 110–70.

R. Suckale, 'Arma Christi', *Städel-Jahrbuch*, N.F.VI, 1977, pp. 177–208.

D. Summers, *Michelangelo and the Language of Art*, Princeton 1981.

H. Thode, *Michelangelo, Kritische Untersuchungen über seine Werke*, I, Berlin 1908.

C. de Tolnay, *The Youth of Michelangelo*, Princeton 1943 (reprinted 1970).

C. de Tolnay, *Alcune recenti scoperte e risultati negli studi Michelangioleschi*, Accademia Nazionale dei Lincei, Quaderno N.153, Rome 1971.

C. de Tolnay, *Corpus dei Disegni di Michelangelo*, I, Novara 1975.

C. de Tolnay, *Corpus dei Disegni di Michelangelo*, II, Novara 1976.

Il Tondo Doni di Michelangelo e il suo restauro (exhibition catalogue), Gli Uffizi, Studi e Ricerche, 2, Florence 1985.

J.B. Trapp, 'The Owl's Ivy and the Poet's Bays', *Journal of the Warburg and Courtauld Institutes*, XXI, 1958, pp. 227ff.

Giorgio Vasari, *La Vita di Michelangelo nelle redazioni del 1550 e del 1568*, ed. P. Barocchi, 5 vols, Milan and Naples 1962.

[Vasari] *Vite de' più eccellenti pittori, scultori e architetti scritte da Giorgio Vasari...*, ed. G. Bottari, 3 vols, Rome 1759–60

[Vasari] *Le Vite de' più eccelenti pittori, scultori e architetti scritte da Giorgio Vasari...*, ed. G. Milanesi, 9 vols, Florence 1878.

G. Vasari, *Vasari on Technique*, trans. L.S. Maclehose, Dover reprint, New York 1960.

A. Venturi, 'Il "Cupido" di Michelangelo', *Archivio Storico dell'Arte*, I, 1888, pp. 1–13.

L. Venturini, 'Qualche novità e alcune considerazioni su due tavole ghirlandaiesche', *Paragone*, XLI, 23, September 1990, pp. 67–76.

G. Vertue, *A Catalogue of the Collection of Pictures etc. belonging to King James the Second...*, London 1758.

W. Wallace, 'Michelangelo's Rome "Pietà": Altarpiece or Grave Memorial?', in *Verrocchio and Late Quattrocento Italian Sculpture*, eds S. Bule, A.P. Darr and F.S. Gioffredi, Florence 1992, pp. 243–55.

K. Weil-Garris Brandt, 'Michelangelo's "Pietà" for the Cappella del Re di Francia', in *Il se rendit en Italie, Etudes offertes à André Chastel*, Rome and Paris 1987, pp. 77ff.

K. Weil-Garris Brandt, '"The Nurse of Settignano", Michelangelo's Beginnings as a Sculptor', in *The Genius of the Sculptor in Michelangelo's Work* (exhibition catalogue), Montreal Museum of Fine Arts, 1992, pp. 21–40.

J.H. Whitfield, 'Leon Battista Alberti, Ariosto and Dosso Dossi', *Italian Studies*, XXI, 1966, pp. 16–30.

J. Wilde, 'Eine Studie Michelangelos nach der Antike', in *Mitteilungen des Kunsthistorischen Institutes in Florenz*, XIV, 1932, pp. 41–64.

E. Wind, *Pagan Mysteries in the Renaissance*, London 1958.

F. Zeri, 'Il Maestro della Madonna di Manchester', *Paragone*, XLIII, 1953, pp. 15–27.

J.E. Ziegler, *Sculpture of Compassion: the Pietà and the Beguines in the Southern Low Countries c.1300–c.1600*, Brussels and Rome, 1992.

Lenders to the Exhibition

Lent by Her Majesty The Queen (No. 27)

Dublin, The National Gallery of Ireland
(No. 3)

Florence, Gabinetto Disegni e Stampe degli
Uffizi (Nos 15, 17)

London, The Trustees of the British Museum
(Nos 8, 14, 16, 18, 20)

London, Royal Academy of Arts (No. 11)

London, Lent by the Trustees of the Victoria
& Albert Museum (Nos 9, 10, 13)

Oxford, The Visitors of the Ashmolean
Museum (Nos 25, 26)

Paris, Musée du Louvre, Département des
Arts Graphiques (Nos 19, 21, 22)

Rome, Monumenti e Gallerie Pontificie
(No. 12)

Vienna, Gemäldegalerie der Akademie der
bildenden Künste (No. 5)

Vienna, Graphische Sammlung Albertina
(Nos 23, 24)

Wiltshire, The Corsham Court Collection
(No. 7)

Works in the Exhibition

Paintings

1
Domenico Ghirlandaio
*Virgin and Child, c.*1480
Panel, 92.3 × 58 cm (including modern
addition at the top of the arch)
London, National Gallery (NG 3937)
Plate 61

2
David Ghirlandaio
Virgin and Child with Saint John, 1480s
Panel, 78.8 × 46.5 cm
London, National Gallery (NG 2502)
Plate 62

3
Francesco Granacci
*Rest on the Flight into Egypt with the Infant
Saint John, c.*1494
Panel, 100 × 71 cm
Dublin, National Gallery of Ireland
Plate 35

4
Michelangelo
Virgin and Child with Saint John and Angels
('*The Manchester Madonna*'), perhaps 1497
Panel, 104.5 × 77 cm
London, National Gallery (NG 809)
Plate 23

5
Associate of Michelangelo
Virgin and Child with Saint John, late 1490s
Panel, 66 cm diameter
Vienna, Gemäldegalerie der Akademie der
bildenden Künste
Plate 24

6
Michelangelo
Entombment, 1500–1
Panel, 162 × 150 cm
London, National Gallery (NG 790)
Plate 42

Sculpture, including Casts

7
Sleeping Cupid
probably 16th century
Marble, 90 cm long
Wiltshire, The Corsham Court Collection
Plate 16

8
Sleeping Cupid
Roman, 1st or 2nd century AD
Marble, 59.5 cm long
London, British Museum

9
Michelangelo
Bruges Madonna, between 1504 and 1506
(Plate 30). Plaster cast, supplied in 1872 by
A. van Soist of Brussels, of the marble statue
in Notre Dame, Bruges, 128 cm high
London, Victoria and Albert Museum

10
Michelangelo
Pitti Tondo, between 1503 and 1506 (Plate 29)
Plaster cast, supplied in 1876 by Oranzio Lelli
of Florence, of the marble relief in the Museo
Nazionale del Bargello, Florence, 85.5 × 82 cm
London, Victoria and Albert Museum

11
Michelangelo
*Taddei Tondo, c.*1503–4
Modern fibreglass resin cast, made in 1986 by
John Larson, of the marble relief in the Royal
Academy, London, 109 cm diameter
London, Royal Academy of Arts

12
Michelangelo
Pietà, begun 1498 (Plate 36)
Plaster cast made in *c.*1945 of the marble
statue in St Peter's, Rome, 174 cm high
Rome, Vatican Museums

13
'Rimini Master' (South Netherlandish),
*Pietà, c.*1430
Alabaster, 38.4 cm high
London, Victoria and Albert Museum

Drawings

14
Domenico Ghirlandaio
Study for the Birth of the Virgin, for the fresco
in S. Maria Novella, Florence, 1486–90
Pen and ink, 21 × 28 cm
London, British Museum

15
Domenico Ghirlandaio
Two standing women, study for the fresco of
the *Naming of the Baptist* in S. Maria Novella,
Florence, 1486–90
Pen and ink, 26 × 16.9 cm
Florence, Uffizi
Plate 5

16
Domenico Ghirlandaio
Standing woman, study for the fresco of the
Birth of the Baptist in S. Maria Novella,
Florence, 1486–90
Pen and ink, 24.1 × 11.5 cm
London, British Museum
Plate 6

17
Domenico Ghirlandaio
Drapery study, for the altarpiece of the
Visitation in the Louvre, Paris, 1491
Pen and ink, brown and pink wash, lead
white heightening, 29 × 13.1 cm
Florence, Uffizi

18
Michelangelo
Philosopher, c.1495–1500
Pen and brown and grey ink, 31.1 × 21.5 cm
London, British Museum
Plate 4

19
Michelangelo
*Studies of figures, leg and head, including a
standing infant*, c.1495–1500
Pen and brown ink, black and red chalk,
40 × 22 cm
Paris, Louvre
Plate 31

20
Michelangelo
*Studies for the Battle of Cascina and the Bruges
Madonna*, 1504
Black chalk and pen and ink over lead-point,
31.5 × 27.8 cm
London, British Museum

21
Michelangelo
Kneeling nude girl, study for the *Entombment*,
c.1500–1
Black chalk, pen and ink and white
highlighting on pink prepared paper,
26.6 × 15.1 cm
Paris, Louvre
Plate 52

22
Michelangelo
Male nude, study for the *Entombment*,
c.1500–1
Pen and ink, 37 × 19.5 cm
Paris, Louvre
Plate 53

23
Michelangelo
Dead Christ supported by mourning figures,
1530s
Red chalk, 31.9 × 24.8 cm
Vienna, Albertina
Plate 54

24
Michelangelo
Dead Christ supported by a mourner,
1530s
Red chalk with a little black chalk,
40.4 × 23.3 cm
Vienna, Albertina
Plate 55

25
Michelangelo
Studies of the Dead Christ supported by mourners,
1550s
Black chalk, 10.8 × 28.1 cm
Oxford, Ashmolean Museum
Plate 56

26
Michelangelo
Dead Christ supported by mourning figures,
after 1550
Red chalks, 37.5 × 28 cm
Oxford, Ashmolean Museum

27
Copies after marble Sleeping Cupids,
from the album *Busts and Statues in Whitehall
Garden*, 17th century
Pen and ink and wash, 16 × 24 cm
Windsor Castle, The Royal Library
Plate 13

Picture Credits

The Royal Collection © 1994 Her Majesty the Queen: Pl. 13

Badia a Settimo. Photo Archivi Alinari: Pl. 45

Berlin, Staatliche Museen zu Berlin – Preußischer Kulturbesitz, Gemäldegalerie. © Bildarchiv Preußischer Kulturbesitz 1994. Photo Jörg P. Anders: Pl. 46

Bologna, San Domenico: Pls 9 (photo Archivi Alinari); 10, 12, 34 (photos Conway Library, Courtauld Institute of Art); 11

Bruges, Notre Dame. Photo Conway Library, Courtauld Institute of Art: Pl. 30

Budapest, Szépmüvészeti Múzeum: Pl. 104

Dublin, Courtesy of the National Gallery of Ireland: Pl. 35

Florence, Museo Nazionale del Bargello. Photos Conway Library, Courtauld Institute of Art: Pls 17, 18, 19, 20, 21, 22, 29

Florence, Casa Buonarroti: Pls 7, 8, 48 (photo Giorgio Laurati), 51

Florence, Ospedale degli Innocenti. Photo Scala, Firenze: Pl. 3

Florence, Santa Maria Novella. Photo Scala, Firenze: Pl. 58

Florence, Ufficio Restauri, Soprintendenza per i Beni Artistici e Storici: Pls 82, 90, 106, 108, 114, 123

Florence, Galleria degli Uffizi: Pls 14, 15 (photo courtesy A. Parronchi), 44 (photo Archivi Alinari), 125 (photo Scala, Firenze); Gabinetto Disegni e Stampe degli Uffizi: Pl. 5

London, The Trustees of the British Museum: Pls 4, 6

London, National Gallery: Pls 1, 2, 27, 33, 42, 47, 49, 57, 61–81, 84–9, 92–9, 105, 107, 109–13, 115–22, 124

Munich, Alte Pinakothek: Pls 43, 100–1; 102, 103 (photos London, National Gallery)

Oxford, Ashmolean Museum: Pls 32, 56, 83

Paris, Musée du Louvre. Clichés des Musées Nationaux. © photos R.M.N.: Pls 31, 52, 53, 60

Rome, Galleria Nazionale d'Arte Antica di Palazzo Barberini. Photo Casa Buonarroti: Pl. 26

Rome, Fabbrica di S. Pietro in Vaticano: Pls 36, 40, 41

Rome, Monumenti e Gallerie Pontificie. Pls 37, 38, 39 (photos © Robert Hupka); 91 (Vaticani Archivio Fotografico); 94 (photo © Nippon Television Network Corporation, Tokyo, 1994)

Siena, Biblioteca Comunale degli Intronati: Pl. 50

Vienna, Gemäldegalerie der Akademie der bildenden Künste: Pls 24, 28

Vienna, Graphische Sammlung Albertina. Photos Bildarchiv der Nationalbibliothek: Pls 54, 55

Washington, Photograph courtesy of The Samuel H. Kress Foundation, New York, and the Photographic Archives, National Gallery of Art: Pl. 25

Wiltshire, The Corsham Court Collection. Photo Conway Library, Courtauld Institute of Art: Pl. 16